"As a leading entertainment lawyer, production executive, successful producer and, more recently, an academic at TMU, Steve Levitan has extensive experience, insight and expertise when it comes to all aspects of content creation. *The Content Production Business* is an essential guide to anyone who aspires to have a professional career as a content maker."

— David Zitzerman

"Steve Levitan's new book *The Content Production Business* is not only the first book of its kind, it is a comprehensive, thorough and immensely helpful primer, providing easily understood coverage of the legal, economic and creative fundamentals that anyone interested in the content production business must read."

— Scott Jolliffe, Intellectual Property Partner at Gowling WLG

"As an accomplished producer, media entrepreneur and educator, Levitan knows how creativity and business must work hand in hand in content creation. This is an essential primer for anyone wanting to succeed as a producer!"

— Charles Falzon, Dean of The Creative School at Toronto Metropolitan University

"This book is really smart! The reader, whether novice, professional or industry stakeholder, will come away with a powerful, pragmatic 'indie film' design for success. Levitan balances artistic vision with the commercial savviness necessary to survive and grow in a very competitive media industry. He illustrates his ideas with legal precision and a unique social intelligence while employing impactful stories from the field."

— Jean Desormeaux, Sheridan College

"Steve Levitan lays out in gritty and pragmatic detail how to develop, finance, executive produce and sell a television series. This is the long overdue business and legal guide for producers and those who dream of becoming television producers."

— James Nadler, Chair of RTA School of Media at Toronto Metropolitan University

The Content Production Business

This book goes beyond the technical steps in the process of making film, TV and media material, examining what it means to be an ongoing supplier of content to the marketplace and how to become one. Steve Levitan brings insights and experience from his lifelong career producing in the content industry, where he has also acted as a professional advisor to content makers, distributors and providers, whilst setting up his own production company.

Producing as a Business offers strategic, tactical, financial, legal and marketing insights for the successful establishment of content creation enterprises. Readers will gain insight into how to avoid starting from square one with each project, while also learning how to maintain a meaningful level of ownership and build a revenue stream that can sustain a core operation, helping establish them as a "player" in the industry. This text is aimed at the international production industry, with real examples referred to throughout.

Film, television and media production students who are looking to understand the business of producing, as well as first-time producers who are already familiar with the basics of the production process, will benefit from an examination of the building blocks that form lasting production companies.

Steve Levitan is the sole owner of Protocol Entertainment Inc, founded in 1993 – which devotes itself to excellence in the development, financing and production of series, mini-series and movies for the North American and international markets. He is also one of Canada's most reputable entertainment lawyers. Since 2012, Levitan has also been an instructor at Toronto Metropolitan University's RTA School of Media and its Creative Industries School as well as Sheridan College's Pilon School of Business. He is a registered mediator for cultural industries.

The Content Production Business

Legal, Economic and Creative Fundamentals

Steve Levitan

Routledge
Taylor & Francis Group

NEW YORK AND LONDON

First published 2024
by Routledge
605 Third Avenue, New York, NY 10158

and by Routledge
4 Park Square, Milton Park, Abingdon, Oxon, OX14 4RN

Routledge is an imprint of the Taylor & Francis Group, an informa business

© 2024 Steve Levitan

Library of Congress Cataloging-in-Publication Data
A catalog record for this title has been requested

ISBN: 9781032460178 (hbk)
ISBN: 9781032460161 (pbk)
ISBN: 9781003379737 (ebk)

DOI: 10.4324/9781003379737

Typeset in Univers
by codeMantra

To Bill Freedman

Wise, Kind, Dignified and Dearly Missed

Contents

Contents

Introduction

By 1965, 13 years after they had emigrated to Toronto as World War II refugees, my parents felt almost secure enough to undertake a financial risk. They were determined to celebrate my 13th birthday with something close to the kind of Bar Mitzvah reception that other families in the community held. They made me a proposal. The gifts (which were mostly in the form of cash in those days) would be first applied to cover the cost of the ceremony and party. If there was any money left over, it would go to me. Of course, I agreed. After it was all over, they were proud to gift me $150. This was not a small amount of money in the mid-sixties. The number was too round though. I was convinced that in actual fact there was nothing left after everything was paid for. It was just that my parents couldn't bring themselves to leave me with nothing. I used the money for two things. One was a subscription to the weekly edition of *Variety* maga-zine which I maintained for over 50 years. It initially cost about $50 per year. The sec-ond was a brand-new Kodak Super 8 Instamatic movie camera.

Variety came every week rolled into a tube shape and wrapped in plain brown paper. I read it religiously every Sunday from cover to cover. Nothing seemed insignificant, nei-ther the obituaries, the classified ads (for things like elocution lessons) nor the results of obscure Off-Off Broadway theatre runs. It was the only reference material I could find to shed light on how the entertainment industries really worked. I was thirsty for any insight at all.

The camera was state of the art in consumer electronics at the time. It was about the size of a tissue box. It had flip out door sprung open by a small button on the top. The door revealed a cigarette pack-sized compartment into which one would insert the super eight film cartridge. There was one other button on top of the camera. You held it down to shoot, released it to stop. Once exposed the three minutes of film had to be sent to Kodak labs for processing by mail. The processed film would come back in about a month, sometimes two. If it was black and white film it might take more than three months. To make anything of the result I needed a cheap hand splicer and special glue which rarely held the narrow strips of film together. To view the finished movie (if it could be called that) I would have to somehow procure a projector and rig up a screen. Even then, the only audience that could be cajoled into watching – friends and family – could be counted on one hand.

DOI: 10.4324/9781003379737-1

I had confidence that I could learn how to make "content" because I could literally do that by hand. I could even show it to a few people. But I had to rely on *Variety* to clue me in to how to make a living doing what I loved.

As the Information Age has grown from its infancy into what we may assume is its young adulthood, the importance of culture to all the societies of our planet becomes even more apparent. All the great challenges, conflicts and achievements of our time play out over media of one kind of another. Wars and ideological battles are conducted over data streams as well as actual battlefields, perhaps more so. The inbuilt human need for story, for visualization, for relatability, for escape and for mutual understanding has never been more critical.

As this book is being written, billions of people of all ages and backgrounds make "content" every day and make it accessible to almost the entire world in seconds at virtually no cost. Technology has democratized the means of content creation as well as the ability to expose it to the widest possible numbers of viewers. It has not, however, simplified the monetization of content. Quite the contrary. As this book is being written the best estimate is that close to 500 hours of content are uploaded to YouTube every minute. Every minute, just on YouTube. Almost every single person uploading anything to any site has in the back of her mind that the video might just become viral – attract millions of viewers, make the creator famous, perhaps generate some revenue and maybe even become a "hit". Consider the odds. At over 700,000 hours of content uploaded to YouTube *every day*, how improbable is it that any one item would go viral? In the 1960s the number of competing film makers of any kind was more like 100,000 or so, they each might make one or two films or TV programs a year. Today everyone on the planet is a potential filmmaker and there is no real limit to how much they can create or how many projects they make available to the world. Some content can be viewed for free, some costs a pretty penny.

This book is an attempt to provide a guide to those aspiring to build careers as content makers. It reflects on how to make content creation one's life's work and to earn a reasonable enough living in the process that one can continue doing so. It might serve as a handbook, a reference to the basic issues and practices that underlie content production irrespective of changes in technology and business trends. It focusses on the foundational constants underlying the creation of commercial in order to prevent this book from being outdated. One new tech device, application or platform is replaced by another with increasing speed. New technological developments create excitement and

new possibilities, but at the end of the day the actual creation of content by humans for humans still involves the same basic elements. For those reasons, the newest or most current technological advances and their related content issues are left to other more specific texts.

Focussing on "professional" content creators, this book will bring together key fundamental concepts and provide observations, advice and insight into how sustainable success might be achieved. This begs the question of what is meant by success in the content creation profession.

This book takes the point of view that success as a "producer" includes creative satisfaction, recognition by peers in the industry, fair economic reward and the ability to maintain a career over a long period of time.

This book is not intended for law or MBA students. It will not go into legal or business concepts in granular or technical detail. Rather, it will describe key principles in law or business that are of particular importance to the content creation industry in plainspoken and general terms as simply as possible. It will do so within the context of the creative process as I have experienced it.

This book is aimed at content creators, the kind of producers that develop their own content, finance the production, manufacture it, oversee the availability of it to audiences and aim to reap the emotional as well as the monetary rewards. Although many of the concepts and principles that will be covered apply to the broadest range of "producer" types, the focus is not so much on producers for hire or those who obtain producer credits for specific tasks or resources. The target is the kind of producer who is there at the origination of ideas for projects and right through to the completion and exploitation of those projects. A good deal of attention will be devoted to the establishment of production companies as vehicles for ongoing and sustainable presence in the marketplace.

The kind of content this book deals with is the kind that consumers will pay for with either their money or significant amounts of their attention. References to content, productions, programs or projects imply mainstream commercial audio-visual shows that one might find in theatres, on cable or streaming television or content websites. They would typically be long-form, meaning one-half hour, or one hour episodic series, miniseries or movies. They would have significant production value and thus sizeable production budgets. Hence, the need for a guide to how to develop, finance, produce and monetize the programs.

The emphasis as well will be on those working outside of the Hollywood "studio system" — what are commonly referred to as "independent producers". Their numbers are growing all over the world and their ability to work outside of (albeit sometimes together with) the largest media companies is expanding.

Needless to say, there are no hard and fast rules nor any checklist to follow to ensure success in an industry as changeable, competitive and in many ways ephemeral as the content creation industry. There are, however, foundational legal, business and creative elements that need to be understood and more than ever before they need to be applied in a holistic way for producers to remain productive and thrive.

The lens of past experience provides a valuable roadmap. This book will bring the lessons I've learned over a more than four-decade long career. Successes as well as mistakes and failures will be analysed. Personal real examples will be employed where possible. There will also be a good deal of opinion based on my particular career path. For that reason, I think it's important to briefly describe my career, my preferences and bias so that the reader can take the information in this book for what it's worth.

Although my career as a filmmaker, such as it was then, may have begun in the mid-sixties, my professional career started in a somewhat more traditional field. By the early seventies, having made a number of hobby films and having finished an undergraduate degree from one of the first Canadian universities to actually offer a real film program I was faced with a serious problem. Although I was brash enough to believe I could make a reasonable film, I had no real idea how to go about finding the money to pay for it. The industry at the time in Canada was in its very early stages and there really was no infrastructure for original production on a commercial scale. The Canadian Broadcasting Corporation (our national broadcaster) helped somewhat as did the National Film Board. Their budgets were small and their appetite narrow. Other than moving to Hollywood and starting a career there, very few opportunities existed to raise the resources for making any kind of production for someone who preferred to live and work in their home town.

It seemed that law school might answer some of the questions I had about raising money from various sources, putting deals together, starting a business and might even afford me a peek behind the scenes to see how decisions about the "greenlighting" of projects get made. A number of government subsidies and incentives were starting to be employed in Canada and slowly but surely what looked like a nascent industry started to form. The rules were complicated, access was difficult and the economics

opaque to say the least but movies were getting made. I enrolled in law school in 1974 with the single focus of working only in the cultural industries although the field barely existed in Canada. To my disappointment, there were no directly applicable courses available in law school other than the basic general ones to give me answers. Nevertheless, I graduated in 1977 and apprenticed to a law firm specializing in the field and eventually was called to the bar in 1979. I called myself an Entertainment Lawyer – one of a handful in the country.

Over ten years of practice, having represented scores of writers, directors, actors, producers, financiers, investors, distributors, exhibitors, broadcasters and others, I did learn much about how productions could come about. I saw how creative talent as well as market savvy and relationships lead to financing and how productions reach the marketplace – or fail to. The challenge of weaving all these varied entrepreneurial, creative, contractual and financing arrangements into a coherent tapestry was complicated then and still is today.

My first real production credits were for a number of films and television series that I assisted clients to produce beginning in 1980. By 1989, I was hired to run the very successful production company of one of my clients and left full-time legal practice. It was an invaluable learning experience giving me priceless exposure, now from the inside, as to what to do right and what to avoid in an actual production enterprise. In May of 1993, together with a very close friend, I formed what is now my own production company. The intention was to apply all the knowledge learned and experience gained by then and establish an organization that would be looked at by the industry at large in Canada, as well as in the United States and internationally as a reputable source of commercial product. That company is still in existence today and continues to earn revenue from its more than 600 hours of scripted dramatic content.

As a lawyer I gained key expertise in a very wide variety of industry-related activities, formed valuable contacts and was afforded insight into what makes deals work in the content industry and what does not. As a producer I have had learned a great deal about what to pitch, how to pitch, when to pitch and to whom to pitch projects. I have learned how to appropriately finance projects, get them produced on time and on budget, work with the creative teams to achieve the best quality possible and collaborate with distributors who can do the best job of exploiting the projects to earn revenue. It is that body of knowledge that I will draw on for this book.

I have seen enormous technological change in all sectors of the content creation industries since my Kodak Instamatic days. Movie theatres morphed into multiplexes and

arcades. Home video players and recorders made everyone a content creator. Television expanded into cable TV, then streaming then social media, then augmented reality then virtual reality and is still reinventing itself. Gaming grew from box-based to internet to cloud-based entertainment and is dwarfing the movie industry in size. User-generated content is everywhere. Artificial intelligence created content is rapidly entering, and may distort the field. The proliferation of modes of content platforms creates a huge pull on the available time and mental focus of ordinary people. When one thinks about it, the public probably spends more time every day on screen-based content than any other consumer product with the possible exception of mattresses.

Much has changed and will continue to change, but as a long-time practitioner in and student of the industries, I can safely say that the essential elements of the entertainment experience are still very much the same as they were when Aristotle wrote "Poetics" – his treatise on the proper structure of drama and literature. There are more tools than ever before available to more people than ever before to manufacture memorable and valuable experiences for others. It's easy to explain why a hit has become a hit after the fact but improbable to expect any new project to replicate that result. Marketing and market analysis are more important than ever before but also more accessible.

The challenges of creating a hit, or even a modestly successful project, may seem daunting but the field is there to be occupied by those armed with the right knowledge, instincts, tools and drive. The opportunities are still exciting and the rewards of a creatively and financially successful career in the content industries are still within reach. The purpose of this book is to help those hungry to learn and aspiring producers navigate around the hazards and find their best path forward. At the very least, this book will provide a good summary of the foundational elements to success: what kinds of things one needs to know, what kinds of people one needs to know, how to apply that knowledge and how to enjoy the journey.

Maple River

Throughout this book, we will be referring to a real project produced by my company which happens to involve many if not all the key concepts, issues and principles that this book deals with. We will call the series "Maple River" (it would be prudent to maintain confidentiality).

In the early 2000s, during one of the larger television markets that we regularly attended, we had conversation with a business colleague and sometime consultant to our company. As we had already established, a reputation in the industry for successful live-action TV series adaptations of children's books, he drew our attention to the "Maple River" series of books. There were over 100 titles in the book series and the television rights were held by an American company that was looking for a coproduction partner. The main characters were 12 years old – the same age group we had success with. They were all girls who were best friends in a riding club. Their antagonist was a privileged girl in the same club. They were devoted to each other and shared a common devotion to their horses. Each book in the series was a different "adventure".

My first reaction was less than enthusiastic. Focussing exclusively on girls seemed to cut the potential audience in half. Horse riding seemed like an activity most kids would find hard to relate to. Working with horses as well as child actors was a challenge. Weather was a constant risk for a show that would need to be shot outdoors for a large part of each episode. And the books had been out of print for several years. We did not reject the idea but kept it in the back burner.

At another meeting in the same market, our consultant introduced us to an Australian producer who was hugely enthusiastic about the potential for a series based on the books. He was persistent and eager to join forces. Sharing the risks with a third partner and increasing the financing pool made the project more attractive. His optimism, more than anything else, won me over. We all set up a meeting in New York City with the rights holders. All agreed to a three-way coproduction with relatively equal financing and production responsibilities and obligations.

After a while, three broadcasters agreed to pre-license the series, one in the United States, one in Canada and one in Australia. The financing for a 26-episode, $10,000,000 series was completed and we committed to begin production on a Canada/Australia official Treaty Coproduction (explained later in this book). All the cast, crew, production elements and creative controls were shared between the Canadian and Australian production companies. The US company was responsible for only delivering a pre-licence from a US broadcaster and the funding that represented (Figure I.1).

Almost immediately after the production commenced, the US company ran into severe financial difficulties that prevented it from meeting its obligations. My company took over its rights in the books and its funding role. Now we were two.

Maple River

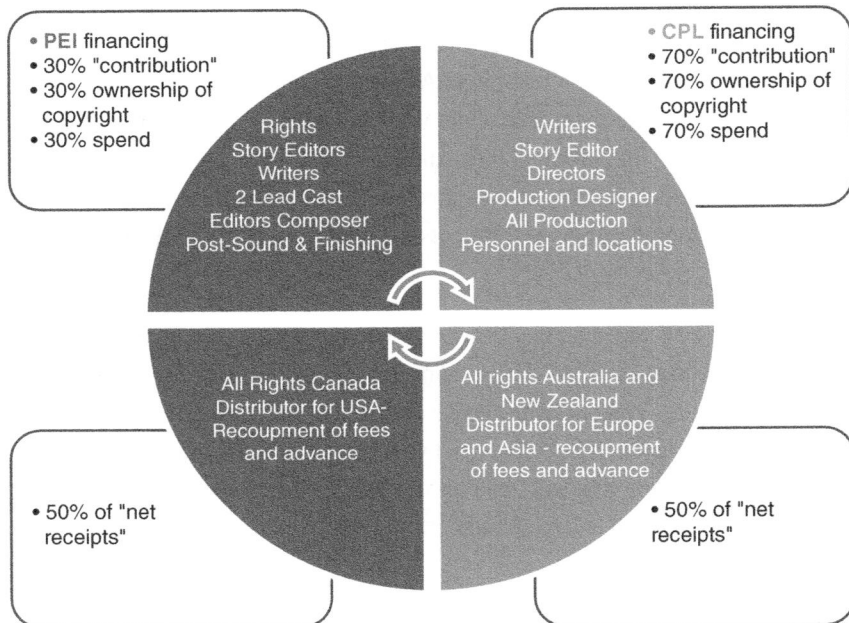

TREATY COPRODUCTIONS - THE SADDLE CLUB : 26 X ½ HR

- PEI financing
- 30% "contribution"
- 30% ownership of copyright
- 30% spend

- CPL financing
- 70% "contribution"
- 70% ownership of copyright
- 70% spend

Rights
Story Editors
Writers
2 Lead Cast
Editors Composer
Post-Sound & Finishing

Writers
Story Editor
Directors
Production Designer
All Production
Personnel and locations

All Rights Canada
Distributor for USA-
Recoupment of fees
and advance

All rights Australia and
New Zealand
Distributor for Europe
and Asia - recoupment
of fees and advance

- 50% of "net receipts"

- 50% of "net receipts"

The production went extremely well despite the many logistical and cultural challenges of coproducing a television series of this kind when the key decision makers were based on opposite sides of the planet. The outcome was a great surprise to me, if not to our Australian counterpart. The series proved to be very popular to its intended audience in Canada and the United States and hugely popular in Australia. So much so that we were renewed for a second season of 26 episodes by all three initial broadcasters.

International distribution of the series outside Canada, Australia and the United States was very successful as more and more territories licensed the program. Merchandizing and licensing of all manner of products carrying the show's brand and styling exploded, particularly in Australia. Home Video versions of the series and movies assembled from the episodes sold extremely well.

Eventually a third season was ordered. That is when problems began. Our Australian co-producer was let go by his parent company executive. That champion was lost and it took a year to rebuild the Australian support. The pause of a year caused three major challenges. First, it strained the patience of our Canadian broadcaster who wanted to

schedule new episodes without interruption. Second, our cast of 12-year-old girls by this time had grown too old for their characters and had to be recast. This is almost never a good thing. Thirdly, the American broadcaster got a new CEO and he set about chopping all costs that he could and tried to escape his obligations to our series.

Nevertheless, and not without litigation, the third and last season of the series went forward and was completed. Ironically, given the issues involved and my initial scepticism, the Maple River series has been the most consistently in demand of all the shows we have produced.

That series is a great vehicle for demonstrating how the topics that follow in this book might play out in real life. More detailed examination of aspects of the series will be used in many of the following chapters to give specific examples.

Students of film and television production at all levels as well as producers at early stages of their careers should find this book a useful resource to consult for context, fundamental principles and explanations of the basic elements of the content production business – the development, financing, production and exploitation of audio-visual entertainment.

Maple River

Chapter 1
Storytelling and Technology

If you had been alive 45,000 or 50,000 years ago, you might mix charcoal with animal fat, saliva and berry juice and then spit it at your hand pressed against the wall of your cave to make the outline of a handprint. Why would you do that?

The nature of existence in those days was predicated upon four basic driving needs, three of which pretty much everyone can name – survival, nourishment and procreation.

Survival supersedes all. The other needs are irrelevant if you perished. Your every sense was attuned to slight changes in your environment that might represent danger. The sound of a broken twig, a smell, a foul taste or a growl. The human brain is hardwired to perceive even tiny changes in the environment or in familiar patterns. Any change might necessitate protective measures.

If you could not find food, you would grow weak, unable to protect yourself or procreate. You might become food yourself to other predators. Your brain is also wired to react to smells, sounds, tastes and changes in surroundings to assess whether food might possibly be available.

At puberty, sexual drives lead to creating the next generation, increasing the size of families and therefore both the workforce and protection team. If there is no generation, the family genes diminish and disappear.

These are well known drives and easy to understand. It is understandable that the human mind evolves to serve those needs. The hand print on the cave wall, however, or the rough picture of a pig or deer tend to be viewed as quaint neanderthal pastimes. There is another way to look at cave art. Since they date back to the earliest evidence of human existence, they must represent a quality of humankind that has virtually always been there – inbuilt, hardwired like the three commonly accepted primal urges. That quality is the need to communicate by way of story.

What else would move early humans in what we now call Indonesia, Africa or Europe to engage in the similar behaviour thousands of miles apart? Wherever evidence of early humans is found, there is evidence of the need to assert the human identity, reinterpret the human environment, the human experience and the human condition. We are instinctive storytellers. In fact, many historians, anthropologists and philosophers

DOI: 10.4324/9781003379737-2

take the view that the principal factor distinguishing humans from all other life forms on the planet is our need, ability and skill at sharing thoughts. We are compelled to communicate with each other about things that are not physically there or immediately observable. We use pictures, sounds, ideas to share past or future experiences – stories. The very process of uncovering cave drawings, digging up burial sites or old bones or lost civilizations is a great example of the lengths that humans will go to in order to reveal the story of how we came to be who we are.

It follows then that as stories and storytelling are an intrinsic human need, storytelling as a profession is a noble calling. This brings us to the topic at hand. What are producers of content if not storytellers, providing nourishment for the human soul just as farmers produce nourishment for the human body? Humans will continue to demand, perhaps even depend on stories. Content producers will continue to supply them. As technology frees up more time and energy that humans used to devote to survival, nourishment and procreation, people will not only have more freedom to consume stories, but they will increasingly rely on stories to connect with nature and each other. A demand that can be fulfilled by a supply is a business.

This book begins with that brief socio-anthropological thesis because it is important to recognize the creation of content as a manifestation of our humanity, its capacity for good as well as its capacity for harm. Content is not simply "product" as it is often called in many circles. It touches everyone in profound ways that are not always discernible. Every message makes an impact whether negligible or unforgettable. Unless one has a wide perspective on the role of content in everyday life, it is hard to understand why people in all walks of life are willing to pay for content with their time, attention and hard-earned cash. Why do they do so for an ever-increasing proportion of their waking hours? What makes people choose to view content rather than hug a friend, call a parent, nurture a child or simply enjoy the sunshine or the night sky? The struggle to answer these questions, more importantly than the answers themselves, will make us all better content creators. Appreciating what stories resonate widely and why they do so will make us more successful content creators.

The Past

One does not always know where one is headed. In the world of content creation, it is even harder to know what the preferred mode of content will be and what the preferred medium or the preferred economic model will be. A new form of content, or method of

sharing, is always just around the corner. All content creators struggle to predict how best to reach their intended audience.

It is possible, however, to get a general or rough idea of where consumption patterns will go. To plot that trajectory, two pieces of information are indispensable. The first is an accurate description of where things come from.

No neanderthal could have predicted ChatGPT. It obviously did occur to them, however, that there are more efficient ways to make pictures than spraying a cocktail of fat, juice and saliva at their hand or scraping a charred stick on a wall. Even before those primitive content production methods, there most likely was a long tradition of oral storytelling. Both technologies, as minimal and basic as they are, still have the capacity to effectively transport viewers or listeners to a different time and place than the one they physically occupy. Sculpture soon followed, its subject matter reflecting the basic human needs – identity, fertility, food, threat. Static pictures evolved into murals showing action – hunting, harvesting, mating.

Storytelling, the ability to share thoughts and feelings in a relatable way to others, would have greatly assisted humans to form better protective living conditions and more efficient hunting or gathering techniques. As existence became safer and food more nourishing, reproduction became more successful as well. As fire illuminated the night storytelling and imagination occupied the mind. Rituals, myths and legends evolved to try and explain the human condition. Religions formed. Philosophies began to be articulated. All revolved around the basic questions of storytelling – what does it mean to be human and what is our place in the world?

The Epic of Gilgamesh was carved into city walls about two millennia before the common era. The Old Testament was first written down some 800 years later and Homer's epic poems some 400 years after that. There are strikingly common story elements to each. Story was soon used for persuasive goals – to inform, unify and control societies that were becoming increasingly urban and organized.

The Past

Content was still mostly delivered orally or by actual human hand. Speeches, sermons, performances and theatre gradually became available to common folk, not only the privileged. But they still took place in real time and space – places of worship, courtyards, theatres and marketplaces. Great edifices were built to accommodate the growing audiences.

Handwritten books, paintings and sculptures were the privilege of the upper classes but grew in sophistication and numbers as societies became richer and patrons more

ambitious. Storytellers, musicians, composers, writers and artists depended mostly on patronage or public donation to earn a living from their crafts.

The evolution of content creation and delivery was proceeding apace but relatively slowly.

By the middle of the fifteenth century, the Gutenberg printing press changed everything. For the first time, a book could be manufactured by a machine. Mass production of manuscripts reduced the time and labour required to produce a book. Copies could be made available and much more affordable to more and more people. Demand grew, and the technology continued to improve supply.

Copyright laws soon had to be enacted to protect creators from others copying and selling their work without authorization or recompense. Creators were empowered to enjoy the economic benefits of their work, and consumers were happy to pay for their content. The content production became big business. The means of production, its modes, its methods of delivery and consumption have never stopped evolving.

By the 1700s, the industrial revolution has begun and ad-supported newspapers or pamphlets were appearing. By the early 1800s, photography did for visual content what the printing press did for the written word. The development of new inventions, formats and devices for the creation and dissemination of content accelerated rapidly. The telegraph in the early 1800s was soon followed by the telephone in 1876; radio, the phonograph and motion pictures some 20 years later; and television only 20 years after that. Technologies were becoming ever more sophisticated, and more complex forms of content could be delivered to much larger audiences, over greater distances, at the same time and in the comfort of their own homes.

The computer grew out of World War II. The 1950s saw all forms of content print, photography, movies, music recordings, magazines, radio and television networks explode in popularity. Soon came cable and satellite television, home video devices and portable music players.

The 1980s saw the beginning of the Information Age with the advent of the internet. As bandwidth increased and home computers became household appliances, the computer screen became everyone's surrogate to reality. Sharing content in all its forms in real time worldwide was effortless. Easy-to-use applications and smart phones allowed everyone to carry the world in their pocket. Content was not only a big business, it had become a worldwide commodity as common as food or drink. Human attention became

an ever more valuable resource, and content was the means of mining it. Attention became the stock in trade of the largest business organizations in the world. Content became the new oil. Information replaced industry as the most important sector in the fastest growing economies of the world.

Nevertheless, theatres did not disappear. Places of worship and lecture halls were still filled. New technologies did not lead to the extinction of old forms of content creation. They may have reduced some in popularity or size, but overall, the impact of technology on the content production business grew the market rather than shrinking it. People spent an increasing amount of their time and disposable income on content rather than less.

The Present

Over the millennia, by using technology to separate intelligence from consciousness, the human brain evolved to devote less of its space and function to the physical needs of life and more to the imaginative, the creative and the intellectual. Today, most of us spend our day sitting alone with a screen. We are fed information we did not ask for. We can ask for literally all the information we want and get it instantly with a few words or keystrokes. Rather than depending on physical activity to stay alive, we push ourselves to exercise. We are literally like sitting ducks, easy targets for those who wish to capitalize on our attention.

Our attention has never been more valuable. It contains a wealth of information to advertisers, marketers, health professionals, insurance companies, politicians and financial service companies just to name the obvious. Mining the data that is generated by our attention produces valuable predictive information about what behaviours or actions we might take, products we might like or programs we might watch. More ominously, it also affords the opportunity to mould our behaviours, our opinions and our ideologies.

Content has always had its detractors. Blasphemy, obscenity, violence, sexuality, hate speech and disruptive political views have always been targeted by those that are uncomfortable with the message contained in content. Does graphic violence in video games contribute to mass shootings? Does pornography consumption do harm to healthy human sexuality? Can journalism distort social priorities? There are no yes or no answers. There are those that use content to promote positive social values and those who do the exact opposite. The point is that never has content been so effective

The Present

at shaping our thoughts and actions, nor have there been more sophisticated methods to use content to those ends.

Social media, video on demand, newsfeeds, how-to videos, chat rooms and sharing platforms have enabled every one of us to be a content creator. We have all become content creators. Who among us has not posted or shared a picture, an article or a video? According to Statista, as of June 2022, more than 500 hours of video are uploaded to YouTube every **_minute_**. That is just one of thousands of platforms that rely on user-generated content.

If there were any doubts about whether it is in the DNA of humans to assert their identities, share their doubts and fears or tell their stories to others the internet has dispelled them. To the contrary. The internet has excelled at monetizing that aspect of our DNA.

The ever-shortening duration of the news cycle and privately owned messaging platforms have already obscured the line between truth and fiction.

Search engines evolving into natural language-processing applications like chatbots may have already obliterated that line. Creativity may no longer be the sole domain of humans. Truth may no longer have any meaning other than in mathematics.

By the time you read this, there will no doubt be newer and more exciting and perhaps more frightening forms of content technology. The pace at which they appear and the variety of their uses is limitless. The Greek philosopher Heraclitus observed that the only constant in life is change over 2,000 years ago. That feels truer now than ever.

There does happily seem to be one reliable fact about human nature illustrated by the daunting survey above. We still do need and want to tell and hear stories. We will no doubt continue to. How, where, when, how and why we get them will just as surely change and evolve.

The Future

What can we project for the future from the timeline that begins in neanderthal caves and has ended at this very minute?

Content forms will evolve just as cave paintings have led to virtual reality productions. Media will change just as clay walls have led to headsets. Delivery mechanisms will evolve just as amphitheatres have led to streaming services. Content will still have

value, be in demand and drive economic activity. There is no real benefit to speculating on the details. We are sure to be surprised by the unpredictable.

As leisure time increases, content may, in fact, increase in value. Certainly, the right kind of content may. Content consumption has interestingly never gone out of style. For those intending to make a business out of content creation what can be learned?

To begin, let's distinguish between content creation and attention mining. Content creation in our context is the fabrication of a story intended to engage the imagination and stimulate an emotional response. It may be factual such as a documentary or fictional such as a science fiction movie. Attention mining is the overt or covert analysis of data gathered from the viewing habits of members of a content audience – what they like and do not like, what they have in common, what they can and cannot afford to do or buy. Content creation is intended to engage people emotionally, entertain, inform or inspire. Attention mining is intended to monetize or exploit the information gathered about viewers. For content creators, the consumption experience itself is the value they wish to provide. For the attention miners, the content is the cheese in the maze that makes the lab rats a valuable resource.

To be sure, natural language-processing technology is the current focus and for good reason. Its power is transformative. It is hard to know an infant technology's ultimate reach, scope, utility and potential for harm. Will it evolve into an even more sophisticated technology like predictive analysis or dispense with language as we know it entirely and move into mind reading? Of course, we do not know. What we do know is that what fuels all these mechanisms for attracting and holding attention is story and that is likely to remain constant – at least for the far foreseeable future.

Story

In any business, one needs to have an intimate knowledge of the nature of one's product. The value it represents to the intended consumer. How and why it may work, what it can and cannot do and its advantages and dangers. Cars are expensive products just like movies. They are incredibly useful at transporting people to different places, just like movies. They capture attention for periods of time just like movies. They can also be dangerous if certain safety features are not present or are ignored. Cars are also big business; millions of people buy them every year. To be a successful content producer, one should have the same kind of insight into the nature of a story since story is the essence of content just as transportation is the essence of automobiles.

Aristotle's "Poetics" in the third-century BC is our first example of a detailed analysis of the constituent elements of the story. He was concerned mainly with the forms of the story that were popular in his day: drama, poetry and epics, but the elements he analyses are still well recognized today in every form of content from Gregorian chant to hip hop, from pantomimes to big special effect-driven Hollywood movies. As debatable as Aristotle's concepts may be and as hard as they may be to exactly define, the building blocks of the story, how they fit together and work to create a memorable experience, are still as good a reference point as ever. Anyone aiming to be a content producer for a living who ignores or disrespects the value of taking these concepts seriously does so at their peril.

The story should reflect life – natural experience, emotions and interactions. If a story or a story element is not relatable on that level, it is unlikely to be successful. That is not to say that characters may not behave in an inhuman way. Humans often do. Superhumans may fly, Greek gods may defy the laws of physics but their behaviours, motivations, emotions and the consequences that flow should be relatable on a real-world level.

A story should have rhythm. There is a pace of storytelling that the audience has come to expect; it may differ from genre to genre but should be specifically crafted for each individual story. The beats of a story just like the beats of a musical composition propel the viewer in a comfortable and familiar way along the journey. Musical scores in content are designed for that exact purpose. Music also helps convey other aspects of the story such as suspense, pathos, danger, surprise, joy or defeat. Music alone though will not overcome a story that is crafted without deliberate attention to rhythm or pace.

Characters should be differentiated. They should each have a distinctive voice, attitude, motivation, desire or need, challenges, victories and defeats. Depending on the genre and the audience, characters may either be morally good or morally bad. They may also be both for the right audience. What is important is not the details per se but the effort to think through what is appropriate for each character, how the thread of their journey weaves in and out with the journeys of the other characters and how they react to opportunities and achievements as well as obstacles and setbacks. Their dialogue should be natural to the character, familiar but not too predictable. Each character should ideally discover something they did not know. In dramatic content, characters should for the most part be serious, important in some way, and the protagonists should have an altruistic or virtuous goal. The story will concentrate on their strengths and heroic qualities. In comedy, the characters are generally more flawed and weaker. The story will focus more on their weaknesses or peculiarities.

Genres should be respected and departed from or altered only with deliberate thought and attention. Audiences take comfort in the predictable and familiar way in which stories within a genre are told. "Boy meets girl, boy loses girl, boy gets girl back and they live happily ever after" is so pleasing a structure that has been and will continue to be used as the backbone of romance stories whether dramatic or comedic. In fairy tales good characters prevail, and bad ones are defeated. In epics, the weak defeat the strong despite overwhelming odds. Contrary results within genres can be constructed but will only succeed with careful design.

Plots should have a beginning, middle and end. This is commonly referred to as the "three act structure". In plays, movies or episodes, the very general arc of a plot is to begin with setting up the main character, their need or goal, their antagonist and the obstacle (or obstacles) in their way in the first act. In the second act, we see the main character begin to face and act on their challenge, even partially succeed, until faced with an unexpected and seemingly disastrous discovery or new challenge that they might not overcome. The third act or denouement is where the final challenge is overcome and the objective is achieved either in whole or in part or, in the case of tragedies, not at all. Depending on a show's format, this basic structure can be subdivided into five or sometimes seven acts, but the overall trajectory of the plot is basically the same.

Serialized programs such as those made popular by streaming services end each episode with an unresolved and intriguing plot point intended to draw the viewer into the next segment or episode. This is what is known as a "cliff-hanger". Tune in the next episode (or after the commercial break) to see if the damsel in distress or hero hanging by his fingers lets go and falls or is saved.

Important to remember is the value, and in today's marketplace of content the imperative of grabbing and holding attention. Spectacle whether lavish sets and costumes, elaborate action scenes, graphic violence or sex and dazzling special effects have become standard tools for program providers to win audiences. Commanding attention by the sheer shock or surprise of a scene seems to be the commonly accepted way to compete with all the other program choices. Ironically, all those other programs use the same tools. This has led to the spiral of special effect-driven projects where often the spectacle is more important than the basic elements that we have looked at above. Ultimately, the time-tested fundamentals of the story need to be there. Mind-boggling special effects, gratuitous sex or violence, although ubiquitous in the marketplace, cannot successfully substitute for character, plot and conflict properly crafted.

Story

Having raised the caveat above, it is critically important to bear in mind that content creation is a visual and auditory experience. One should not tell the audience about an event if it can be shown or describe it if it can be depicted. Sound design, score and music are hugely important elements in constructing a viewing experience that transports the viewer emotionally and leaves a lasting impression. How often do hit movies have hit songs?

Technology can be a threat to storytelling. The more technology allows us to show the more tempted we are to use it. If it becomes the raison d'etre of a project rather than a seamless part of the fabric the project may be commercially successful but not memorable.

Producing Content for Tomorrow

It follows from studying the past, analysing the present content marketplace that one can safely assume that the content creation business will remain strong, healthy, profitable and culturally significant well into the future. The specific technologies and the new business models that will have to be developed for them may be hard to identify, but creators of commercially valuable and culturally significant properties will no doubt be rewarded.

Someone who aspires or professes to be a professional content producer almost certainly will have an acute desire to have their story told, heard and felt. They may even have a deep-seated need to tell their stories. They will want to be able to afford the time it takes to make each project. They will want to have the financial freedom to make each project the best it could be. They will want to be compensated for their work and rewarded for their success on each project. They will want to make projects, one after the other for as long as they can. To have the privilege of long careers as storytellers, producers will need to nurture an innate sense of the craft of storytelling. The stronger that sense is, the better able it will be to adapt to all the new technological tools that are surely about to appear.

They will need to honour the basic elements of the story and balance them in familiar yet fresh ways. Technology, even a technology that can produce a script simply with a verbal command such as "write me a hit movie", need not be a threat. It can be embraced, learned and employed to accomplish yet undreamt-of feats of creativity. Fear is a poor innovator. Resistance to change leads to stagnation or worse. One must adapt. Necessity is the mother of invention.

The business models for content seem to evolve in cycles as new technologies trigger adaptations in the marketplace. Producers will need to be more entrepreneurial and creative in business practices as well.

We have seen that in the earliest days content was created for no monetary gain at all. Eventually, artists were paid for the objects they produced or the physical works they created either in an actual market or more likely by wealthy patrons. With the advantage of the economies of scale that book printing, phonograph, radio, movies and television presented, creators could benefit not only from the physical objects they sold but also from the intellectual property they created through rights of ownership that were invented for them. Copyright, as those rights came to be known in law, was an amazing conceptual leap that led eventually to the Information Age that followed the industrial age. Copyright law principles will be covered later in this book.

If new mechanisms or technologies make the dissemination, copying or even creation of content possible by automated applications or devices similarly inventive economic tools will need to be devised to allow humans to continue to pursue intellectual work for commercial gain. Computers, code or applications may approximate human work, may work that is exactly as good or even better, but there will most probably always be a need for direct human-to-human sharing of experience. New forms of content will evolve leading to new forms of expression, new consumption methods and new financial models.

Actual Case Study 1

Compare the Star Wars and Avatar movie franchises. Star Wars has a very simple, tried-and-true plot structure and cast of characters. It is a small but morally noble society threatened by an evil and more powerful empire. The franchise has enjoyed enormous commercial success and probably will continue to do so well into the future. Its characters are commonly known and have spawned countless licences and fan fairs. They have become cultural icons and tentpoles of the Disney studio conglomerate. The Avatar movies, on the other hand, have outgrossed the Star Wars movies considerably. They are much more technologically impressive; the effects are more amazing. The themes are arguably timelier. Yet the Avatar movies do not have nearly the same cultural impact. In the long run, which will have more value?

Producing Content for Tomorrow

Actual Case Study 2

Non-fungible tokens or NFTs exploded onto the marketplace just as Covid lockdowns were occurring in early 2020. They are unique identifiers of a digital work that cannot be copied, altered or substituted. They are recorded using blockchains to authenticate ownership. They can be sold or traded, but the ownership rights are not very well recognized by the law. Ownership of an NFT in a blockchain certificate is not the same as owning copyright or any other intellectual property right in the actual digital file. As a new, exciting and visually captivating technology just when going to art galleries and museums in person was prohibitive, NFTs became super trendy and popular. It was believed that they would dramatically increase in value, especially for the earliest purchasers of NFT. New technologies often arrive with a bang, but if they are too early and not yet fully thought through, they can end with a whimper. By the end of 2021, the NFT market was worth about $21 billion. By May 2022, the sale of NFTs had shrunk by 90%.

Questions

1. What might be said to be the four most basic human drives?
2. What societies have not used storytelling?
3. What are the purposes of storytelling?
4. What were the early media for storytelling?
5. How did creators get compensated for paintings or sculptures?
6. What financial implications did the Gutenberg press present?
7. What made content creation and dissemination a business?
8. What are the key elements to the story that are common worldwide?
9. What opportunities does technology present to content creators?
10. What threats does technology present to content creators?

Chapter 2
The Basics – What You Need to Know

2.1 The Playing Field
You Can't Tell the Players without a Program

Leather workers and tailors both sew. But you would not go to a tailor to have a saddle made, nor would you go to a saddler to get your new suit made. Knowing the key players in the content creation business, their roles, their business objectives and the way they operate is critical. It helps you position your project correctly in the marketplace. It helps you avoid the run around you might get by meeting with people or companies who are not the right fit. It gives you a better perspective of the economic factors that surround your project. It makes you more respected and more likely to form valuable connections. In short, the better one understands the roles, relationships and interactions of the key players in the content creation universe, the greater one's chance of success.

Most people have heard the names and titles of the key participants in the content creation industries and have a fair understanding of the roles those participants play. Still, the terminology is often used loosely and sometimes inaccurately. To make sure that references to those roles are clear throughout this book, this section will set the terms of reference to be used as a standard, at least for this book's purposes. In some cases, the titles and roles are quite rigidly set, but in others, there may be overlaps between the names of roles and their functions. The following descriptions are generally accepted.

Studios and Majors

Official accounts vary, and the landscape changes on a regular basis, but it is commonly accepted that between 80 and 90% of the American media market is currently controlled by six companies. Often called the "majors", these companies are vertically integrated conglomerates that operate in multiple sectors of the media industries from content creation through distribution, broadcast networks, cable services, streaming platforms, theme parks, video games, merchandizing, publishing, etc. It is near impossible to avoid dealing with one or more of these companies. For that reason, this book will begin by describing the most powerful organizations that content creators will encounter.

DOI: 10.4324/9781003379737-3

In the United States, content creators and producers may spend their entire careers working within or for any one of the major companies. This is often referred to as working within the "studio system". The studio does the bulk of the work in funding, marketing, distributing and exhibiting the project. The producer is focused mostly on the actual production process itself. This book is aimed at those who either do not have that option or choose to work more independently – outside the studio system.

At the time of writing, the biggest studios or majors include, in order of size: Walt Disney Corporation (networks, theme parks, movie and TV production, sports networks, comics, consumer products and merchandizing); Comcast (cable and internet services, NBCUniversal TV and cable networks, film and TV production, theme parks, wireless phone services); Warner Bros. Discovery (HBO, CNN, Discovery Channels, Music, theme parks, video games, Web portals, DC comic books); Sony (consumer electronics, films, music, TV shows, video games, telecommunications equipment) and Paramount Global (movies, TV shows, networks, cable channels, news services, sports networks, music, publishing, streaming services, video games). For our purposes, Netflix and other "pure play" companies are not considered majors since, although they are very large and powerful, their activities are limited to primarily one media sector. As well, Apple and Amazon, although they are increasingly active in the content creation industries, primarily focus on either consumer goods or data and not necessarily the origination of content.

Producers and Content Creators

Perhaps the most referred-to players in this book, producers have the most variable role descriptions and most opaque identities. The fact is that there really is no authority, accepted organization or institution that confers the title "Producer" on anyone. A well-used adage in the industry is "a producer is someone who knows a writer". Another is "a producer is someone who makes a project happen". There is no single definition, and there are various types of producers.

The type of producer this book is aimed at is the person who comes up with or recognizes a valuable potential project at the original idea stage and shepherds the project through ideation, development, financing, pre-production, production, post-production, delivery, distribution, marketing and eventually the project's ultimate consumption by the viewer. That is a very big job. As a result, producers who work in the studio system, for or with the majors, will often share or leave many of those functions to different departments of the studios they work with.

The size of the job, which increases with the size of the project, gives rise to variations on the title of the producer. The associate producer usually refers to the person who takes on one or more important producer functions but has no real control over the project itself. A line producer simply oversees production in the same way as a shop foreman. An assistant producer is even more junior. An executive producer may mean one thing in "short form" (television or episodic production) and another in "long form" (movie projects). In short form, it may mean the "show runner" — that person who oversees all creative aspects of the production but not necessarily marketing, distribution or exploitation matters. In long form, the executive producer often is someone who has been instrumental in the project getting made perhaps by supplying a key part of the financing, a relationship or distribution connection.

In any event, the title of the "producer" is often negotiated, and therefore, the person with the most leverage gets to have it. That usually is the owner of the underlying intellectual property who can give the title to herself. As Irving Thalberg once said facetiously: "A credit you give yourself is not worth having". The implication is that if the credit is solely the result of power, it is not as valuable as the credit that is recognized for meaningful work. Our focus is on the individual who does the actual work of producing from beginning to end, the person who has ultimate creative and financial control.

Agents and Managers

Agents are easier to define. They represent an individual and have authority to negotiate a contractual arrangement with an engager for the services of that individual. The scope of their authority is defined in the agreement with the person they represent, usually requiring the client's approval. Sometimes, they may have the authority to conclude a binding contract on behalf of their client. For obvious reasons, that is rare and unadvisable. Established and professional agents will actively shape the careers of their clients, diligently pursue the right kind of work for them and serve as valuable intermediaries between the client and the engager. In the content industries, agents routinely represent writers, editors, actors, directors, production designers and cinematographers — anyone whose individual services are in demand, even some types of producers. Agents are compensated by a commission or percentage fee based on the remuneration their client receives, usually from 10 to 20%.

The role of managers is somewhat different. Their responsibility is not necessarily to obtain work for their clients but rather to oversee the financial matters that flow from

the client's work. They may set deal parameters for the agent to follow, set working conditions as well as necessary "perks" for their client, pay their client's expenses (business related as well as personal or even tax payments) and, for their more successful clients, invest surplus funds. They may take a role in shaping the client's career strategy, image, press relations and publicity. They may have signing authority over their client's financial affairs. They are also compensated by a commission calculated on client's earnings. This may amount to 10 to 20% of the salaries their clients earn.

Clearly, there are blurry lines between the agent and managerial roles and conflicts often arise. Agents primarily deal with producers and their business affairs representatives to make the initial deal. Thereafter, it is usually the members of producers' staff who oversee talent arrangements on an ongoing basis with the managers unless there is a contractual problem that requires the agent's input.

Guilds, Unions and Associations

In most countries that have significant levels of content production, key talent and crew are organized and represented by either guilds, unions or associations. Well-known examples are writers' guilds such as the Writers' Guild of America, Great Britain, Australia or Canada; actors' guilds like the Screen Actors' Guild (USA), Equity (UK), Alliance of Canadian Cinema, Television and Radio Artists (Canada), Media Entertainment and Arts Alliance (Australia); and directors' guilds like the Director's Guilds of America, Canada and Australia and Directors UK. Crew members are represented by international unions such as IATSE and NABET (USA and Canada) and BECTU (UK).

There are collective agreements between the guild or union and the respective association representing production companies in each country. The agreements set minimum pay levels, working conditions, training and accreditation expectations and health and welfare benefits. Members of the guilds or unions and signatories to the collective agreements are prohibited from making arrangements that pay less than the specified rates and provide less than proscribed working conditions. The collective agreements also provide dispute resolution mechanisms like arbitration and on-screen credit parameters.

Exhibitors

In the context of this book, a reference to an exhibitor means any company or organization that makes content available for viewing to a consumer irrespective of the

mechanism or commercial arrangement. That would include theatres that sell tickets, free over-the-air television networks, pay-per-view or subscription cable companies, subscription-based streaming services, ad-supported streaming services or even retail outlets that sell or rent DVDs or tape copies. What is important for our purposes is not the manner of access nor the device used for viewing by the consumer but rather the final step in the supply chain that begins with the production of the content and ends with a member of the public seeing and hearing it. Exhibitors may sometimes pre-commit to acquiring the right to offer the content to consumers and may provide funding for the actual production process. They may also acquire similar rights to content that has already been produced by other means. The economics and monetization of content will be dealt with in detail in a later chapter.

Distributors

Distributor and distribution are other terms often used in confusing ways for various reasons. Our use of the term refers to companies or organizations that offer completed content to exhibitors who in turn make the content available to consumers. Many productions are financed by way of funding that is provided or promised by exhibitors such as studios, networks, cable channels or streamers who then acquire a negotiated bundle of rights by which their investment in the production can be commercially exploited. The current trend for the large streaming services is to fund productions in advance and acquire, in return from the producer, worldwide exhibition rights in all media for 25 years. That leaves precious little in the way of exploitable rights for the producer or production company to monetize. In many other cases, and certainly before internet-based content delivery was common, rights to content would be limited to geographical territories and specified media. A production company, for example, might fund a production by pre-licensing TV rights to a US network and a network in its home territory (say Canada or the UK). That would leave telecast or other rights available for commercialization in all the other countries of the world. In such cases, or today where a production company may have unlicensed rights available to offer to exhibitors, it often makes more sense for production companies to engage distribution companies to make licences (what are often referred to by the industry term of art as "sales") on the producer's behalf.

Young production companies may not have the resources, the connections or desire to engage in the process of making sales calls on the dozens, if not hundreds, of possible licencees of a project in distant territories or obscure new media. That is the business

2.1 The Playing Field

of distribution companies. They offer the rights to content to any interested exhibitor in any territory or any media that the producer allows. They are paid in the way of a sales commission or distribution fee calculated as a percentage of the licence fee paid by the exhibitor. The rest flows to the production company. The fee may range from 15% to as much as 40% or more plus reimbursement of expenses. This may seem expensive, but distributors, often, have specialized knowledge of the marketplace, connections and outlets that would be difficult, costly, time-consuming and distracting for the producer to undertake himself. Distributors may have hundreds of titles on offer in their inventory and hundreds of potential customers. The producer may have only one project at a time and know only a few likely exhibitors. Moreover, the distributor should be aware of the going rate for product in each market and may have leverage, due to the strength of its catalogue, to drive a better deal.

As production companies mature, gain more contacts, knowledge and stature in the industry, they launch in-house distribution divisions to undertake the distribution function on their own. The potential revenue stream would have to justify the cost of that operation, of course. More on the details and nuances of distribution arrangements will follow later in this book.

The type of distribution we are dealing with in this book should not be confused with what some industries call "broadcast distribution operations" or the distribution of content channels by cable or over the internet. We are focused on the distribution of the actual content to those channels or streamers in the first place – before their signal is made available. Even though a channel's signal is made available to a great many viewers, it is the *signal* that they disseminate. Our concern is how they acquire the *content* of that signal and from whom.

Government Agencies

The United States is the dominant media market in the world as its major companies are the most powerful and its content equally as lauded. Its government has not, to date, felt the need to protect its industries or its culture from foreign cultural influence. Accordingly, the role of US government agencies in the content creation industries is minimal. The First Amendment to the US Constitution enshrines the freedom of speech. Although it is increasingly under threat, that right prevents government censorship. The industry self-regulates content with codes and labels to protect consumers. Apart from some funding to strictly cultural and mostly philanthropic institutions such as the National Endowment for the Arts and PBS, the US government really does not play any

significant role in funding content. Individual states may make certain concessions to local tax laws or labour regulations to attract lucrative productions to their jurisdictions strictly to enjoy the economic spill over.

The situation is very different in many other countries of the world where the domination of the American cultural product has been perceived as a danger. In Canada, for example, French is an official language, and the preservation of French culture is a national priority. Accordingly, Canada has developed a set of rules by which certain kinds of productions that conform to government-established rules would enjoy financial benefits from the federal, provincial, and even municipal levels of the government. Many projects that would be hard if not impossible to fund in an unsubsidized market are enabled using such government funding.

A by-product of these policies to fund productions that are perceived to be of national cultural significance is the increased economic activity that the labour-intensive content production industry creates. The result is twofold: cultural autonomy is preserved and the economy grows.

In Canada, the rules governing Canadian content that is eligible for subsidy are being revised to adapt to the increasing presence of large American streaming companies who are technically outside the jurisdictional control of Canadian governments. New guidelines will hopefully be established soon.

The Economic Union has a similar approach to supporting production in its territories as do Australia, the United Kingdom and many other countries. There are differing subsidies in each jurisdiction, differing eligibility requirements and kinds as well as different sources and amounts of assistance. Greater detail on these important tools for producers outside the United States will be covered in a separate chapter.

Questions

1. What is the difference between a studio and major?
2. What makes a major a major?
3. What organization gives a person the official status of "producer"?
4. Who negotiates deals on behalf of a writer or actor?
5. Who takes care of the business arrangements of talent?
6. What kind of organization sets minimum working conditions and pay scales?
7. What do you call an entity that displays or provides content directly to viewers?

2.1 The Playing Field

8. What is a distributor's business activity?
9. How is a distributor paid?
10. What is the difference between a government and a government agency?

2.2 The Basics of Contract Law

Commerce, the ability of parties to transact business with each other, depends on a system of rules and beliefs designed to sustain confidence that things will be done as expected. In other words, promises will be kept and fairness and morality will, for the most part, prevail. Trust, although essential for economies to thrive, is not enough. Take money for example. The actual token exchanged, whether it is paper, metal, stone, digital code, shells or beads has little value. Money is a belief system that only succeeds if both parties agree to a transaction in the attributed value of the token as fair exchange for something else. If you do not believe that 15 dollars is fair compensation for an hour of your labour, you won't do the work. The dollar is only valuable to the extent that it can be traded for some other object that has real value for you.

Contract law is a codification of the principles that commerce relies on to establish stability, confidence and trust in the marketplace so that people and/or corporations can do business with each other and have faith that what is expected will come about. Some contract law is embodied in actual written-out laws and codified, and others are the result of many court decisions over time. From jurisdiction to jurisdiction, there may be slight variations in certain aspects of contract law or nuances in interpretation or practice. Nevertheless, throughout the world, economies still rely overwhelmingly on certain basic rules that contract law establishes. The content creation industries are no exception. Without going into the detail that a law text would cover, the general principles are explained below.

You have a project ready to go. It's time to hire the lead actor. Auditions are set up, and agents are invited to send in clients that they think would be appropriate for the role. Once you send out that notice to an agent, are you obligated to her in any way?

One after another, actors come in to read. Eventually, one stands out far above the rest. You tell her she is perfect for the role. Is she hired?

You contact her agent who gives you the actor's "quote" the established fee that the actor expects. You say you understand. Must you pay for it?

If you do hire the actor, are you obliged to use her in the role? What if someone better comes along?

What Makes a Contract a Contract?

The first thing to understand is that not everything two parties may agree upon is a binding agreement in law or what is more commonly known as a contract. For a contract to be considered valid in law, certain elements must be present. At the very least, there must be an "offer", "acceptance" of the offer and "consideration" for the offer.

The Three Essential Elements of Contract

Offer

There must be an offer. The offer can be oral or in writing. Either form is valid. Oral agreements are made by all of us every day. "If you drive me to the store, I'll buy some milk for you". That is not only an oral offer, but it is an "express" offer. It sets out what is expected in clear terms.

There is also a possible "implied" offer contained in the language. The driver may be justified in believing that she will not have to pay for the milk having done the favour of driving. The passenger may, however, have intended only that he would physically purchase the milk on behalf of the driver, feeling that it is implied that he would be paid back.

This example illustrates two important aspects of offers. The first is that nothing should be left to the imagination if the matter being bargained for is important. Implied terms are like beauty; their meaning lies in the mind of their interpreter. The second is that for a contract to be valid both parties must be of the same mind – ad idem – meaning that they each have the exact same understanding of what is being bargained for and expected.

Although it can be socially awkward, the more specific, detailed and crystal clear an agreement is for both parties, the more reliable and successful that transaction will be. Take pains to be extra precise, unambiguous and definite in what you offer.

It stands to reason from the above that written communication of contractual terms reduces the possibility of misinterpretation of intention, especially if the right care is taken in the writing. People sometimes hear what they wish rather than what is being said and their memories can be inaccurate. It follows that the more value or importance

a transaction has, the greater the need for all relevant communication to be done in writing rather than orally. In the content industries where the subject matter of many of the contracts is imaginative, un-concrete, creative and hard to define with precision, the need for written terms is paramount.

Acceptance

Acceptance of the offer is an unqualified assent to the proposal in the offer.

In our example, a clear acceptance would be for the driver to respond to the passenger by saying "Ok, I will drive you. I would like the milk". An example of a "qualified" acceptance might be "Ok but not now. It would have to be later today". In the latter example, there really has been no acceptance. In fact, the qualification of driving later that day amounts to a counter offer and the contract would require the passenger to agree before the element of acceptance is satisfied. These are examples of express acceptance: words that were spoken with intended meaning.

Acceptance can also be implied by conduct or behaviour. If the driver simply opens the door to the passenger seat, allows the passenger in and drives to the store that would "imply" acceptance. The element of acceptance is, therefore, satisfied. It is important to repeat that there is still no certainty to the complete bargain because the issue of who is ultimately responsible to bear the cost of the milk has not been directly dealt with. Certainty is critically important. To avoid a potentially acrimonious misunderstanding between the friends, it should be made clear whether the act of purchasing itself is the inducement or whether the proposed inducement is the cost of the milk being borne by the passenger. This leads us to the third and perhaps most nuanced element that must be present for a contract to be valid in law – consideration.

Consideration

Consideration is a term of art in the world of contract law, not to be confused with the common meaning of the word. For a contract to be valid in law, something of value must flow to each of the parties. The law does not presume to judge how much value each party gets or whether it is a significant value from an objective standpoint. If a party accepts the "consideration" involved in the offer, there is a valid contract. The consideration may be paper with printing and numbers on it, like a dollar bill, or it may be a bit of digital code. The important thing is that both the offeror and the acceptor

receive something that is of importance – no matter how small it may be. In our milk example, the driver gets milk and the passenger gets a lift. Each gets "consideration". Consideration may take the form of an object, a promise to do something or not to do something, a certain behaviour or an intangible right to own or use a real or intellectual property. Intellectual property rights, described later, are a common component of consideration in contracts in the content industries.

Where there is no consideration flowing to the benefit of one party, there is no valid contract. If the passenger in our example asks for a ride to the store but does not offer anything in exchange, he is under no contractual obligation to do anything for the driver even if he is in fact driven to the store. The lift to the store is in this case a favour, not performance under any kind of contract since there is no consideration received by the driver.

In addition to the three basic elements that need to be present for a contract to be valid, there are five formalities that need to exist for the contract to be enforceable by a court of law.

The Five Formalities

Capacity to Contract

Each party to the contract must have the requisite legal capacity. She must be of legal age, sound mind and free to do or give what is expected. If it is a contract for her to sell property, she must have ownership or title to the property or be properly authorized by the rightful owner to make the sale.

Lawful Purpose

A contract to do something that is against the law is not enforceable for obvious reasons. If someone is hired by a mobster to rob a bank, no court would enforce the contract no matter how evident the offer, acceptance or consideration might be.

Legal Form

Some contracts must be in writing and signed to be enforceable. The sale or lease of land must be in writing in most jurisdictions and copyright laws (to be discussed in detail below) require any dealing with the rights to property that is protected by copyright to also be in writing.

Intention to Create Legal Relationship

All parties involved in the contract must, as has been said above, be ad idem, meaning of the same mind. They must both intend to be bound legally in a lawful relationship. There can be no ambiguity as to whether any of the parties means to perform his or her obligations under the contract. If the offer or acceptance are vague or "wishful" as opposed to purposeful and intentional, the contract may not hold up.

Consent

As in many other walks of life, consent must be informed, clear and unambiguous. It is questionable whether the type of consent requested of a visitor to a website or user of an app who follows dozens of lines of small type on a screen followed by a box to tick signifying "Agree" is valid consent. Some courts decided to not uphold that kind of consent as the typical lay user might not be expected to read, let alone fully understand, the meaning of the fine print.

Breach of Contract

When one or several member(s) of a contract fail or refuse to perform the obligations they undertake under a contract, it is known as a "breach" of contract. Breaches may be actual or anticipatory. An actual breach is a clear failure to perform, like not paying the agreed price or, in our running example, not handing over the milk. An anticipatory breach may be failure to bring enough money to pay for the milk, not showing up on time to perform a task or not procuring the goods someone has contracted to buy.

The consequences of a breach depend on the gravity of said breach. If it goes to the essence of the contract itself (for example, allowing the passenger in the car but not driving to the store), then it is considered a "fundamental" breach. A fundamental breach entitles the victim to void the contract which would have the effect of relieving the aggrieved party of her obligations. If there are damages that can be assessed, she may also be able to claim payment for those damages. The principle governing the award of damages in contract law is that the complaining party should be put in the same condition she would have been in had the contract been fully performed. It is intended to provide restitution for the complainant rather than punishment for the offender. In some cases where the breach consists of a failure to perform a certain task, such as delivering goods, the court may force that performance. This is known

as "specific performance". It is important to note, particularly for those in the content creation industries, that most courts will not force specific performance in contracts for personal services on the basis that it is neither in the public interest nor appropriate in most situations to force one person to work for another. The work is unlikely to be satisfactory, to say the least, and ordering payment to cover any damages is usually a more sensible remedy.

Dispute Resolution

In my time as a practising media-lawyer, it was routine for a client to request a contract to be drafted to memorialize an agreement they had made. It may be an agreement between two producers to join forces on a venture, an agreement to raise funds to develop a script for a potential project or to hire a creative consultant. Invariably, the client would request a brief document that does not take a long time to create or read but that fully protects them against all risks.

Predictably, I would advise that completeness, thoroughness and clarity are more important than the page count or the legal fees involved. I would also add, facetiously but as a caution, that, no matter how long or short the contract was, it would only be looked at if the parties' relationship was breaking down, mainly to see how one could get out of the contract. Working hard to resolve differences and maintaining relationships in content creation industries – preventive rather than reactive measures – to avoid breakdowns are by far the best approach. There is rarely enough time or resources to resort to the ultimate remedy which is a court trial.

Other mechanisms are available to avoid costly and lengthy litigation, of course. The parties may mutually agree to undergo mediation. It is preferable to engage mediators who are properly trained and accredited in their jurisdictions. In voluntary mediation, the parties agree to meet with a mediator who will follow a proscribed process intended to help the parties find a satisfactory solution to their problem themselves, much like a traffic cop. The result may be agreed to arrangement or not. It will not be any more binding than the parties wish, and it may lead to a revised or brand-new contract. A more result-oriented process is arbitration. The parties usually agree in advance to abide by the outcome. In arbitration, an official "arbiter" will go through a similar proscribed process aimed at resolving the conflict but would in effect dictate or impose a solution.

2.2 The Basics of Contract Law

If litigation has commenced in a breach of contract case, courts may very well order the parties to submit to mediation and/or arbitration before proceeding to trial in order to achieve a settlement. When a dispute involves a member of a guild or union, such as a writer, actor or director, the provisions of the collective agreement between that guild or union and the engaging producer who is a signatory to the collective agreement apply. These collective agreements have well-established procedures for dispute resolution that would need to be followed.

Actual Case Study

In the early 2000s, my company began production of "Maple River", a live-action television series aimed at kids ten to twelve years old. Here, it serves as a great example of the issues that contract law deals with. Maple River consisted of 26 half-hour episodes each season. It had a production budget of let us say, $10,000,000 per year. Part of the funding for that budget came from a presale licence[1] of television rights from one of the most popular and highly regarded children's cable channels in the United States. The licence fee covered about 10% of the total production cost. The initial agreement with that channel was in the form of a few conversations, emails and a short "deal memo" – a document that summarizes all of the most important terms. Everything proceeded very well, production commenced and their financing flowed as expected. The full, long-form agreement from the channel came months later and was signed without a hitch shortly before shooting of the series was completed. The series became an international hit.

When the second season of the series was proposed, the channel simply confirmed their participation by email on the same basis as in season one. Season two went forward in the same manner as season one did. A full-blown contract followed eventually. Season two was a hit as well.

Season three began the same way. By then, we were very comfortable with the relationship we had with all the key executives of the channel, and our co-production partners[2] enjoyed the acclaim for the show. We sent them emails to ask for their continued participation in season three on the same terms as before, and through emails and conversations, they confirmed that we could count on them. They approved casting choices, script materials and the budget as they did in the previous two seasons. Once shooting began, we asked for their

funding in the usual way. Only this time, funding did not arrive when expected even though shooting was progressing as it had to. Not only did funding fail to flow, but it became harder and harder to get responses from the channel to our emails and phone calls which were becoming more urgent in tone as our financial situation was becoming more serious.

Eventually, we heard from one production executive who had been fired by the channel that the new chief executive officer[3] of the channel's parent company had decided to cut costs and cancel every corporate commitment that they could. He had no intention of continuing on with season three of our series and would not pay the licence fee.

We had to sue for breach of contract. Their defence was that no long-form agreement had been signed. Our response was that there was ample evidence of an agreement for season three in the form of written communication and the implication from past conduct that we had a contract that could be relied upon.

The lawsuit was commenced while we were still shooting the series. It would have been even more costly to interrupt the production or cancel it to wait for a result as lawsuits can take years. We continued funding the shortfall from our own production company resources. We bore the cost, expecting that it would be recovered. Our legal team felt confident that our case was winnable.

As time went by, a judge was appointed to our case. He insisted that we submit to arbitration as it can be ordered by the court. I personally travelled to the city in America where the suit was being heard and spent a full day with our legal team in one room meeting with the judge and explaining our position for about an hour at a time. Then, the judge would go into a second room and have the same sort of discussion with the channel's team. At the end of a long day, the judge came into our room for the last time. He said that "off the record" he believed, we had the better case and would likely win the $1,000,000 we were seeking at trial. But, he added, it would probably cost us about a year and $500,000 in legal costs to win. He asked if we would accept that amount now as full settlement. Our lawyers asked if we could consult for ten minutes alone. When the judge left the room, they said he was right about his assessment of our chances but wrong about the time and cost. It would take at least twice as long and cost easily dou-

ble what the judge estimated. The channel was a very large, vertically integrated corporation with its own legal department and would string out the case if they possibly could.

We accepted the $500,000 settlement offer and wrote off the balance including the legal fees we had already incurred.

How many aspects of the law of contract could you identify in this actual case?

Questions

1. When would you need a contract?
2. How do you know you have a contract?
3. What is consideration?
4. Give an example of an implied term.
5. What is meant by the capacity to enter into a contract?
6. When should you go to court?
7. What kinds of breaches can void a contract?
8. When should a contract be in writing?
9. How might a court deal with a breached contract?
10. What are the alternatives to suing and going to court over a breached contract?

Notes

1 See chapter 1.5 Production Financing.

2 See chapter 1.9 Treaty Co-productions.

3 See chapter 1.6 The Corporation.

2.3 Trademark Law

According to Brand Finance Brand Directory which ranks brands based on a handful of metrics including the Star Wars, the trademark was valued at $262M US in 2023 – just for toys!

An often-overlooked area of Intellectual Property law that is of real importance in the content industries is the law of trademarks. Consider the ever-popular trend of movies, television series and games based on well-known and well-loved comic book characters. Characters as such are not protected by copyright law. The names Superman or Batman are not protectible by copyright any more than a title would be. However, the specific attributes, super powers, history and the appearance of the character – its costume and the look of its secret identity – may be protected by copyright. How and for what uses could valuable character names like the name of Superman or Batman be protected?

Where Does Trademark Protection Come From?

Almost all industrialized countries have enacted statutes embodying the basic elements of trademark law. Trademark law and the rules governing what can be trademarked, how and for what purpose are contained within those statutes. A trademark is a word, symbol, phrase, design, logo or other identifying marks that single out a particular item or service from other competing goods or services being brought to the market by a particular person or corporation who owns that mark. To be valid, the trademark must be registered with the trademark office of the jurisdiction in which it is intended to be sold. The item itself will contain a symbol such as "TM" for marks that are in the process of being registered in the appropriate government office or "®" for goods and "SM" for services that are already successfully registered.

What Can Be Trademarked?

Almost any kind of object offered for sale can be trademarked as long as it has already established some kind of commercial history (such as sales) in a marketplace, and the creator intends to continue to list it for sale. In some countries, a clear and demonstrable history of use is sufficient to provide trademark status, but to be safe, one should always register a product's brand to make sure it is unquestionably associated with the purveyor. It must not, however, be like already-existing products in the market that are protected by trademark. One cannot gain trademark protection by "piggybacking" on another already-successful brand by adopting a mark that is easily mistaken for the original.

Registration is a complicated, time-consuming and, at times, confusing process unique to each jurisdiction. Even more complicated is the requirement to register in every

country in which the product may be sold. Fortunately, a product manufacturer can obtain an "International Registration" by using an organization that will cover multiple countries with one uniform application on the trademark owner's behalf. The technicalities of trademark registration and maintenance are complicated. It is always best to consult and perhaps obtain the services of a lawyer or other specialist in the field to advise and take the best course of action to optimize the opportunities for aspiring trademark owners.

What Does Trademark Protection Cover?

Most importantly, trademark protection confers on the owner the exclusive right to use the mark in connection with the goods or services they wish to sell. The owner of the trademark is the only one that can sell "official" products in that brand. The law, therefore, gives the owner the right to stop others from selling knock-off, "bootleg" or unauthorized versions of the product. This obviously allows for maximization of the market value for the goods and services under the trademark. Additionally, it provides more quality control for the rightful owner to ensure that the products with a particular mark maintain a good standard of manufacture and utility. However, trademark protection is only for a limited number of years, varying somewhat from country to country.

Many items might qualify for both copyright protection and trademark protection, such as the Superman character and appearance. It would be wise for creators to assert both types of legal status for creations that may have any possible future as physical products. As with copyrighted works, uses of trademark can be licensed or sold to others. The revenues generated from this can be significant. Unlike copyright protection, trademarks can be renewed repeatedly after expiry if the product continues to be available in the marketplace.

For the purposes of content producers, especially those working in animation, science fiction or special effects, the value of merchandise or other physical applications of their original work may become more valuable than the license fees or royalties generated by the movie, episode or original game itself. I am not sure if George Lucas foresaw how many billions of dollars of merchandise would flow from the original *Star Wars* movie. Any possible or foreseeable uses, goods or services that may be sold under a character, image, name or other brands should be considered and protected by trademark registration if possible. To further illustrate the point, most animated programs for pre-schoolers rarely attract significant licence fees, if any, from their

broadcasters or channels. The bulk of revenue that pre-school content producers generate is from the licensing of toys, school supplies, bed linens, clothing or other goods bearing the distinctive features of characters in their shows.

Actual Case Study

The Maple River series mentioned above was lucky to achieve very high ratings and viewership on broadcast television and became hugely popular with its core demographic – girls between ten and twelve years of age. Many manufacturers of products aimed at that demographic saw an opportunity for commercial success and wanted the right to create and sell merchandise or other goods based on the series. A licensing agent who specialized in managing and negotiating these types of commercial undertakings was hired. We registered trademark protection for our series, specifying a surprisingly long list of potential products we might bring to market – products we would not have even imagined to be feasible. The agent worked with us to create a style guide which was engineered to establish and maintain a distinctive look, aesthetic and design for all the potential products. Eventually, we signed dozens of licensing agreements for items ranging from CDs and records to pyjamas to school supplies to even touring live stadium shows. The royalties we received from these licences exceeded our wildest expectations.

Questions

1. Where does one find the rules for obtaining trademark protection?
2. How does one know that a particular item's look, name, graphic presentation and design is protected by trademark?
3. How does one become eligible for trademark protection?
4. Where does that protection exist?
5. What does trademark status allow the owner to do?
6. How is trademark protection like copyright?
7. How is it different from copyright?
8. What if the owner of a mark has no desire to manufacture goods on her own?
9. How might one lose trademark status?
10. What are examples of trademarks derived from content?

2.3 Trademark Law

2.4 Acquiring the Appropriate Rights

Not all of the valuable source material for content creators is in the form of property, intellectual or otherwise. Not all of the copyright or trademark property is created in-house. Often, material that is already in the marketplace, created by someone else or owned by someone else, has a perceived value for a producer or production company. A novel may be great subject matter for a movie, a true life story for a miniseries, a cartoon character for a line of toys or a musical artist's repertoire of songs for a stage play. A key building block in the content creation industries is the acquisition of a rights agreement.[1] This is an agreement by which content creators may legally obtain the authorization to base a new work on or adapt a new work from a pre-existing one. Two of the most frequently used general categories of rights agreements are the acquisition of copyright and the acquisition of life story rights. The nature of the agreements is similar, but the underlying rights differ.

Copyright versus Life Story Rights[2]

Both the rights to intellectual property included under the umbrella of copyright law and the rights to one's life story are intangible rights. There is no real three-dimensional form for the property. Copyrights are created by statutes – actual laws passed by governments, country by country, that describe what kinds of works can be protected from copying, adaptation or commercial use. The statutes describe the uses that can be protected, controlled by the owner and the remedies for unauthorized use. This works well for things that spring from the imagination, skill and craftsmanship of a creator. The intent is to reward the author for the value of his or her work.

Life stories are not invented – they are fact based. Copyright law does not protect facts. The source of protection for life story rights does not come from a different branch of property law but from the general body of law that entitles an individual to privacy and protects an individual from unwanted exposure. This is more like trespass law. There are no statutes or written laws that govern this area of law as it stems from court cases that have been decided over the years. A major difference between copyright law and the rights that one maintains to protect her life story is that, as a rule, life story rights expire on the death of the person (unless that person has commercialized their identity during their lifetime as in branding her identity for endorsements or goods). So, dramatizing the life story of deceased persons should be a little simpler from a legal perspective. No one lives, or has lived, in a vacuum; however, their story is

inextricably entwined with the stories of other people. The rights to the life stories of those other people must also be obtained – assuming they are still alive. There could be dozens of them (as in this chapter's case study). Accordingly, biopics about people long dead are far more common than those about living persons. There is no prohibition from exposing the incidents in a real person's life to the public. The risk, however, is that the subject person may sue for invasion of privacy, libel or slander.

Any other person depicted in the content may likewise sue. A blanket defence to libel and slander lawsuits is that the movie, book or documentary is factually correct – in other words truthful. Libel and slander laws are there to prevent harmful untruths about a person being spread to the public. Invasion of privacy is a little more complicated and, among other things, needs to prove actual damage suffered by the complainant.

Fair use in the form of educational studies such as history books or legitimate new reports is allowed. It is the commercial exploitation of the life story or the harm to a reputation that needs to be properly considered from a legal perspective. The nuances, arguments and details of life story rights are more appropriately covered in legal texts. For the purposes of this book, it should be noted that they need to be approached in the same way as copyright by potential content creators. Namely, an agreement should always be entered into giving the content creator the specific rights she needs to base her intended work on either the copyright material, life story or identity rights of someone else.

Key Aspects of a Rights Agreement[3]

Certain basic terms are common to all rights contracts, whether one is agreeing to purchase rights to a life story (or stories), television adaptation rights to a magazine article or movie rights to a novel.

Parties

It is of paramount importance to have the appropriate persons or companies as parties to the agreement. We have discussed a chain of title above. The party giving up rights must be the rightful owner of those rights as evidenced by the chain of title. By the same token, the purchaser of rights should be the entity (usually a corporation), which has the resources to pay for the rights and the market stature and experience to properly exploit them. An owner of copyright may not want to give up ownership of her valuable intellectual property to a novice producer or one who has a bad history.

<div style="text-align:right">**2.4 Acquiring the Appropriate Rights**</div>

Rights to Be Acquired

Usually, the owner wants to give up as little ownership as possible for the highest price and the purchaser wants as much as possible for the lowest price. This is subject to detailed negotiation. At a minimum, the purchaser needs the specific rights to make the content he intends to market and the rights to exploit that new work in the broadest possible way. The use rights to the content may change as technology makes some uses obsolete and creates others of great value.[4] It is always wise for purchases to specify all known possible uses for their production in the agreement and add: "and any other uses by which such a work may be exploited which currently exist or may hereinafter be devised" as demonstrated in the case study from Chapter 2.3.

Given how separable and severable copyright is, the rights to be acquired should also specify whether they are exclusive to the purchaser or not, what territories the purchaser may exploit the new work in, what media and for what period of time. All of these aspects are separately negotiated and taken into consideration when establishing a purchase price for the particular bundle of rights the purchaser wants.

Purchase Price

The amount to be paid for rights is always subject to negotiation. Although there may be a range of standard prices in an industry, the parties will usually work out a unique arrangement for each deal. By way of example, the purchase price for movie rights to a novel may be a set fee or it may be described as a percentage of the actual final shooting budget of the film with a minimum or a maximum. The set fee may give the author certainty, but the percentage preserves a price that is commensurate with the size of the finished project. Obviously, if the novel is a best seller, the price is higher. If it has had modest success, the price is lower.

The price will ordinarily be tailored to specific uses. For example, if the purchaser acquires the rights to make theatrical movies, as well as television series, and videos-on-demand the price will be constructed to reflect the economics of that specific use. There may be one purchase price for a movie, a different one payable for each episode of a series and a percentage of download fees for subscription video, all in the same agreement.

Part of the purchase price will often be a provision by which the original owner will be entitled to some of the commercial success of the new work. This is usually referred to as a "profit participation".[5] The guiding principle is that if the new project generates significant revenue or, better still, is a hit, then the original owner who created

the underlying value should benefit from that financial success. A typical formula, briefly stated, is that revenue which the purchaser has received from the exploitation of the new work that exceeds all of the costs of production and financing of that work is profit. The original owner of the copyright will negotiate to receive a percentage of that profit.

Credits, Ancillary Rights and Remedies

Purchase agreements will specify what on-screen credit the original owner would be entitled to receive and whether that credit will appear in advertising or promotion, if at all. Rights specifically reserved or held back by the owner (e.g., stage play rights) will be specified. By the same token, ancillary or secondary rights to be acquired by the purchaser (e.g., merchandizing rights) will be detailed and the appropriate compensation for those rights detailed as well. Not all agreements go smoothly, of course, so provisions will be included to allow for financial reporting (key in cases of revenue or profit participations) and dispute resolution.

Option Agreements

One would not spend the money to buy rights unless they perceived those rights to have an important value. The higher the perceived value, the higher the cost, of course.

There is no guarantee, however, that once rights are acquired, a production based on those rights will ever be financed, greenlit or feasible. Trends and public opinion may change dramatically, markets may disappear and similar projects may get to the marketplace quicker. Paying the purchase price is a significant financial risk for the producer and could be onerous. A useful tool for managing that risk is the option agreement.

Under an option agreement, the purchaser does not outright purchase the rights she is hoping to acquire. Instead, the purchaser pays for and acquires the exclusive right to purchase the sought-after rights at some time in the future. The owner agrees to give up control of those rights in the underlying property for the period that the prospective purchaser needs. That period is the "option period", and the price the purchaser pays for exclusive control during the option period is the "option fee". During the option period, the owner may not grant or license any of the rights to anyone else. The option agreement may allow the purchaser to extend the option period after it expires by one or more "option extension" periods for the payment of additional "option extension fees".

At any time during or before the expiry of the option period, the purchase may decide to complete the outright purchase of the rights and trigger the operation of an actual purchase agreement. This is known as "exercising the option". Once an option is exercised, the entire purchase agreement comes into effect.

On exercise of the option, the purchase price is payable according to the terms of the purchase agreement. In most cases, the first option fee is credited against the purchase price, but option extension fees may not be. Accordingly, if options are extended, the total purchase price may become higher. This is an incentive to the purchaser to move the project forward as quickly as she can. It gives comfort to the owner that her underlying property will not be tied up and off the market too long.

Clearly, one would need to have a proper purchase agreement fully negotiated, drafted and (usually) attached to the option agreement itself to avoid the awkwardness and loss of bargaining leverage that would follow if one only begins negotiations once it becomes clear that the project is viable. A properly prepared option agreement with an adequately attached purchase agreement gives both parties the flexibility and certainty that they need to deal with the rights in a highly competitive and changing marketplace.

Actual Case Study 1

Very soon after our production company was launched, I paid a visit to a New York-based publishing company. We had successfully produced a television series together in the past. The purpose of the visit was to introduce my new company to them and explore whether there were business opportunities. A key executive introduced me to the person in charge of a series of "chapter books" for children between the ages of ten and twelve years. "Chapter books" were easy to read, short books in a series, published sometimes as frequently as one new title each month. This chapter book series was rapidly becoming hugely popular. I was given three samples which I read on the plane home. By the time I landed, I felt strongly that these books would make a great live-action television series. I called the executive in charge. She told me that a Hollywood studio had already acquired the rights. I asked if they might be willing to work with me and was referred to the business affairs executive. She told me to my surprise that the studio had only been interested in feature film rights and did not in fact acquire the television series rights. I could not believe my luck! We hastily made

a deal to acquire the rights to adapt and exploit a television series. In fact, we might have been too hasty, as you will see in Chapter 8: Mistakes later in this book. The books kept growing in popularity, and our television series became a worldwide smash hit.

Actual Case Study 2

In one of my early years of practice, the firm had a very successful movie producer as a client. In the previous year, the news outlets had been filled with a heart-warming and inspirational continuing story of heroism, determination and philanthropy. A young man who was a survivor of an awful disease committed to perform a physical achievement, never attempted in our country's history in order to raise money for research into a cure. The entire nation was enthralled and uplifted. Tragically, the disease reappeared and stopped him short. He did not survive it a second time.

Our client, whose reputation was second to none, managed to secure the rights to the life story of the hero and the support of his family. The intention was to produce a movie and advance the awareness of the cause and the charity.

Since the main character in the story was deceased, it may not have been totally necessary to secure his life story rights. It was impossible, however, to dramatize the story properly without portraying at least the other main characters who were involved, the family, the team behind the hero and the people he encountered. It took the better part of many days to track down every individual mentioned in the movie script and seek their consent to be identified in the film and their release of any claims to their personal histories as far as the movie was concerned. Almost everyone agreed.

A very small number did not agree. If their part in the story was considered expendable, they were excluded from the script. If they were integral to the story, their names and identifying characteristics were disguised, and the key facts reimagined to make the story work as well as it could without their involvement.

What principles does this case illustrate? What can be learned from it?

2.4 Acquiring the Appropriate Rights

Questions

1. Is the author of a copyrightable work always the owner?
2. How does one know who the rightful owner is?
3. How does one acquire rights to someone else's copyrighted material?
4. What rights can be purchased?
5. What uses can one make of purchased rights?
6. What if one wants some rights but not others?
7. What may an owner of copyright expect to get if she sells some or all her rights?
8. What can you do if the price of purchasing rights is too high and you are not sure if the project will go forward?
9. What happens when an option period expires?
10. Name two ways you can avoid losing your rights when an option period expires.

Notes

1 See 2.4.2.

2 See Glossary.

3 see Option to Purchase Deal Memo, Appendix #.

4 See Appendix 1: Examples of Exploitation Rights.

5 See Chapter 6, Monetizing Rights, Revenue Allocation.

2.5 The Corporation

Along with money, the corporation ranks as one of civilization's greatest inventions. It is not possible to imagine the progress of society from the agrarian primitivism of the Middle Ages to the explosive growth of digital technology in the twenty-first century without the central role played by the company as an instrument of economic activity. Corporations are the vehicle of choice in the content industries. They are overwhelmingly the entities that produce content, distribute content or provide content to consumers.

The inspirational idea that makes companies so special is that a non-human entity is capable of conducting commercial transactions while still retaining all the rights of a human that come with the ownership of property. They can also have the capacity to

enter into binding contracts or to sue or be sued in courts of law. In short, corporations are, for all intents and purposes, considered to be just like living, breathing persons in virtually every country in the world. The one major difference is that humans have a limited life span, and corporations, at least in theory, may last forever.

Corporate Law

There are, of course, rules that govern the creation, structure and operation of corporations. Those rules exist mostly in special laws passed by countries, and/or states and provinces within those countries. Because companies ought to be allowed to do business anywhere, corporate law is generally uniform from jurisdiction to jurisdiction. Some places may have unique provisions designed to attract or regulate businesses in their countries. Our focus here is to describe the basic features common to all.

Incorporation

To exist, the company must be created under the prevailing statute in its home jurisdiction. That will typically involve registering with a centralized government body and filing the creational documents commonly referred to as "Articles of Incorporation". These are the general rules describing the essential features of the company, its ownership structure, its internal governing body, its rules of operation and its most senior executives or "officers".

Essential Features

As a legal entity, the corporation owns its assets, is liable for its contractual obligations and debts and enjoys the profits of its undertaking. The humans who created the company only benefit through their ownership of shares. Since it is the corporation directly on the hook, the humans themselves are neither contractually obligated nor subject to legal action if anything goes wrong. This is one of the main purposes of creating a company for a business – to shield the founder from personal liability. In the high-risk content industries, the limit on liability is very important.

Along with limited legal liability, the corporate "person" (as, once again, the corporation has considered this from a legal perspective) is also a taxpayer. It is taxed on the profit it earns. Although different jurisdictions have higher or lower tax rates and varying features designed to attract or control businesses, the general rule is that corporate tax rates are significantly lower than the tax an individual might pay if the human earned the profit herself. This is another of the key reasons people incorporate – to obtain tax benefits.

2.5 The Corporation

If only one human owns the company, the situation is straightforward. He or she may pretty much do as they please. Overwhelmingly, however, there will be more than one person involved to share in the benefits of ownership. This leads to yet another ingenious invention related to corporations.

Share Structure

No one owns a company outright. What one may own is shares in the company. The Articles of Incorporation will have created one or more classes of shares that can be acquired, bought or sold by individuals. All companies originally have a class of shares known as "common shares". Each share, evidenced by a certificate, represents an equal piece of co-ownership of the company. If there are hundred common shares, each share represents 1/100th of the ownership of the company.

Each share in a class will have identical rights and privileges. Those rights and privileges include the rights to share proportionately in the profits and voting rights and rights to appoint directors to the board of directors.

It may be desirable for the company to involve others in the ownership structure such as investors, key employees or strategic partners. This will typically lead to the creation of different classes of shares for those "outsiders". They are most often called "preferred shares" and can have whatever features the common shareholders wish to give them. The preferred shares may have enhanced or reduced voting rights, and they may have priority or inferior positioning to receive dividends or other financial distributions.

The flexibility of share structures allows companies to attract new capital investment while affording both the founders and new participants the control they need and financial benefits they want.

Shareholders can receive money from their corporation in three basic ways:

a) by way of a dividend declared by the board of directors paying a certain amount per share,

b) by way of a salary if the shareholder is also an employee and

c) by way of a loan.

Each method has its own tax benefits and costs. Creative planning can lead to significant economic advantages.

Governance, Directors, Officers and Shareholders

There is a tidy circle of responsibility, authority and accountability in corporate structure. Each company has shareholders, directors and officers, and their rights and duties are described in the originating documents of the company.

The shareholders are the owners of the company and have key voting rights, among which is the right to appoint directors to the board of directors. The board may have as many members as the shareholders wish. Since it is the shareholders that ultimately control the company, it is crucial to avoid blocking or diverting the progress of the company as a result of unresolved disputes between the shareholders (or their successors if shares have been passed to heirs). Accordingly, there should always be an agreement among the shareholders to cover what they can and can't do with their shares and what happens to the shares if they decide to part ways, sell some shares and/or in event of the death of a shareholder.

The board of directors is responsible for overseeing the financial health of the company and approving its financial statements. It hires and fires the key executives of the company, namely the "officers". The directors are accountable to the shareholders. Each director and the board itself have a duty to preserve the value of the company for its shareholders by maintaining its profitability and objectives.

A company may have as many officers as the board wishes, but from the beginning, it must have a president and (usually) a secretary. The president, sometimes also called Chief Executive Officer, is responsible for overseeing, guiding, managing and steering all the day-to-day operations of the company to accomplish the corporate objectives as approved by the board of directors on behalf of the shareholders. A company may have a formal strategic plan created by the board of directors, with or without the president or others. The president's duty is to follow that plan. The president will have the freedom and authority to hire and fire other staff members as she wishes in accordance with the strategic plan (if there is one) and the financial parameters of the company.

The role of the corporate secretary is to keep records of all shareholders' and directors' meetings and resolutions as well as all other formal affairs of the company and maintain those records in the corporate books. Important decisions voted on by the board of directors are reflected in documents called "directors' resolutions". Similarly, important decisions voted on by the shareholders are called "shareholders' resolutions".

2.5 The Corporation

Parent Company versus Single-Purpose Production Company

Content production involves raising and spending very large amounts of money, engaging many employees of varying levels of expertise and sophistication and using many resources from vehicles, cranes, camera equipment, firearms, explosives, stunts and special effects, depending on the project. There is always risk of injury, delay, financing glitches and equipment breakdowns. Like a train, productions are very hard to get going initially, but once underway, their momentum is very powerful. Unlike trains, productions may be derailed very easily. Even a one-day stoppage of a production could cost hundreds of thousands of dollars. The financial repercussion of a production catastrophe could bankrupt any production company. Accordingly, the practice has evolved of using "single-purpose companies" through which to produce each individual project.

A "single purpose company" is a corporation set up for one sole activity. In our context, the main production company – the "parent" – would incorporate a wholly owned subsidiary company that would be contracted with to simply undertake all the contracts and obligations required to physically produce the show and deliver it to the intended broadcaster, channel, streamer, platform or distributor. In that way, all the potential risk is confined to the single-purpose company, and the main or parent company would be sheltered, at least somewhat, from liability. All the rights, copyright and physical elements of the show would be owned by the parent. It would be the parent who enters licence contracts to monetize the show.

Of course, this leads to much more accounting and legal structuring, but having all the value of the content reside in the parent company and the risk relegated to subsidiary companies allows the parent to grow in value and accumulate a library of content assets with fear of financial injury.

Actual Case Study

When the time seemed right to form my own production company, I told one of my closest friends about my intentions. He insisted that we do it together, and we, therefore, incorporated a company. Our arrangement was that each of us would be completely equal in almost all respects – equal share ownership, equal

voting rights and equal profit participation. The two of us would be the only two directors. The main difference would be that I would be the operating partner and he would be more passive. Correspondingly, my salary would be twice as high as his. We formed a shareholders' agreement that covered dispute resolution and the disposition of our respective shares in the event that either one of us was incapacitated or deceased. Because I was the principal operating officer of the company, we included a provision in the shareholder's agreement requiring the company to take out and maintain a life insurance policy on myself that would pay a significant amount of money if I was to die. We carried on business that way for ten years without incident or concern and were happily successful. Eventually, it became clear that we would need to part ways for various reasons, some industry-related and some personal. We agreed that I would pay him for his shares and take over the company alone. To determine a fair price for his shares, we agreed that each of us would appoint an experienced valuator and that together the two valuators would agree on a third. The trio of valuators would present us with three prices: a worst-case, medium-case and best-case price that a knowledgeable purchaser would pay for the shares. We agreed in advance that I would pay the middle number without any further negotiation. And so it went, avoiding what could have been a very messy, rancorous and damaging separation.

Questions

1. How is a company created?
2. Who gives corporations official status in law?
3. What can humans do in business that companies cannot?
4. Who owns a company?
5. Can the owners of a company be sued for something the company did?
6. Who operates the day-to-day affairs of a company?
7. Who oversees the person referred to in Question 6?
8. Who is the person referred to in Question 7 answerable to?
9. How might one get money out of a corporation?
10. What can reduce the harmful results of a dispute between shareholders?

2.6 Corporate Financing

Companies all start with some sort of initial financing which is what people call "Startup capital". This can be any amount or combination of cash, labour, technology and/or facilities.

Startup capital is what entitles the founders of a company to the ownership of the initial shares. It gives them an advantage. If the company is successful, the initial shares, which may have nominal or little value at first, will increase in value. The founders can enjoy that financial gain. Those initial shares also give the founders effective control over the corporate strategy operations and their status in the marketplace. There are a great many excellent books and source materials covering startup and young companies currently in circulation. For our purposes, however, we will look at companies that already exist and have a history.

Inevitably, companies encounter circumstances where they need additional financing. Times may be great, and yet, more money is still needed to finance growth to take advantage of looming opportunities. Alternatively, revenues may be interrupted or losses may have occurred and a cash infusion is needed to tide the company over to safer times. There are two basic ways for companies to raise money, debt and equity. Intentionally omitted is crowdsourced funding since it is uncertain, tends to focus on projects rather than corporations and rarely yields significant amounts.

In all cases, content creators are well advised to retain the services of experienced and knowledgeable professionals, such as lawyers and accountants, to negotiate and structure financing arrangements. Most lenders and investors will have done and require the same.

Debt Financing

Taking out a loan is not in itself a bad thing. If the carrying cost, the cost of payments and the cost of interest is affordable and as long as there is every likelihood that the load would be repaid debt is very useful-in some cases, even wise. Companies may need short or limited term loans on a project-by-project basis to cover production costs of content creation, for example. This will be covered in Chapter 2.7.

Corporate debt can be structured in many ways. The company can arrange a fixed loan with a fixed repayment schedule secured by collateral such as a library of content. It can also negotiate a revolving line of credit. A line of credit is a loan facility with a lender that allows the corporate borrower to draw down sums of money on an as-needed and random basis if the total amount outstanding does not exceed an agreed-upon maximum. This is not unlike overdraft protection on a personal bank account. The line of credit will, however, need to be secured.

Security for a loan, whether fixed or revolving for companies in the content creation industries, is somewhat tricky. Unlike real estate developers, for example, the assets that content companies deal with are mostly in the form of intellectual property. They do not have the same valuation mechanism as land does. It is relatively easy to obtain a reliable valuation of a vacant lot in a given location. It is much harder to obtain a reliable valuation for the motion picture rights to a book (even a hit bestseller) or the value of a library of several television series. There is value there, but it could be next to nothing or it could be millions of dollars. Lenders to content creation companies will often require something more traditional in the form of collateral or security for a loan. They may need pledges of other more tangible assets or personal guarantees of repayment from the borrower's principals or both.

Nevertheless, with properly prepared financial statements showing a good earnings history of at least three years, conservative and demonstrable revenue forecasts and accurate cash flow projections, most companies can and do routinely obtain corporate loans, the sizes of which depend upon the specific package each company brings to the table. A main advantage of debt financing is that it does not give up ownership of the company in exchange for the funding.

Equity Financing

Simply put, equity investment is the raising of capital by exchanging shares of owner-ship or co-ownership for cash or other assets of commensurate value. In our context, it would mean granting shares to an investor, whether common shares or preferred shares, of the company in exchange for a negotiated sum of money. That sum would represent a percentage of the overall valuation of the company that the parties agree is a fair exchange for the money offered.

There is no hard-and-fast rule for valuing any company whether on past earnings history, future market position, proprietary technology or any other factor. The case study from Chapter 2.5 addresses this. The shares given up, the rights and privileges attached to those shares and the price paid are simply what the parties agree to in the end. Thus, desperate companies will give up more, and hungry investors will pay more.

It is also possible to offer shares of the company to the general public, what is known as "going public". To consider this route, companies should be able to demonstrate an impressive history of profitable operations going back five years or more. They would need to identify an opportunity to expand their operations significantly and explain how the funds raised would be applied. Although it is most often a driving factor, enabling the principals to sell their shares at a large profit will not be considered an appropriate purpose on its own. Going public involves regulatory approval from local government agencies which apply strict rules intended to protect investors. This is always costly and time-consuming and involves many lawyers, accountants and financial brokers. The result is not always successful. Even if the intended money is raised, the company needs to be sure it is worth the process. The time, cost and diversion of attention to core business practices is very onerous. Moreover, once public, the company has ongoing reporting and public relations duties to its new shareholders and will remain under the scrutiny of the government security's regulators. A whole new staff of employees is usually required to handle these functions.

Questions

1. Where does the money come from to start a company?
2. Why would a successful company need to raise more money?
3. When is undertaking a corporate loan a good thing?
4. What would a company need to show to get a loan?
5. What kinds of loans are there?
6. What is equity?
7. How does one determine how many shares to sell and for how much money?
8. What does one give up by bringing in equity investors?
9. What are the benefits of going public?
10. What are the costs of going public?

2.7 Production Financing

Attempting to Parallel Parking a Large Van in a Tiny Spot

Making Shows for Gain Rather Than Just Getting Them Made

All too often the passion for a project and the enthusiasm to get it going overcome the financial discipline and strategic thinking that leads to positive business outcomes. A business can fail surprisingly quickly even though it may be making a string of critical successes and audience favourites if the financing arrangements for its productions are not responsibly and carefully structured. Conversely, even box office flops and critical duds can be profitable for a production company if the financing is well designed. This section will cover the different stages of financing: development financing, production financing and interim financing; discuss the various sorts of financing components that can be employed; and tools and techniques that can be used to enhance the production company's chances of creating positive revenue streams well into the future.

The key concept to keep in mind for all executives in production companies is that any project at any stage should be designed to minimize risk and maximize reward. That is not to say that risk should be avoided at all costs nor that the only consideration should be profitability. The important thing is to give sufficient thought, do enough research and be brutally honest about each project's potential. In a portfolio of productions at differing stages of development, production and distribution, the careful balancing of the competing factors of creative versus commercial value over the entire slate of projects is an essential ongoing priority for the executive team.

As an overriding principle, it should be obvious that productions should only be embarked upon when they are fully financed without cash investment or deferrals by the production company. Even then, the production company ought to be assured that its production fees and overheads are adequate, and a significant potential revenue stream from the exploitation of the show is likely and worthwhile.

Projects should, as a rule, not be embarked on when the company is undertaking a significant financial risk unless there is a strategically compelling reason to do so. A few examples of this may be when there is an important relationship to maintain the possibility of forging a strategically valuable new opportunity or extraordinary profit potential.

Nevertheless, it is surprisingly common, even for well-established companies, to go forward with underfinanced projects. A common risk would be greenlighting a project when there is just enough financing to pay for the manufacture and delivery of the show but not enough to pay the production company's producing fees and/or overhead. The shortfall is intended to be covered by "deferrals" of those fees and costs, but they are rarely recovered. Another risk would be to knowingly commence a production on an unrealistically low budget just because all the projected financing was not secured. Production cost overruns, which are likely to occur in such situations, could severely hurt the production company's overall financial health or even bring the company down altogether.

Ultimately, the value of a production company is based on the quality of the assets it owns (the intellectual property rights it has acquired and created in the form of productions) and its profitability over time. So, to build a successful company, one must produce well-financed and revenue-generating projects that maintain positive cash flow over time. Although the pressures of financing a project will push a company towards giving up rights in order to get projects going, it must do its best to hold on to as many rights in the productions it creates as possible to develop a library of assets that can have a significant value.

Development Financing

A healthy production company will have a range of projects in development, all designed to fit the company's profile, market presence and production expertise. Taking on projects outside of the genre or style that the company is known for may be risky or challenging. However, market conditions or the need to diversify may sometimes call for unusual projects to be considered. In such events, the company should make sure that the talent and personnel it has access to bring the requisite comfort level to potential financiers and licencees. A successful track record is one of the most persuasive and effective selling tools for new projects. Key talent such as writers, showrunners, directors and stars are at the top of that list. Their involvement may be the deciding factor for getting a project greenlit.

Typically, development goes through three stages: Ideation, Pitching and Creating Development Materials.

Ideation and Pitching

Projects must come from somewhere. They begin with an idea, either one created inside the production company or brought in by option agreements, personal service contracts or relationships. The ideation stage is where it appears clear or likely that a

certain kind of project has a unique opportunity of market success. An executive, writer, producer or even an intern may come up with an idea that is so strong, timely and suitable for a particular company that it is worth pursuing. The concept needs to fit what sophisticated market analysis shows to be a commercially viable genre, format, theme or trend in the broader content universe. The concept should be compelling or, at the very least, appropriate for the potential licencees or funding partners that the company already has a history or good relationship with. It should be feasible to produce properly within the economic parameters of its intended market niche. Most importantly, it should be a project that has a reasonable chance of providing a financial return to the company over and above its direct and indirect costs of production.

It is very easy to come up with an idea for a movie, TV or streaming series that sounds popular. The typical consumer probably spends more time on media content than virtually anything else in their lives. Very few would have trouble, suggesting what would make a "good show". It is much harder to devise a show that makes a "good pitch", is a natural fit in a content provider's inventory of offerings and is financeable. Good, targeted ideation makes the whole process smoother, more manageable, more enjoyable and more rewarding. Bad ideation can easily drain time, resources and cash from production companies. That is why the ideation stage of the development process is at once the riskiest and the most important to get right.

It's all too easy to become so obsessed with a project for personal and/or creative reasons that key executives do not let go when they should thus cause the company to shift focus and waste time, energy, resources and cash. An often-used technique that provides some comfort that a project has "legs" is to acquire the rights to adapt intellectual property that has already proven popular in another medium. Books, characters, articles, personal histories, songs, comics, games, remake and sequel rights, trademarks and other forms of successfully commercialized and adaptable properties have all been used to good advantage in the making of movies and series. It's much easier to propose a series based on *Gone with the Wind* than to suggest an original Civil War romantic drama series.

Once a concept is settled upon, it must be brought to a stage where it can be presented in an attractive and persuasive way (the "pitch") to potential commissioning editors, "buyers" and financiers. All these factors lead to the inevitable conclusion that the production company will, more often than not, finance the earliest stage of development by using its own resources, in-house writers or creators, corporate funds or outside talent arrangements. The key expenditures during this stage will include analysing market

appetites, optioning rights, writing proposals, working up proper presentation materials, perhaps "demos" and video material, and graphic design that engages key talent such as writers, animators, directors or stars.

A well thought through, professionally presented and compelling pitch may be one of the hardest things to achieve in the media production industries, but it is often the most important factor for creative and financial success. Pitching tools, techniques and tactics and some real-life examples will be discussed at length in the section on "The Core Team, Who Does What Exactly".

The pitch has several objectives:

Firstly, it is intended to elicit a commitment from a funding partner to join in the financial risk involved in undertaking the next stage of development.

Secondly, the pitch session is a proof-of-concept experiment. If the pitch is well received, it confirms the judgement of the production company's staff. If not, perhaps the project is not right for that partner, more suitable for some other entity, not within the right timespan or it just does not work at all.

Thirdly, the pitch provides useful intelligence on how potential licencees view projects, what they may be looking for and where the market may be going.

Ideally, the funding partner being pitched to should be a senior development executive at the organization for which the project is intended to be licensed when it is ready to be produced. In rare situations, third parties who are not industry participants may be interested in investing money into the ideation process. That is not recommended as it usually takes more time and effort than it is worth to sort out and brings in an outside voice that needs to be managed, thereby weakening the vision.

The pitch itself should occur in the key development person's office or over a meal-related meeting. Pitching at festivals, organized market events and/or informal gatherings is rarely successful and would need to be followed up by a formal meeting anyways. The pitching process will continue to be covered in-depth throughout the rest of this book.

The cost to get to the end of the pitch process is not necessarily high unless one is optioning bestsellers or paying holding fees for top talent. In such cases, however, it may be well worth the gamble since these elements can often make a successful production. There may be travel costs, entertainment expenses or other costs of creation,

but financing the ideation stage of development in-house keeps valuable and sensitive intellectual property more confidential and gives the company much more freedom to work towards a pitch without the watchful oversight of a funding partner.

Creating Development Materials

The ideal outcome of a successful pitch is not, as many believe, a greenlight to production or what the industry refers to as "sale" (an offer to license the program). The ideal outcome is a "development deal". A development deal is a commitment from a potential licencee of the finished production to contribute cash, resources, input and expertise into the creation of sufficient materials that would, taken as a whole, result in a production order or commitment.

Development materials would include an overall creative proposal outlining the story, characters, style, tone, genre and market appeal of the concept (sometimes called a "bible"); description of key creative personnel attached; engagement of writers to write scripts and/or outlines; production design elements; location scouting; preliminary casting; special effects or graphic design samples and importantly production budgeting and a financing plan if the development process proceeds that far.

In a typical development deal, the potential licencee of the project (a TV network, cable network, streamer, studio, distribution company, etc.) would specify the development materials it wishes to have created and the timelines it requires to take the project to a state where greenlighting could be properly considered. It would request that the production company prepare a development budget for the project covering all the anticipated costs of the development plan and costs associated with it. This is not to be confused with a production budget or the production company's internal development budget (both to be explained below).

Once approved, the development partner will commit to fund a significant portion of the development budget. In rare cases, they will fund the entire development budget. In return, they would be granted an exclusive option to license broadcast, streaming, theatrical distribution rights or other important rights in that organization's sphere of operation – its media, territories and outlets. The development partner would have the right to comment on and approve all key materials to be created within proscribed times after each element is delivered by the production company. At any time up to the completion of the development materials, the funding partner would have the right to commit to funding production or pass on the project.

The development commitment entitles the potential licencee to exclusivity. This means that the production company will be barred from offering the project to any other competing partner but may be allowed to bring in non-competing partners who operate in different territories, media or venues.

Having a development deal with the right industry partner offers many key advantages. Obviously, it reduces or eliminates the cost of development to the production company. More importantly, however, it confirms the market appeal of the project and ties the project to a commercial user that might ultimately fund the production. Having decided it is worth considering and putting money at risk to see a project developed, the end user is incentivized to make the development successful. The creative input given by the funding partner is also a great benefit. It tailors the project for a specific end user which usually knows better what it wants and needs and that, in turn, enhances a project's potential for success. Lastly, development deals, conducted properly, can lead to invaluable relationships even if they do not result in production orders. The integral nature of personal relationships in the content creation industry cannot be overstated.

The essence of the funding provided under a development deal is important to consider. It is rarely a gift or grant. Instead, the funding partner will view it as a loan that is to be repaid when and if the production goes forward, whether at its initiative or anyone else's. This is what is called a "non-recourse" loan. It is repayable only in the event of specific occurrences. If the funding partner commits to funding production, the amount they previously contributed to development is deducted from the first production financing payment.

If the funding partner passes on production, the developed project may be put into "turnaround". In these cases, the production company will be free to offer the project to other industry users (broadcasters, streamers, distributors, etc.). If the project then goes into production, the initial funding partner will be repaid its full development contribution and will then release its hold on the project. In some cases, the initial funding partner may require the production company to re-offer the project to it before any new deals can be entered into. This is known as a "right of last refusal". In this case, the initial funding partner gets a second chance to consider the project on the same terms. If it passes again, the production company is free to proceed. If it does not pass a second time, it would match the new terms and fund production.

Without a development deal, a production company might take a different path and fully develop a project bearing the expense alone, following a singular creative vision

and only then presenting it to potential end users. This is like hitting a bull's-eye with one's eyes closed. The chances of success are remote in an episodic production and only somewhat higher in the feature film industry. This is still a very speculative and costly strategy and is usually to be avoided if possible.

In some countries and industries, there are what might be called "non-industry" sources of development funding. These are usually fixed pools of money made available by governments or other agencies that have agendas beyond simply making successful commercial products. They may be oriented to supporting a particular industry, technology, region, labour market or social or political cause. To the extent that the development budget on a given project is not fully funded by traditional industry sources and the production company deems it not advisable to fund the shortfall itself, these non-industry sources can help. It should be emphasized though that their timing, agendas, rules and procedures may be burdensome and, in some cases, may conflict with the desires or intentions of the actual industry partners. More detail on the advantages and disadvantages of governmental and other non-industry sources of financing will be discussed below.

Managing Corporate Development

It should be clear now that from the production company's point of view, its development process, although the lifeblood of future success, is loaded with effort, uncertainty, cost, risk and luck. Development can be hugely motivating when a project gains momentum or "development hell" — a costly and discouraging distraction when progress is too sluggish. That is why strategic thinking, stringent cost control and disciplined procedures are so important. It is very easy for corporate executives and staff to fall in love with projects. They must just as easily be able to fall out of love with them if the projects do not fit the market, the economics, the popular trends or the company's profile or capabilities.

A key tool to ensure disciplined development is to establish a fixed internal budget for the production company's development activities. The internal amounts of money allocated towards either ideation or development should be appropriate to the annual budget and cash flow of the company and re-examined at least every quarter. Weekly status report meetings should be conducted to include not just the development execs but key members of the leadership team to review ongoing projects, new projects, spending allocations, opportunities and hazards.

2.7 Production Financing

Production Financing

The best outcome of completing development is a production "greenlight" or "order". Ideally, that is when an industry development partner has committed to funding the actual production of the project. The industry term for that commitment is a "presale" or "pre-licence" because it assigns rights to the project in exchange for production financing before the production has begun.

In some cases, production companies may have completed development without a presale and might have the resources or access to production funding outside of traditional industry sources to get the project made "on spec". Although this route is rarely justifiable on pure business terms, for first-time producers eager to gain credibility or show what they are capable of it may be an acceptable choice, especially if the budget is low enough and the financial risks manageable. For those intending to sustain an economically viable and long-lived production operation, it is almost never advisable. The bragging rights attached to being in production, the ego gratification or the creative fulfilment that comes from going ahead with a "spec" project come with a very high cost and have the potential to be economically disastrous. It is far more prudent for a serious production company to only proceed with productions that are financed through mainstream industry sources and other third-party funders who are in the business of doing just that.

At the end of the development process, the production company will have a relatively complete package consisting of the basic creative and business elements needed to commence a production. The package will contain scripts, outlines and perhaps a shooting schedule or even key creative personnel commitments. For financing purposes, the most important element will be the production budget.

The Budget

The first question any potential funder will ask will be "what will it cost"?

The general marketplace for a given project has established budget parameters depending, of course, on factors such as outlets, genres, formats, styles and norms. Each project's budget should conform or relate to those parameters. If it strays too high or too low, the project may not go forward or succeed.

The budget will be created based on the script material and the attenuating creative elements that flow from it: locations, sets, special effects, studio costs, cast, etc. It

ought to be as complete as possible, including even financing costs, legal and accounting costs, completion guarantees (if needed) and even some marketing costs. It is also imperative that the budget anticipate and include the cost of any "delivery elements" specified by the funding partners.

The production manager, line producer and perhaps a first assistant director will break down the script (or anticipated scripts if it is a series) scene by scene and element by element and plan out the most efficient shooting schedule while simultaneously considering creative goals, costs, logistics, weather, availabilities of talent and delivery dates. They will provide a very accurate forecast of what costs will be incurred or spent each week from the beginning of preproduction to the delivery of the completed project. All of that is relatively straightforward.

The trick is to match the budget with the financing – or to match the financing with the budget!

The development funder that has "greenlit" the project, having approved the creatives, will require approval over the production budget. They may suggest changes, approve some elements, reject some elements or add requirements. After some negotiation and recalculation, a final shooting budget will be arrived at. This is one side of the project financing equation – the cost side. The other side is the financing that may come from many different sources. Both sides will need to match.

The Financing Plan

The juggling that is involved in funding a production needs to end in such a way that the production company will have all the money it needs to produce a viable and competitive production in its intended market. Ideally, this will be done with the company only giving away small amounts of ownership, control and revenue participation or else the effort may be unlikely to be worth the time and effort involved in producing it (Figure 2.7.1).

The production company will want to hold on to as much of the intellectual property rights as possible and retain as much autonomy and control over the project as it can. The rights will lead to revenue streams and asset values that contribute to the health, net worth and profitability of the company, and the creative and financial controls will help keep the project manageable and faithful to its intended vision. For that reason, a carefully constructed and reliable financing plan needs to be created. Table 2.7.1 depicts a blank template financing plan for a TV series.

2.7 Production Financing

The Financing Plan:

TV Series Financing plan

Cdn License ▦ US License ▦ Dist'n Adv. ▦ Prov. Tx Credit ▦ Prov. Reg. Bonus ▦ Fed'l. Tx Credit

FIGURE 2.7.1 What makes up a financing plan. Graphic by author.

The financing plan for a movie or "one-off" production can be used by simply deleting the references, columns and values for "episodes".

The production company's financial staff and key executives will work to complete this plan in the most advantageous way for the company. They will plug in values and potential elements in differing iterations until the most feasible plan is arrived at. At first pass, the financing sources that are known or knowable are entered into the spreadsheet. These may be the presales and possibly fixed and predictable sources such as government tax credits or rebates. If the total amount of these values does not match the budget, more sources may need to be employed. These may consist of additional presales, distribution advances or government assistance. At first, these new components may be estimated values or targets. As deals are completed, the values become real, the plan is updated and the actual amount of available financing becomes clearer.

If a funding shortfall is inevitable, then the budget may have to be revised downwards (e.g., by reducing shooting days, eliminating locations, redesigning sets, curtailing stunts, and effects, etc.). This is like attempting to parallel park a large van into a tiny space. The production company will have to go back to the presale licencee(s) to get approval for any lower budget. Obviously, this will be a delicate and awkward negotiation and is best avoided, if possible, by finding the right amount of financing.

Table 2.7.1 A sample financing plan for a TV series

Production					
Production Company					
Number of Episodes	eps X		Total budget		
			Per episode		
		Season		Per Episode	
Source	Nature of Participation	$	%	$	%
				$0	

The "Source" column in the financing plan will list all the potential and actual sources of funding. Once completed, the plan should give a snapshot of how much money is anticipated to be raised from each and what the production company may have to give up to each source. Clearly, the fewer sources of funding a project has the better so that the production executives can spend more time and energy ensuring that the project is running smoothly and made well rather than braiding multiple strands of financing together that may not naturally get along or scrambling around to raise more money.

We will discuss the main funding sources in detail below and explain the differences in the "Nature of Participation" of each.

Sources of Financing (In a Suggested Order of Preference)

Presales (or Pre-licences)

Simply put, this is a commitment by an end user or content provider such as a broadcaster, streamer, cable channel or distributor (sometimes referred to as "the Buyer") to pay a significant amount of money for the right to use the project in their business. Because the pre-commitment gives them exclusivity in the marketplace and the right to tailor a production to suit their needs, it is the highest amount that licencees normally pay for the rights to productions. These shows may appear to consumers with credits such as "Netflix Originals" or "Universal Pictures Presents" or similar designations depending on the specific buyer. Already finished productions that users acquire rights to after the fact are normally called "Acquisitions" and go for much lower licence fees.

In presale situations, the production company will receive a much higher licence fee and thus a higher percentage of the financing required to cover the production budget – perhaps even all the financing needed. What the company will give up is usually the right to exploit the project in the specified media, territories and for specified amounts of time required by the buyer. In ideal cases, significant territories, time windows and/or media are left to the production company to exploit for either additional financing sources if needed or a revenue stream.

Clearly, if one can fully finance a production by giving up rights (even all rights) in one or two territories and retain the rest of the world for its own benefit that would be a best-case scenario. It's not as impossible as it sounds. If, for example, the production is highly sought after because of its creative team's track record or based on a blockbuster book (say, *Harry Potter*), the production company may be in the driver's seat to negotiate the best possible commercial arrangements. If a production company's home territory provides significant funding for qualifying projects (as do Canada, the United Kingdom, France and Australia), one or two presales in specific countries may be enough to complete the financing. Government subsidies and incentives for content production are made public and the amounts, eligibility criteria and rules of access are well explained on the relevant government websites at national, state and/or municipal levels.[1]

However, consider this a warning against the "full funding trap". This is a type of presale where one end user, such as a streaming company, offers to provide literally all the funding required to cover the production budget and a little more to give the producer some "profit". In return, this type of buyer (a streaming company, cable

channel or Hollywood studio) will normally demand to have exclusive rights to the program throughout the world, in all media, for up to 25 years or more. The "trap" is that, in effect, the producer will have given up substantially all the value in a project in exchange for easy financing. For first-time producers looking to make their mark, or for companies who have no better alternative, this might be advisable. Otherwise, it might be wiser to fight to retain significant rights even if it means a lower value presale and the need for additional funding partners.

It is important to note that presale licence fees (and for that matter, most types of production funding) are normally paid out over time rather than all at once. They are spread over the period that the production takes place and tied to the funder's approval of key elements and stages of completion. Accordingly, a carefully and accurately prepared cash flow schedule needs to be constructed by the financial and business affairs staff to ensure that funds are available to the production as and when needed. In many cases, that will necessitate an "interim financing" arrangement [see the section "Sources of Financing (In a Suggested Order of Preference)" of this chapter].

Distribution Advances and/or Guarantees

Distribution companies are firms that are in the business of entering arrangements with producers to monetize unexploited rights in projects where the producer has little or no capacity to do so on its own. For example, in a case where a given production is entirely financed by means of one presale that takes up the US territory and another that takes up Canada, a distributor may be engaged to arrange licences or exploit the project in the rest of the territories of the world on behalf of the production company. The distributor negotiates licences, collects the revenues and is entitled to a percentage commission or "distribution fee" (15 to 40% of gross revenues) as well as recovery of its reasonable expenses.

These additional licences will be "acquisitions" to buyers which means that the licence fees will be smaller, but there may be more of them. The aggregate of all these deals can, in fact, add up to a considerable sum over time even after the distributor has charged its fees and expenses.

Where additional funding is needed to round out a production financing plan, where a production company may need immediate cash flow infusions for corporate purposes, or where it is deemed advantageous to have the distributor at some financial risk to incentivize its sales effort, the production company may negotiate a distribution

2.7 Production Financing

advance or guarantee. Where needed, distribution advances or guarantees can usefully top off production funding shortfalls.

A distribution "advance" is just what it says. The distribution company will advance funds to the producer before it has a finished project that it can take to market. Payment of the advance may occur in stages during production or all at once on delivery of the completed product.

A distribution "guarantee" is a binding promise by the distributor to pay or have paid to the producer a fixed sum by a specific date in the future, regardless of whether it has generated sufficient licence revenues or not. As it is not paid during production, it is a contract that must be "bankable" by the production company if it is a required component of the financing plan. A bankable contract is a binding commitment to pay money made by a company that a bank considers to be reliable and not a default risk and, therefore, acceptable as security. Both distribution advances and guarantees are recoverable by distributors from any licence revenues they have generated against the producer's share of those revenues. This means that as revenues come in the distributor recovers any previous payments, they may have made from what would be considered the producer's share of revenues. Once the distributor has fully recouped any advance payments it has made, the producer is paid out its share of revenues on an ongoing basis.

Care must be taken to negotiate a proper balance, the size of any advances, guarantees and the level of distribution fees against the likelihood of the producer seeing any return beyond the up-front payments. The higher the advance or guarantee, the higher the distribution fee will be and vice versa. It goes without saying that lower distribution fees provide stronger revenue streams for producers.

The distribution fee should, however, be high enough to incentivize the distributor adequately. Nonetheless, it should not be so high that the producer's share of revenues is too small. Conversely, with a very small distribution fee, the producer's share may be higher, but the distributor is less motivated to make sales.

Distribution agreements are highly complex and should involve experienced professionals to help the producer negotiate fair deals. Nevertheless, unless the production company intends to make sales in foreign territories or specialized media by itself, the services of a distribution company, under a fair contract, to exploit open markets controlled by the producer is a very good way to create an ongoing revenue stream for small- to mid-sized production companies.

Grants and Subsidies

Many, if not most, countries outside of the United States offer government grants, subsidies and/or incentives to production companies. In most cases, they are only available to companies that are residents of those countries, but there are rare occurrences where subsidies are available to foreign producers as well.

The rationale for these forms of government assistance is always based on two conflicting objectives: one, to promote the creation of content that is culturally significant by local producers who are not easily able to compete with large-scale international films or television products and two, to create jobs and boost the local economies.

Country by country, these mechanisms vary, but the most valuable ones, such as the range of subsidies and grants in the EU, the United Kingdom, Canada and Australia, are quite similar. They consist of either grants or employment tax rebates for the less culturally "significant" projects and include equity investments in projects of higher national cultural importance. The totals of these kinds of funding sources can be very important, ranging from about 10% of a budget to sometimes 60% or more. This key area of international content production is important and will continue to be as you will see throughout the text.

There is a notable difference between the nature of equity investments and grants and subsidies. Grants and subsidies are not repayable to the governments that supply them, whereas equity investments give the investor part ownership of the production a preferential position in the revenue stream of a project until the investment has been repaid and a profit participation thereafter. As well, government funding sources all require significant national interest elements such as mandated personnel, shooting locations/expenditures and themes/content. Some of these incentives are based on predictable and reliable rules and formulae and can be easily forecasted and plugged into a financing plan at an early stage. That is a big help.

Sometimes though, these subsidies may inflate the cost of productions and/or diminish or restrict the best creative choices for producers or the commercial potential of a project.

And these arrangements may be difficult to combine with purely commercial sources of funding whose goal is simply to make the best project possible for the lowest cost and with the best talent.

Nevertheless, these forms of financing are of increasing importance in the worldwide content production sector and can usually be of great assistance for the right project.

2.7 Production Financing

When grants or subsidies are combined with a significant presale or two a project's financing can be completed without the need for more partners. This can in fact be a great advantage.

Third-Party Equity

All producers have heard of angel investors who have fully or partially funded projects and made a lot of money. A great many more equity investors have not done very well by such investments, and most have lost all or part of their money. While it may be attractive to producers to use equity investors for their apparent simplicity and ease of funding, there are major issues involved.

Take Plotnik's curse. Mrs. Green, a dowager, notices with envy a large diamond around the neck of her widowed friend Mrs. Gold and comments on it. Mrs. Gold announces that it is the famous Plotnik Diamond. Green confesses how very jealous she is of her friend's great luck in obtaining such an amazing jewel, but Gold warns: "It's not so great. The diamond comes with a curse.......Mr. Plotnik!"

Many equity investors fall in the Plotnik category. They are demanding, possessive and typically interfere in matters that they are ill-equipped to deal with. So, if equity investment is the best remaining source of funding available, make sure to choose knowledgeable and experienced ones rather than the "rich uncle" types. Of course, they will exact the most onerous terms, but at least, they will be sensitive to a producer's process.

As mentioned above, equity investors will have rights of approval over key elements of the production. They will pay in their investment over stages of the production just as other funding partners will, will be entitled to recover their investment in priority over others out of the revenue stream and will negotiate the highest possible profit participation. Until the investments of equity investors are repaid, the production company is rarely entitled to receive any part of a production's revenue stream. Another challenge arises in intertwining the interests and requirements of various investors, each of which want an advantageous participation in the revenue stream of a production and who may have different commercial or non-commercial purposes for their investments.

Crowdsourcing

Not a lot of space will be given to this method of funding productions although questions about it often come up, especially with beginner or novice producers. For the most part, this mode of financing works best with small-budget productions intended more as talent

showcases than as mainstream commercial ventures. The amounts that can be raised have historically been lower than first-class commercial productions need and, even then, the most successful offerings have been backed by well-known celebrities or artists.

For a short film or very small-budget movie, crowdsourced funding may be appropriate.

For larger budgets and episodic productions that are intended to have multiple seasons, crowdsources make little sense. Unlike licence arrangements with commercial content providers like TV networks, cable channels or streamers who program returning series, the funding for subsequent seasons of a series is not predictable from crowdsourcing.

It should not be underestimated how skilfully constructed and expertly maintained a crowdsource offering needs to be in order to succeed. It can be a significant draw on the time, energy and resources of the offering company.

Own Resources

The last common source of funding in this list is the option to use either the production company's own cash, resources or production fees to fund a production.

If possible, a production company should avoid investing its cash in the production of its own project (distinct from the initial ideation stage of development). The potential for clouded judgement, conflicts of interest and extraordinary financial pressure make this option fraught with peril. If no other way can be found to fund the production, one must ask whether the production should go forward at all.

The deferral of budgeted fees and/or overhead charges that would otherwise be payable to the production company falls into the same category. That said, it is done countless times. Usually, deferrals are the result of poor initial production planning, inadequate budgeting or unforeseeable circumstances. Therefore, proper development, market research, contract negotiation and a realistic financing plan should make deferrals unnecessary.

If deferred fees or charges are expected to be recouped from future revenues, the other funding parties, especially equity investors, may be difficult to deal with. The negotiation of relative recoupment positions is always somewhat contentious.

Resources such as equipment the company owns, editing suites or cameras for example, are less of a problem for a production, but as with deferrals, the cost of providing

them should be recoverable by the company because they do have a value even if not paid for in cash. This too may be hard to sort out with other funders but perhaps less so if the arrangements are made on fair market values. In any event, the prudent producer will fully disclose such arrangements to all the other funding partners.

Putting It All Together

Table 2.7.2 depicts the same blank financing plan used in Table 2.7.1 now filled out with various sources of financing for an unnamed Canadian project that involved both industry and government funding sources. It has many funding partners, including

Table 2.7.2 A completed sample financing plan for a TV series

	Financing Plan				
Production					
Production Company					
Number of Episodes	10		**Total budget:**	15,070,270	
			Per episode:	1,507,027	
		Season		**Per Episode**	
Source	**Nature of Participation**	$	%	$	%
Space Network	Licence fee	2,517,219	16.70%	251,722	16.70%
Syfy Network	Licence fee	1,462,544	9.70%	146,254	9.70%
FCPTC[1]	Tax credit	798,149	5.30%	79,815	5.30%
OFTTC[2]	Tax credit	3,278,267	21.75%	327,826	21.75%
CMF – LFP[3]	Licence fee top up	2,369,156	15.72%	236,915	15.72%
CMF – EIP[4]	Equity	2,905,574	19.28%	290,557	19.28%
Bell Fund	Equity	55,274	0.37%	5,527	0.37%
International Presale UK	Presale	1,684,087	11.18%	168,411	11.18%
		15,070,270	100.00%	**1,507,027**	100.00%

Footnotes
1. Federal Canadian Production Tax Credit
2. Ontario Film and Television Tax Credit
3. Canadian Media Fund – Licence Fee Program
4. Canadian Media Fund – Equity Investment Program

equity partners, perhaps too many to be advisable. Again, one or two good presales that leave significant exploitable rights to the production company is the ideal target for a well-financed project that should provide a good revenue stream.

Interim Financing

A problem arises once a production is greenlit, personnel engaged and work begun. Immediately, money begins to be spent in large amounts, inexorably. Every week until the production is completed and delivered, there is a payroll to meet, equipment to pay for, foods to serve, vehicles to rent, etc.

However, funding parties will neither pay their entire commitment up-front nor on a weekly or "as-needed" basis. So, one must find a way to make sure that there will be sufficient funding in the bank to cover the projected payables week by week. This is not as fantastical as it may initially seem, however.

Experienced production managers, line producers, assistant directors and production accountants can reliably estimate how much cash will be needed per week from the beginning of preproduction through to final delivery. The business affairs department, having negotiated the most favourable payment schedules possible from funders, can plot the dates when money from the funding partners is to be deposited. Together, they will create a spreadsheet that details the costs per week and compares costs to the cash inflows each week. This is known as a "cash flow schedule" and is a key tool for the financial management of a production. A sample of a partial cash flow schedule showing (in this case) projected monthly payables and the weekly "cash in" contributions from financiers for an episodic dramatic series can be seen in Table 2.7.3.

There will be periods when there is more cash than payables (typically in the early stages when funding begins) and many more weeks when the payables exceed the funds yet available (as production reaches full speed). Funders usually pay after they approve key stages of the production that have already been completed to their satisfaction. Tax credits, grants or subsidies payable by governments may only be paid many months or years after the production has been audited, or "certified", as officially qualifying for the assistance. So, for significant periods of time, the production will need to obtain funds from other sources to cover the deficits. To avoid the real hazard of using the company's own cash to fund those "gap" periods, the practice is to arrange "interim financing".

2.7 Production Financing

Table 2.7.3 A completed sample cash flow schedule for a TV series

TV Series, MTV and CTV-
Detailed Production Cash Flow — In US$

Accts	Category	Budget	Approx. To Date	Prep 18-Jun	Prep 25-Jun	Prep 2-Jul	Prep 9-Jul	16-Jul	23-Jul	30-Jul	6-Aug	13-Aug	20-Aug	27-Aug	3-Sep	10-Sep	17-Sep	24-Sep	1-Oct	8-Oct	Oct.31	Nov.	Dec	Totals	
			Preproduction					*Production*									*Post-Production*								
01.00	Story rights/acquisitions	0																						0	0
02.00	Scenario	553,523	300,000	58,881	58,881	58,881	58,881	2,000	2,000	2,000	2,000	2,000	2,000	2,000	2,000	2,000								553,523	0
03.00	Development costs	0																						0	0
04.00	Producer	806,898	40,000	25,000	25,000	25,000	25,000	41,681	41,681	41,681	41,681	41,681	41,681	41,681	41,681	41,681	41,681	41,681	41,681	41,681	41,681	41,681	41,681	806,898	0
05.00	Director	225,270			18,773	18,773	18,773	18,773	18,773	18,773	18,773	18,773	18,773	18,773	18,773	18,773								225,270	0
06.00	Stars	648,839			54,070	54,070	54,070	54,070	54,070	54,070	54,070	54,070	54,070	54,070	54,070	54,070								648,839	0
	Fringes	248,906	50,000		16,576	16,576	16,576	16,576	16,576	16,576	16,576	16,576	16,576	16,576	16,576	16,576								248,906	0
	Total "A"	2,483,436	390,000	83,881	173,299	173,299	173,299	133,099	133,099	133,099	133,099	133,099	133,099	133,099	133,099	133,099	41,681	41,681	41,681	41,681	41,681	41,681	41,681	2,483,436	0
10.00	Cast	364,868						40,541	40,541	40,541	40,541	40,541	40,541	40,541	40,541	40,541								364,868	0
11.00	Extras	204,587						22,732	22,732	22,732	22,732	22,732	22,732	22,732	22,732	22,732								204,587	0
12.00	Production staff	516,907		25,000	30,000	30,000	35,000	36,879	36,879	36,879	36,879	36,879	36,879	36,879	36,879	36,879	20,000	10,000	10,000					516,907	0
13.00	Design labour	90,565	2,000	5,000	5,000	5,000	5,000	7,618	7,618	7,618	7,618	7,618	7,618	7,618	7,618	7,618	7,618							90,565	0
14.00	Construction labour	295,536	20,000	25,000	50,000	50,000	50,000	10,060	10,060	10,060	10,060	10,060	10,060	10,060	10,060	10,060	10,000							295,536	0
15.00	Set dressing labour	145,200	10,000	10,000	10,000	10,000	10,000	9,467	9,467	9,467	9,467	9,467	9,467	9,467	9,467	9,467	10,000							145,200	0
16.00	Property labour	64,740		2,000	2,000	2,000	2,000	5,749	5,749	5,749	5,749	5,749	5,749	5,749	5,749	5,749	5,000							64,740	0

(Continued)

Table 2.7.3 (Continued)

TV Series, MTV and CTV- Detailed Production Cash Flow

In US$			Preproduction					Production									Post-Production								
Accts	Category	Budget	Approx. To Date	18-Jun	25-Jun	2-Jul	9-Jul	16-Jul	23-Jul	30-Jul	6-Aug	13-Aug	20-Aug	27-Aug	3-Sep	10-Sep	17-Sep	24-Sep	1-Oct	8-Oct	Oct. 31	Nov.	Dec.	Totals	
17.00	Special effects labour	6,721						747	747	747	747	747	747	747	747	747								6,721	0
19.00	Wardrobe labour	116,203		5,000	5,000	10,000	10,000	9,578	9,578	9,578	9,578	9,578	9,578	9,578	9,578	9,578								116,203	0
20.00	Makeup/hair labour	133,111					15,000	13,123	13,123	13,123	13,123	13,123	13,123	13,123	13,123	13,123								133,111	0
22.00	Camera labour	209,066					15,000	21,563	21,563	21,563	21,563	21,563	21,563	21,563	21,563	21,563								209,066	0
23.00	Electrical labour	105,243				10,000	10,000	9,471	9,471	9,471	9,471	9,471	9,471	9,471	9,471	9,471								105,243	0
24.00	Grip labour	101,660					10,000	10,184	10,184	10,184	10,184	10,184	10,184	10,184	10,184	10,184								101,660	0
25.00	Production sound labour	36,360					3,000	3,707	3,707	3,707	3,707	3,707	3,707	3,707	3,707	3,707								36,360	0
26.00	Transportation labour	255,775	10,000	15,000	15,000	15,000	15,000	22,308	22,308	22,308	22,308	22,308	22,308	22,308	22,308	22,308								255,775	0
27.00	Fringe benefits	490,422	7,000	15,000	15,000	15,000	25,000	45,936	45,936	45,936	45,936	45,936	45,936	45,936	45,936	45,936								490,422	0
28.00	Production office expenses	165,447	25,000	10,000	10,000	10,000	10,000	9,494	9,494	9,494	9,494	9,494	9,494	9,494	9,494	9,494	5,000	5,000	5,000					165,447	0
29.00	Studio/backlot expenses	34,650																			11,550	11,550	11,550	34,650	0
31.00	Site expenses	321,122						35,680	35,680	35,680	35,680	35,680	35,680	35,680	35,680	35,680								321,122	0
32.00	Unit expenses	135,929	5,000	5,000	5,000	5,000	5,000	11,770	11,770	11,770	11,770	11,770	11,770	11,770	11,770	11,770	5,000							135,929	0
33.00	Crew travel and living	13,932						1,548	1,548	1,548	1,548	1,548	1,548	1,548	1,548	1,548								13,932	0
34.00	Transportation	245,144	5,000	5,000	5,000	10,000	10,000	23,349	23,349	23,349	23,349	23,349	23,349	23,349	23,349	23,349								245,144	0

(Continued)

Table 2.7.3 (Continued)

TV Series, MTV and CTV- Detailed Production Cash Flow

In US$

Accts	Category	Budget	Preproduction Approx. To Date	18-Jun Prep	25-Jun Prep	2-Jul Prep	9-Jul Prep	Production 16-Jul	23-Jul	30-Jul	6-Aug	13-Aug	20-Aug	27-Aug	3-Sep	10-Sep	Post-Production 17-Sep	24-Sep	1-Oct	8-Oct	Oct 31	Nov.	Dec	Totals	
35.00	Construction materials	107,670	20,000	20,000	15,000	15,000	10,000	3,074	3,074	3,074	3,074	3,074	3,074	3,074	3,074	3,074								107,670	0
36.00	Art supplies	17,010	2,000	1,000	1,000	1,000	1,000	1,223	1,223	1,223	1,223	1,223	1,223	1,223	1,223	1,223								17,010	0
37.00	Set dressing	154,350	25,000	25,000	25,000	10,000	10,000	6,594	6,594	6,594	6,594	6,594	6,594	6,594	6,594	6,594								154,350	0
38.00	Props	67,950					7,000	6,772	6,772	6,772	6,772	6,772	6,772	6,772	6,772	6,772								67,950	0
41.00	Wardrobe supplies	113,850		15,000	10,000	5,000	5,000	8,761	8,761	8,761	8,761	8,761	8,761	8,761	8,761	8,761								113,850	0
42.00	Makeup/hair supplies	1,800						200	200	200	200	200	200	200	200	200								1,800	0
45.00	Camera equipment	147,155						16,351	16,351	16,351	16,351	16,351	16,351	16,351	16,351	16,351								147,155	0
46.00	Electrical equipment	240,254						26,695	26,695	26,695	26,695	26,695	26,695	26,695	26,695	26,695								240,254	0
47.00	Grip equipment	60,919						6,769	6,769	6,769	6,769	6,769	6,769	6,769	6,769	6,769								60,919	0
48.00	Sound equipment	33,382						3,709	3,709	3,709	3,709	3,709	3,709	3,709	3,709	3,709								33,382	0
49.00	Second unit	5,820						647	647	647	647	647	647	647	647	647								5,820	0
50.00	Second unit LA shoot	51,760									51,760													51,760	0
51.00	Production laboratory	192,964						21,440	21,440	21,440	21,440	21,440	21,440	21,440	21,440	21,440	55,000							192,964	0
	Total production "B"	5,248,072	146,000	178,000	203,000	203,000	263,000	453,740	453,740	453,740	505,500	453,740	453,740	453,740	453,740	453,740	55,000	15,000	15,000		0	11,550	11,550	5,248,072	0
																									0

(Continued)

Table 2.7.3 (Continued)

TV Series, MTV and CTV-
Detailed Production Cash Flow

Accts	Category	In US$ Budget	Preproduction Approx To Date	18-Jun Prep	25-Jun Prep	2-Jul Prep	9-Jul Prep	Production 16-Jul	23-Jul	30-Jul	6-Aug	13-Aug	20-Aug	27-Aug	3-Sep	Post-Production 10-Sep	17-Sep	24-Sep	1-Oct	8-Oct	Oct 31	Nov.	Dec	Totals	
60.00	Editorial labour	203,175						14,513	14,513	14,513	14,513	14,513	14,513	14,513	14,513	14,513	14,513	14,513	14,513	14,513	14,513			203,175	0
61.00	Editorial equipment	76,518						5,466	5,466	5,466	5,466	5,466	5,466	5,466	5,466	5,466	5,466	5,466	5,466	5,466	5,466			76,518	0
62.00	Video post-production (picture)	141,809										28,362				28,362		28,362			28,362		28,362	141,809	0
63.00	Video post-production (sound)	130,500										26,100				26,100		26,100			26,100		26,100	130,500	0
66.00	Music	382,215	50,000			100,000		100,000						50,000				50,000			32,215			382,215	0
67.00	Titles/opticals/stock footage	60,000															8,571	8,571	8,571	8,571	8,571	8,571	8,571	60,000	0
	Fringes	43,355						3,097	3,097	3,097	3,097	3,097	3,097	3,097	3,097	3,097	3,097	3,097	3,097	3,097	3,097			43,355	0
	Total post-production "C"	1,037,572	50,000	0	0	100,000	0	123,075	23,075	23,075	23,075	77,537	23,075	73,075	23,075	77,537	31,646	136,108	31,646	31,646	118,323	8,571	63,033	1,037,572	0
70.00	Unit publicity	900						900																900	0
71.00	General expenses	60,324						4,309	4,309	4,309	4,309	4,309	4,309	4,309	4,309	4,309	4,309	4,309	4,309	4,309	4,309			60,324	0
	Total other "D"	61,224	0	0	0	0	0	5,209	4,309	4,309	4,309	4,309	4,309	4,309	4,309	4,309	4,309	4,309	4,309	4,309	4,309		0	61,224	0

(Continued)

Table 2.7.3 (Continued)

TV Series, MTV and CTV-Detailed Production Cash Flow

In US$

Accts	Category	Budget	Approx. To Date 18-Jun	Prep 25-Jun	Prep 2-Jul	Prep 9-Jul	16-Jul	23-Jul	30-Jul	6-Aug	13-Aug	20-Aug	27-Aug	3-Sep	10-Sep	17-Sep	24-Sep	1-Oct	8-Oct	Oct 31	Nov.	Dec.	Totals
			Preproduction				Production										Post-Production						
	Deposits																						
	- UBCP		25,000																		(25,000)		0
	- DGC		25,000																		(25,000)		0
	Weekly totals	586,000	311,881	376,299	476,299	436,299	715,123	614,223	614,223	665,983	668,685	614,223	664,223	614,223	668,685	132,636	197,098	92,636	77,636	175,863	11,803	116,264	8,830,304
	Cumulative totals	8,830,304	897,881	1,274,179	1,750,478	2,186,777	2,901,900	3,516,123	4,130,346	4,796,329	5,465,013	6,079,236	6,743,459	7,357,682	8,026,367	8,159,003	8,356,101	8,448,737	8,526,373	8,702,236	8,714,039	8,830,303	
	Financing																						
	Protocol	1,000,000	100,000		100,000		100,000		100,000		100,000		100,000		100,000		100,000		100,000		100,000		1,000,000
	MTV prep	1,656,574				1,656,574																	1,656,574
	MTV	5,074,800						845,800		845,800		845,800		845,800		845,800						845,800	5,074,800
	CTV	1,098,930					366,310								366,310							366,310	1,098,930
	Grand totals	8,830,304																					
	Deficit	586,000	797,881	1,174,179	1,550,478	330,206	559,016	347,439	861,662	681,845	1,250,529	1,018,952	1,583,175	1,351,598	1,553,973	840,809	937,907	1,030,543	1,008,179	1,184,042	1,095,845	0	
	Surplus																						

Expenditures will be reported on a daily and/or weekly basis and compared to budget and cash flow schedule projections to monitor whether the production is proceeding as planned, over or under budget. Simply put, interim financing is a loan (preferably from a recognized chartered bank) that can be drawn down to cover the weekly costs payable throughout production in those periods where production funds are insufficient.

An interim lender will analyse the production budget to ensure it is adequate for the purpose and approved by all other financing parties. It will want to see the financing plan and ensure that the project is ultimately fully funded (even though some contributions may not be paid for many months into the future) and that all components are reliable and/or backed up by fully signed and "bankable" contracts. The interim lender will also need a properly prepared cash flow schedule so that it can see when drawdowns from them are expected.

Interim loans involve costs that the budget needs to absorb. Lawyer fees for both the bank and the production company's counsels need to be covered as does interest on the loan until repayment. Altogether, a very substantial portion of the budget may be eaten up with financing-related fees. It is important to adequately prepare for that at the earliest stages of budget preparation to avoid unwelcome surprises.

The security that the lender is lending against (apart from the track record and sometimes corporate and/or even personal guarantees by principals of the production company) is the basket of binding contracts between the production company and its financing partners. The financing plan will lay them out. Bank lawyers will review every contract and ensure that the expected funds are reliable. These contracts clearly need to be signed and sealed before preproduction begins to avoid major speed bumps in the interim financing process or, worse, stoppages of work due to insufficient funds on hand.

Once the bank is satisfied that the funding contracts are all in good order, it will require that they be "assigned" by the production company to the bank. This means that the production company will declare that all payments be paid to the lending bank and deposited into its account. That bank account is what the production company will use for all inflows and outflows of funds related to the production.

As additional security, the bank will take an assignment of the copyright to the production from the production company. Like a mortgage, it will entitle the bank to seize the project and take whatever steps it deems necessary to make sure its loan is paid off with interest, bank fees and a solicitor fee as well.

2.7 Production Financing

To add to its already extensive collection of protections, the bank will limit the total amount of the loan to potentially 85% of the total of all outstanding financing contracts. This is intended to protect its downside exposure in the event of default but also to provide room for interest and fees to be paid to the bank out of the total funding. So, the production company generally does not get paid unless and until all costs are in and the bank taken care of in full – another reason to avoid using fee deferrals as production financing.

There is one more important requirement that a bank providing interim lending will often impose – a "Completion Guarantee or Bond".

Completion Guarantees or Bonds

A completion guarantee is like an insurance policy that ensures that in the event of certain unforeseen circumstances such as large-budget overruns, serious delays or mismanagement of the project, a production can be completed as close to on time and on budget as possible. It is provided by a handful of very experienced companies that are trusted to take over productions which are in trouble or, if takeover is not feasible, to pay back the investors', licencees' or lenders' outlays.

A completion guarantee is required by major funding partners, government funding agencies, investors and lenders much of the time. In fact, each of those participants will be named beneficiaries of the guarantee so that if the production is unable to be completed their investments are protected ahead of any others. Any beneficiary that feels like their investment or loan is in serious jeopardy or the production is in danger may call on the guarantor to take over.

The cost of a completion guarantee is required to be contained in the production budget. It may amount to as much as 3% of the budget in some situations. That is significant and should not be overlooked in the budgeting process.

More experienced producers with established track records of responsible productions may be allowed to post bonds instead of completion guarantees. A bond is a substantial amount of funds, frozen in a bank account or held in escrow, that can be used by investors to cover cost overruns or released back to the production company once all is completed and sorted out.

Stress

Financing a production is never easy or straightforward. Even in the simplest case of a single funding source such as a studio, the pressures of accurately forecasting costs, managing expenditures and scheduling are hard to balance. Add to that the critical importance of making sure that the funding is there when needed and without fail.

Then, there are the hazards of allowing one's passion for a project to affect one's judgement. Pushing forward to early, or despite warning, signs can lead to disastrous consequences. Overspending to improve a creative vision that is not counterbalanced by savings elsewhere can cause hazardous panic and mistrust.

Clearly, it is existentially important to have professional and expert help in planning, negotiating, supervising and maintaining all the financial aspects of content production from the earliest concept to final delivery of the end product. The more a project seems calm and under control, the higher the level of trust and confidence from funding sources. Conversely, nothing makes a producer's job more difficult than when the funding partners lose confidence and fear for their investments.

Summary

Well-planned strategies for financing the development as well as production of projects are critically important for the financial health, profitability and the valuation of production companies. A properly conceived development plan will focus on concepts that suit marketplace demands, fit market opportunities and match the corporate profile and goals. It is advisable to minimize the internal cost of taking concepts to pitch stage as these costs are not usually recoverable by the company. Successful pitches lead to development deals. Adequately funded and cleverly devised development plans, with the appropriate partners who contribute development funding, enhance the likelihood of projects going forward into production. A production budget must be carefully created to anticipate all desirable elements and costs of production including legal, accounting, banking, interest and completion guarantee charges. Once greenlit, a financing plan for the project should be as simple and realistic as possible, designed to provide adequate funding for the manufacture of the program to expected specifications and quality. The financing plan should be designed to maximize funding and minimize the rights, ownership interests and profit participations that are given up in

2.7 Production Financing

exchange. Proper matching of cash outflows and inflows with the benefit of interim loans, if necessary, will result in a smoother and more efficient production process and thus a better quality and more profitable end product.

Questions

1. What is Plotnik's curse?
2. What are the stages in the development process?
3. Who covers the cost of ideation?
4. If one has the money, why not pay for all development oneself?
5. What is the most desirable source of production funding?
6. Explain the reason for the answer to question 5?
7. Which is better: a high distribution guarantee with high fees or a low one with low fees?
8. What is a cash flow schedule for a production and what key information does it contain?
9. What is an interim loan?
10. How do lenders to productions ensure that they are paid back?

Note

1 See example of Canadian Content Rules in Appendix 2.

Chapter 3
Starting Up

Equipped with broad knowledge of the fundamental legal and financial underpinnings of the commercial-grade content industries, one can begin the process of determining how, when, with what and with whom a content production business can be set up. Some relevant factors about the content industries in general are important to keep in mind. Foremost is the nature of risk which is embedded in the industry. Competitive content is costly and time-consuming to produce. It requires considerable experience, skill, artistry and judgement. In a marketplace crowded with products on proliferating outlets, content requires considerable marketing and promotion as well. Although data analysis of the content industries is increasingly detailed and accessible, there is never a guarantee that any one project will succeed over another. High risk is inherent in every decision and project. The financial and reputational risks have significant consequences. Every year, there are just as many surprise hits as there are surprise bombs. Careers can be made or unmade overnight.

For creators, providers or exhibitors of content, the mitigation of risk is an inevitable concern. The establishment of trust and confidence between creators and exhibitors (channels or streamers) and likewise between exhibitors and their direct customers (the audience) is crucially important. Outlets which commission competitive content from creators have large amounts of money at stake that they must invest wisely. They must maintain their reputations as an engaging destination of content among their viewers.

For new entrants into the content supply sector, building confidence in a company's ability to create affordable, well-received and popular content is an existential necessity. Building and maintaining that reputation should guide the set-up of a new content organization in both its strategic and operational plans. The "image" of a supplier as honest, talented, trustworthy, responsive and a reliable supplier of successful content is paramount. So is its reputation for being well informed about current and emerging audience patterns, preferences and behaviours. That stature in the marketplace is key to a production company's ability to gain access to decision-makers who might commission products. It increases the chances of getting projects greenlit on an ongoing basis.

DOI: 10.4324/9781003379737-4

When Is the Right Time?

Starting up a production company too early can be fatal. It could take years for an unknown entity to be considered a safe, let alone a desirable supplier to established channels, services or studios. Investors in the company would be hard to find without projects in production or in the pipeline. Additionally, the startup capital that investors or the principals themselves would provide is rarely enough to last more than three years without concrete results and/or positive-earned revenue.

Track Record

The prime time to launch a production company is when one's positive forward momentum as a creator has reached an optimal level. That time is when one is connected in important ways to a project or, better still, several projects that have attracted industry attention either because of their quality, popularity or profitability. In other words, when one has developed a good track record. Connection to flops is a bad track record.

Quality, popularity and profitability are very separate things although they may seem to be intertwined to a lay person. Quality speaks to how well made the project is from an industry insider as opposed to a consumer point of view. Popularity goes to the size of the audience or the amount of attention the project receives in the consumer sector of the marketplace through conventional media, social media or word of mouth. Profitability is when the project's earned revenue in the marketplace exceeds its costs of production, distribution and marketing. No one factor is necessarily dependent on another as each factor may be present in a project without any of the others.

The kind of track record that most often leads to success is where a few projects that the principals have related to have achieved profitability, popularity and quality all together. A history of profitability alone will often be sufficient to successfully launch a new content company. Popularity alone is sometimes enough. Quality alone rarely is. The optimum track record is when one's productions combine all three.

The principals behind a new content company need not necessarily have been producers to take advantage of the track record of their previous projects. They ought to, however, have played demonstrable or well-known key inside roles. As we have seen, official producer-type credits are not, in themselves, determinative. Extreme care should be taken not to mislead others about one's real involvement in a project,

although it is common in the industry but often backfires. Often, industry insiders do have access to or already know who was of key importance to a project's success and who was not.

Of course, having been the originator of a successful project and having overseen its development, financing and production is the best form of track record. Clearly this is a bit of a "chicken and egg" conundrum. To have a good chance to successfully launch a production company, one must have already successfully produced a triumphant project or two. The traditional career path, therefore, is for aspiring producers to work their way up the chain of production until they have achieved the personal reputation and market value that justifies the creation of a production company. One often begins as an intern or trainee at an already established and successful production company and gets increasingly involved in as many aspects of the production process as possible. This kind of experience is more impressive than simply having worked in the crew of a production or two, regardless of the roles. It is the corporate experience that is essential. Exposure to, or better still, active involvement in all the key departments of a production company is the optimal experience.

Working one's way up the ranks in a large production company or a vertically integrated company that handles distribution, exhibition and production may theoretically afford a wider learning experience. It will, however, take longer, involve more politics and include more obstacles for one wishing to move up and/or across departments. Smaller companies, particularly those which have had success in the market sector in which one aspires to work, may afford quicker paths to learning and possibly greater hands-on experience.

Either way, having worked in ideation, pitching, development, financing, production, distribution, marketing and exhibition, one brings the requisite arsenal of skills to a new venture. As a result, the new company will more likely be considered worth hearing out, working with, financing or commissioning product from.

Connections

While adequate financing, a track record, valuable intellectual property rights and a high profile are all essential components of the startup capital of any new production company, a wide range of connections to key players in the industry is the most essential. The kind of trust and confidence that underpin orders for content or commissions of

new projects and the commensurate amount of financing and risk come from the very personal judgement of the actual persons who make the order. Having the trust of the right people in the right places with the right influence or authority to back your project is more important than anything.

From the very beginning of one's career, whether that be in school, university on a set in a corporate setting or at a festival, the cultivation of relationships is the greatest contributing factor to successful careers. The cliché goes: "a producer is someone who knows a writer". That can and should be expanded to include every possible category of person involved from top to bottom and across the content industries whether in production, financing, law, business, distribution, exhibition (by any means), journalism, marketing or facilities, whether at home or abroad. The most successful producers seem to know everyone.

This is a tall order indeed but no exaggeration. One must be determined to be as deeply and broadly connected as possible, not just at the beginning of one's career but throughout it. One must never stop the process of acquiring and maintaining those connections. "Out of sight, out of mind" is another reliable adage for any producer to keep in mind. Attendance at the right restaurants, watering holes, industry functions, festivals, conferences, markets or other gatherings becomes a way of life for successful producers.

It is obvious that the time to launch a production company should be when one's set of relationships in the intended sector is sufficiently robust, reliable and willing (or, better, enthusiastic) to do business with the new entity.

Stay in touch, follow up, maintain up-to-date records and set up meetings, in person whenever possible to keep relationships strong. Arrange meetings over coffee, breakfast, lunch, dinner or drinks on a regular basis, especially with people likely to rise the ranks. Social media apps are useful but no substitute to shaking hands, sharing a real-time experience or looking eye to eye. This all takes a lot of sustained effort and may often draw one out of one's comfort zone. The reality is that nothing leads to success more reliably than having willing champions in your corner.

Market Conditions

The content markets are in a constant state of change, evolution, fragmentation and consolidation. One blockbuster hit can change strategic plans across sectors, media

and business practices around the world. One new development in technology can create entirely new genres of content or redefine existing ones. The main reason that popular songs developed around an average running time of two and one-half minutes is that Thomas Edison's wax cylinders for the early gramophones could only hold up to about three minutes of content.[1] Composers specializing in ten-minute songs were out of luck! The same phenomenon applies to technological developments in all the content sectors. Formats follow devices. Before streaming content became popular, no one would have imagined that it would make any sense at all to release all the episodes of a TV series at the same time.

One must diligently keep informed about what kind of content is working in the marketplace and in the different demographic and geographic sectors of the marketplace. Genre, subject matter, format, tone and style are all key factors that change over time. Once there is a hit, others will try and replicate its success. When a new device, such as the mobile phone, makes the consumption of content easy everywhere and anywhere, new formats, applications, viewing habits and business structures quickly develop.

One can never be certain whether a phenomenon will become a trend, when it will do so or how or where. It is easier to identify what has gone out of style or become hackneyed or "uncool". Intelligent analysis of changes and developments in the content industries is nonetheless crucial. With continued focus on the timeliest information, one can make intelligent assessments of trends and business cycles and time or delay the launch of a new production company accordingly. When there is a glut of animation for preschoolers, it would be a bad time to launch a company specializing in that kind of content. Conversely, when there is a shortage or a breakout success in that field, it may be a good time. If the marketplace perceives a new supplier as having an edge or advantage of any kind, whether technological or creative or having valuable exclusive proprietary rights, its successful launch will be more likely.

The same considerations apply when different economic models emerge, government subsidies arrive, get curtailed or disappear.

Assess the market's history, its current status and try to predict its future progress to determine when your company's focus, skills, resources, track record and assets are well suited to launch. Enthusiasm to get going, while valuable, should come after a cold hard, fact-based assessment of whether to rush, postpone or carefully proceed to launch.

Market Conditions

Opportunities

The timing of when to launch a production company is often materially affected when one perceives an opportunity – present, short term or even long term. An executive with whom one has developed a close relationship may be promoted to a senior position of authority. The rights to a valuable and potentially explosive piece of intellectual property may be within one's grasp. Key information about the need for a new genre of programming at a streaming company may have leaked.

Perceived opportunities should be carefully considered along with all other practical considerations. They must be verifiable, sustained and make economic sense. Rushing through an open door can lead to danger; delaying may result in the door closing. Notwithstanding all the cautions, the ability to move quickly and decisively on a real opportunity is often rewarding. All of this underscores the great need to be as informed as possible about market developments.

Who Do You Need?

A new production company must have the right personnel to accomplish at least the basic functions that a proper supplier of content needs to cover. Some of those persons need to be internal to the company, while others would either be partially or permanently external. Any mainstream organization that considers a precommitment to acquire content from a production company will want to be assured that the company has all the people, talent and resources it needs, the ability to outsource what it does not have and the capacity to deliver the intended product as expected. Simply greenlighting a great script with a great cast, terrific director and the correct funding does not ensure that the project will be produced properly, if at all. The whole really is greater than the sum of its parts. As in any other commercial context, advanced buyers of content will want to be satisfied and confident that the company they are ordering from has everything it needs to deliver what was bought.

Internal Personnel

Starting at the top, a successful company will have a chief operating officer usually also called a president who is respected and trusted in the industry. Often, this person is one of the founders in a new startup. The president will have final authority over the

business functions of the company, overseeing all departments and financial matters. She will be responsible to and report to the board of directors. In mature production companies, the president may not be an actual producer, but in freshly founded production companies, smaller in size, she usually is.

Another key role for the new production company is a financial officer. This person oversees and is responsible for not only the financial functions of the corporation – its financing arrangements, cash flow, statements and health – but also the proper financial management of each project from development through production to delivery. A mistake made by many startups is to begin with a less experienced finance person such as a production accountant or production manager. While this may save overhead costs, it usually leads to financial mistakes that can be much more expensive.

A properly qualified financial executive is crucial for both corporate and production purposes. As the company moves forward, it will have to satisfy the original sources of startup capital (even if they are the executives themselves) that the finances are run professionally. It will also need to instil confidence in banks, commissioning networks, channels or streamers and often government agencies.

Additionally, the company will need to be constantly on the lookout for new projects, securing rights, developing pitch materials, conducting pitch meetings and attracting writing and other key talents. This is what a development officer does. She also builds and maintains relationships with the development and original production executives in the client organizations that the company may want to do business with – the people at broadcast, cable or streaming channels that commission new projects. These important relationships can and should be developed over time and will need to adapt to changes in personnel at client companies as well as industry trends. Bringing on a development officer that already has solid relationships in the right community is a great start. The time it takes for a novice to get up to the right level and stature in the industry may be longer than a new company can afford. The development officer's role is focussed on the future of the company and ties in closely with the president and chief financial officer.

Another essential role for the internal staff of the company is that of overseeing the daily operations of actual productions that are in progress – helping to create production budgets, financing plans, production schedules, reporting schedules and other logistics. Once the company is in production, this is a crucial responsibility and perhaps too specialized and too big for any of the other executives to handle along with their allocated responsibilities. Clients of the company will be very reassured to know that

Who Do You Need?

there is a dedicated person on staff whose only duty is to make sure that the productions proceed on time, on budget and contain the anticipated production value.

In rare cases, companies may begin with one or two executives combining roles – if they are lucky enough to have persons capable of doing so. With success and as the company grows, the staff will have to grow as well and talented/focussed executives will need to be brought on to take charge in specific areas of responsibility. These may include business affairs executives to handle the numerous and sometimes complicated business negotiations and legal documentation, post-production specialists, technology specialists, marketing experts and data analysts.

External Services

All production companies engage outside lawyers or law firms and accountants or accounting firms. Many also retain public relations firms and recruitment firms. Some may, from time to time, hire editors, special effects artists and/or mentors and business advisors.

At the very least, the indispensable roles of outside legal counsel and accounting firms should be carefully considered. The content industries really do require specialized knowledge, sensibilities and attitudes, and the business practices may be esoteric. The professionals who provide legal or accounting services should be chosen based on their expertise in the sector and their relationships within it.

Agents, Representatives and Talent

Along with the network of buyers and sellers of content, a new production company must cultivate the crucially important community of actors, writers, directors, other key talent and their representatives (e.g., agents and managers).

Mutually respectful and creatively rewarding working relationships with talent are indispensable to the success of a production company. Creative collaboration is an indefinable and amorphous undertaking, much more nuanced than, say, ordering a custom-tailored suit. To get the best work from talent, they must be motivated, supported and guided in a way that makes them proud, fulfils them creatively and enhances their stature as artists. This is best accomplished through a working atmosphere of trust and respect. The best actor, writer or director may perform poorly or even refuse to work on a project no matter how high the salary if they feel the relationship is disrespectful or negative. Conversely, they may take on work at reduced fees if they relish the working

atmosphere. Some may even override the best advice from their agents or managers, just to honour working relationships.

Agents are of more value to production companies than simply negotiating terms on behalf of talent. They are a source of sometimes key information about industry activities in general. They may expose the company to new talent. They may help put various elements together for a project, combining a writer, director and actor in one group that makes a project more desirable ("packaging"). Keeping positive, respectful and balanced relationships with talent agents will always help a production company. Antagonistic, domineering or disdainful relationships with talent agents (which are quite common) will prove to hurt a production company eventually. These relationships are even more critical for new production companies than mature ones and should be the focus of targeted effort, primarily by the company's development and/or business affairs executives.

There is another community of representatives that production companies may work with, especially newly formed companies. These are people who represent the company itself. They may define opportunities for the acquisition of intellectual property, introduce potential coproduction partners, financing sources or unexpected distribution or licensing outlets for the company's product. Individuals who are well connected in specific niches of the marketplace such as corporate representatives (who are often freelancers) can be a valuable source of the new projects and revenue streams that companies need to maintain momentum and growth. Care must be taken, however, to make sure that they are not acting on both sides of a deal, do not have a conflict of interest, deliver what they propose and have good reputations. In all cases, the terms of their authority, ambit of operation, compensation and participation in the production should be clearly negotiated and documented in properly drawn up legal agreements.

What Do You Need?

The time may be right and the right group of people may have come together but more is needed for the new production company to be well equipped to succeed. Just as a car needs enough fuel to get to its destination, a new production company needs the right amount of money, assets and facilities to operate until its activities create revenue streams that can sustain its operations. First and foremost, a new production company needs enough money to fund the day-to-day activities that will lead to having projects produced.

Financing

What will it cost to run all the essential functions of a startup company per year? What salaries will the key executives require? What will it cost to acquire rights, to develop projects or to travel to markets, conferences or meetings with buyers? What kind of office space and equipment is needed? What kind of web presence, marketing and promotion should be created? What are the costs of legal and accounting to set up and maintain the corporation? What other kinds of expenses might the company incur as it proceeds towards its first productions? How many years of similar costs will it take before the company earns more than it spends?

Putting pencil to paper to add up all the foreseeable costs inevitably leads to a frightening number. Frightening because that amount of money should be secured before the company begins operations, and if the company is not successful, that money may need to be repaid or may be lost.

Realism, conservative estimating, disciplined spending and focussed adherence to the company's goals are required to give the new production company its best start. It is a great advantage for the founders to already have properties in development and/or the rights to valuable material in place as the company starts. Even so, consider the time frame of a typical production. It may take a month to work up a proper "pitch" for a project and six more months once a development deal has been concluded to create the required materials. If the greenlight comes from a non-studio buyer, it may take another six months to secure all the production financing. Preproduction may take six weeks, production on a TV series six months, post-production another three months. This comes to almost two years for the company's first production to be completed. Only then might the company earn production fees and overhead cost recoveries related to that project. Distribution revenues may not roll in for another year or more. In the meantime, it has spent two years' worth of startup capital. It is probably, out of pocket, at least a year's overhead. All this is to illustrate the need for careful forecasting and financial planning to make sure that the company has what it needs to survive until it succeeds.

Whether the financing comes from equity investors (which may include the principals or founders), lenders or government grants, it is crucial that there is enough. Cutting corners to harness all available funds is always a consideration but must be done carefully and wisely to avoid handicapping the company. It is important to set the company up with enough and the right kind of financing for success. Struggling to make ends

meet while trying to get projects off the ground is a huge distraction from the dedicated focus it takes to get orders. The struggle often makes producers appear desperate which is not a great selling tool.

Enlisting the help and advice of qualified professionals to create the startup financing plan is key. It must look practical, efficient, realistic and adequate for the company's purposes. If it does not, the financing will either not materialize or will be inappropriate. The structuring of the financing terms must be fair and should not unduly restrict the company's executives to operate as they need to.

Projects in Development

The lifeblood of a production company has two main sources: the first is the slate of projects it has in development which is where new projects come from and the second is the basket of revenue streams that flow from already completed projects. For new companies, the cultivation of a range of market-driven properties in development will take time. Some projects may come from other companies and, therefore, already be in a more advanced stage of development. These will have to be documented carefully to ensure that they are free and clear of encumbrances, especially if a company executive has brought them over from another company that they previously worked for.

If the projects are new, they must fit the company's strategic plan, fit the marketplace trends/preferences and be affordable. Projects that are simple enough to explain in a few words but also have obvious market appeal can usually be developed more quickly. These are good projects to start with. Whether starting from scratch or taking up a project that already has made some progress, the priority for the new production company will be to have enough projects in its slate to balance the odds of rejection and the kinds of projects that can move quickly into production.

Option Agreements

As discussed previously, acquiring options to purchase the audio-visual rights to projects is a cost-effective way for production companies to take on projects without having to spend the large amounts of money that would be required to purchase the rights outright before there are any interested buyers of the intended production. The costs of options should be included in the startup financing plan and be adequate to acquire enough options to form a development slate. The associated legal costs also should not be overlooked.

Who Do You Need?

Travel

The benefit of meeting with potential buyers in person, at industry trade markets or, better still, in their offices or home towns cannot be underestimated. As much as business transactions become automated, move online or get conducted remotely, nothing matches the face to face, in-person meeting for effectiveness. So much of the content business is based on subjective, "gut instinct" decision-making that it is essential to meet with as many people as possible. Travel to and accommodation at key industry trade fairs[2] should be budgeted for in the startup financing. So too should follow-up or separate travel to the home bases of key buyers for more directed meetings.

Facilities

It is still important for production companies to have physical office space. Much of the important work is creative and needs the chemistry that occurs when people are in the same place at the same time. Especially for new companies, the teamwork, spirit, enthusiasm and drive that are essential for momentum are optimized by the key initial staff sharing the same physical space. This comes with the usual hardware: computer systems, desks, chairs, internet, and phone service, etc. It is also very useful for the company to have some sort of in-house video production editing or post-production hardware and software even if it's only a rudimentary system for creating pitch materials or product reels.

Actual Case Study

My own career trajectory might be a useful example. Beginning as an entertainment lawyer, I acquired a healthy list of relationships in the content creation, distribution and exhibition sectors. Many of the important producers, sales agents and broadcast executives were well known to me and I to them. I had dealt with most of the talent agents in the industry and many sought-after writers, actors and directors. My first production credits were on films produced by clients who awarded me Executive Producer credit for having been instrumental in bringing their productions to life. Still, it was probably not enough for me to be taken seriously as a producer on my own.

I left practice and accepted an offer to run business affairs at one of Canada's most successful production companies, eventually becoming president. During the three years of my work there, several important films and television series were initiated and produced, and my role as executive producer was clearly established.

After three years, on the expiry of my employment contract, I was ready to form my own production company. By then, my relationships as a producer were strong with both the Canadian creative community and many important companies and buyers in the United States and abroad. I believed that I could get projects into production relatively quickly and had enough resources to last two years.

To my surprise, a very good friend, extremely connected in other sectors of the content industry, insisted that we start the production company as partners. By the end of the first year of operation, having travelled to the key trade fairs and to New York and Los Angeles to meet with potential buyers and coproduction partners, the company had three movies for television financed and ready to shoot. Two were co-productions with a New York producer for an American television network. The third was a direct-to-video movie that sprung from a spontaneous pitch to an American home video executive I had been introduced to for the first time at that night's dinner table. All three productions qualified as Canadian content.

Perhaps more importantly, by the end of our first year, we had acquired an option to purchase the television rights to a best-selling series of books for kids that eventually became one of the most watched children's live-action series in the world. Being lucky enough to secure the rights to a hit in one medium that can be adapted successfully as audio-visual content for the screen is a terrific springboard to success. It leads not only to a lucrative revenue stream but enhances one's reputation as a winning creator of content.

What does this illustrate? What lessons can be learned?

Who Do You Need?

Questions

1. What is a startup production company?
2. Who should be involved?
3. What is a good time to launch?

4. Can one person do it alone?

5. What does the new company need?

6. What are the first steps?

7. What does a successful launch look like?

8. How much time does it take to become successful?

9. How much money does one need?

10. What does one need apart from financing?

Notes

1 See: https://www.loc.gov/collections/edison-company-motion-pictures-and-sound-recordings/articles-and-essays/history-of-edison-sound-recordings/history-of-the-cylinder-phonograph/

2 See Appendix 4: List of Media Conferences.

Chapter 4
Basics of Business Plans and Operating Plans

When I was ready to start my own production company, one of my favourite people in the world gave me this advice: if you want to be a successful producer, you need to make a key choice about whether to be big or to be small. If you choose to be big, you must keep getting bigger and never stop until you are the biggest there. If you choose to go small, you must keep getting smaller and never stop until you are working out of your shirt pocket.

Of course, this is an oversimplification even though it does describe the majors, on one hand, and the small independent producers, on the other hand. There is no hard-and-fast rule to follow or binary choice to make that guarantees success. There is also plenty of room for middle-sized companies to thrive if they are properly prepared.

The adage does, however, point to a number of important issues. Firstly, the need to have a sound business plan. Oftentimes, people are so enthusiastic about embarking on a career as producers that they are not as careful or thoughtful as they could be. Perhaps they have just produced a first success or have a project that is gaining positive momentum and are in a rush to get going. Regardless of the circumstances, it is crucially important to have a considered business plan or business strategy. Although this book is not intended to cover the newest, best practices for devising business plans, it will discuss the basic elements that are relevant for business plans in the content industry.

The second issue that the adage highlights is that there is no one path to success for anyone. One's career path as a producer (or any other profession) is determined by one's choices. Those choices may be affected by circumstances beyond one's control or they may result in unexpected outcomes of the options one has taken. Either way, a well-considered strategy for a new production business will result in an enormously useful roadmap.

The third issue is that the adage begs the question of what defines "success" as a production company. The answer is personal to each individual. Money, celebrity, messaging and creative fulfilment are key motivators, but success comes from the thoughtful combination and proportion of each goal tailored to the life plan of each individual.

DOI: 10.4324/9781003379737-5

The Utility of Business Planning

Every good business plan in any industry should begin with a starkly honest and objective self-analysis of each of the principles. Each one should answer for themselves, without self-deception or guile, who they are as a person, what they are good at, what they plan to do in the business, how they plan to do it and with and for whom. This will lead to a corporate profile and even a corporate mission. It will guide what kinds of projects are undertaken, for what reasons and in what sectors. It will provide everyone in the company with a shared focus.

The corporate goals thus articulated will be an invaluable resource for not only the members of the company but also for spouses, potential investors, lawyers, accountants, potential partners, government agencies, bankers, even landlords and suppliers. The company will stand for something, have a personality, follow operating principles and its image will be clearer and usually more respected. This is different from a marketing tool, and it will be dangerous if it becomes one. The failed companies that "believed their own public relations", meaning that they overpromoted themselves and relied on their own hyperbole, are too numerous to count.

A business plan represents the best forecast of the near future of a company – its first few years – and its near-term expectations. It will recognize and channel the respective strengths and weaknesses of the key personnel and harness their efforts in the most effective way.

The plan should be in writing; however, it will not be immutable. It must exist in the real world and balance emotion with objectivity. It will need to adapt to new developments, mistaken assumptions, changing market conditions and many other unforeseen occurrences. It must be reviewed from time to time and be flexible enough to change with the times. Creative disruption is ever present in the content industries. The only constant is change.

The plan will indicate what achievements are expected in the first few years, what resources (financial, human and practical) will be necessary to reach those achievements and when the company will earn at least revenue to be able to pay for its ongoing overhead costs ("breakeven") or better still earn a surplus and become profitable. The startup principals, investors, key employees, bankers and perhaps government agencies will find this to be crucial information. It will be important to measure actual performance of the company against those forecasts and timelines. Will the company

have enough money (or "runway") to pay its operating costs until it becomes profitable (or "takeoff")? Alternatively, will it run out of funds and have to raise more?

Important questions that the business plan should address are as follows:

- What relationships does the company have that may be of the most value or help?
- Who are the most appropriate buyers to target?
- What kind of product will the company stand for?
- What style, tone and image will be associated with the company?
- Who are the competitors of the company?
- Who is selling the same kind of show to the same buyers?
- What is competing for the attention of audiences with the company's product?

The Profit Motive

It is crucial to keep in mind that the goal of any company is to make a profit. The goal of a successful production company is to do so by making a product that is popular with viewers. It is not sufficient solely to make a critically acclaimed, well-received or creatively satisfying product. All too often, the elation that comes from having a project greenlit takes over and clouds judgement. There is a temptation to continue on with a project that may not earn fees or revenue or may even require a risk investment from the company rather than cancel a production and suffer the emotional disappointment. Ignoring the imperative to make money on each production is a perilous mistake. Companies may have fantastic projects, but they will cease to exist if the projects do not generate revenue.

The Four Basic Ways Content Production Generates Revenue

Production Fees

All content production budgets contain allocations of fees to the production company or individuals employed by the production company to compensate them for their work in producing the show. The budgets will typically also provide for the production company that has developed, initiated and financed the show to recover reasonable corporate or

overhead costs that relate to the specific production. Those companies will also own or co-own the intellectual property rights in the finished production and benefit from the resulting royalties.

Service production is production by contract. A production company is hired to physically manufacture a project that another entity has developed and financed. The hired company is paid a negotiated fee for its services and, generally speaking, is not entitled to any ownership of the finished product nor a share of any revenue generated by the project. A production company may have as its business purpose the goal of subsisting exclusively on service contracts. There is little risk as the financing is supplied by others, but there is also limited reward as the fees need to be competitively low. For that reason, service companies need a high volume of projects to generate significant revenue. "Output deals" by which large volume content companies like studios agree to engage one company to service many productions in order to provide service companies with steady work and reliable income.

Distribution Revenues

As discussed in greater detail throughout the rest of this chapter, it will be to the company's benefit to ensure that the financing of a production does not give away all the exploitable rights of the end product. Sufficient rights should be retained so that the production company can control, exploit and turn them into cash (Figure 4.1).

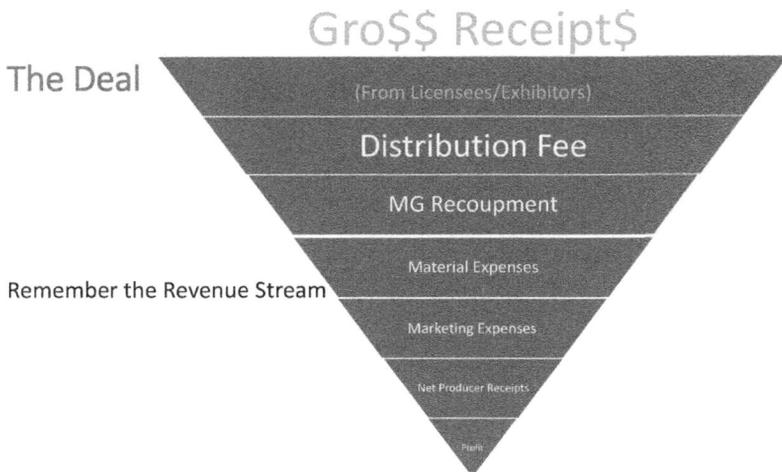

FIGURE 4.1 Distribution revenue stream. Graphic by author.

If, once the project is financed, the rights to license it in certain territories remain unspoken for, or rights to exploit the project in certain media or windows of time have not been given up, the money that can be generated from those unexploited rights may be very significant indeed. These revenue streams may go on for years into the future. Whether these transactions are done in-house by the production company or through third-party distribution companies, they represent the lifeblood of cash flow and profitability for production companies. The business plans of companies that intend to develop, finance and produce their own projects should ensure that as many exploitation rights to a project as possible are retained and controlled by the company.

Ancillary Revenues

Unlike distribution revenues which are derived from the licensing of the finished program itself to exhibitors, channels or viewers, ancillary revenues are derived from what is commonly known as spin-off rights. These are forms of intellectual property that have arisen or may be created based on the copyright of the initial project. An example would be toys based on an animated movie or a video game based on a television show. The children's content market in particular is well known for having value based primarily on the toys and other merchandise that can be developed, adapted or devised from programs. These kinds of transactions, licences to exploit characters, designs or other creative elements may be conducted by special staff within the production company or may be done by third-party licensing agents who specialize in the field and receive a commission. Either way in many cases, the value of merchandising and licensing of rights can dwarf the value of licences of the underlying movie, or television show. This revenue stream potential should be given serious consideration in every production company's business plan.

Library Value

The reserved rights that a production company owns in its productions and the ancillary rights that go along with them are often referred to as the "library" of the company. These rights in the library, or catalogue, of the company can be valued based upon the estimated amount of revenue they might generate over the lifetime of the product. When production companies merge, buy or sell each other, it is the asset value of the library that represents the bulk of the price paid. Business plans should develop a strategy for building as high a value for the company's library as possible.

The Four Basic Ways Content Production Generates Revenue

This will afford an exit path if they ever wish or have to give up the company. Their share of ownership in the company will be worth primarily what their share of the library value is.

Operating Plan

Production companies are like any other company except that their industry has a high profile and their products, although they may be very expensive to make, cannot be predicted to fulfil expectations. An aeroplane may cost 10 million dollars for a manufacturing company to make, but it is always expected to fly. A drama series may cost the same amount to make but will more often than not fail to achieve the desired audience. Nonetheless, both are design and manufacturing companies. Traditional operational planning for a content production company can follow similar organizational principles.

People

At the heart of any production company is its people. It is hard to think of an organization (other than perhaps a sports team) where the chemistry and complementary skill sets of the personnel are more integral to its operations and success. The entire staff must be chosen with that in mind.

The chief executive is in charge of overall corporate functions and responsible for ensuring that the company achieves its goals. Accordingly, that person must be fully engaged. Too often, especially in smaller or newer production companies, the president is also an executive producer and heavily involved in each of the productions. That divided focus risks leaving crucial corporate functions unsupervised. The president must establish key performance indicators for each department and see that they are met.

There must be a clear reporting structure in each company. Do each of the heads of development, finance production and marketing report directly to the president? Does the company need a vice president to filter matters for the president?

The president must ensure that the corporate culture is established and maintained. Enthusiasm for projects is essential in content production companies but can be dangerous if it clouds judgement. Often, too much time and too many resources are wasted

on projects that will not gain traction. The team should be ready to go all out for a project that is close to succeeding but equally prepared to abandon a project that is rejected by the marketplace.

It is important to recognize when personnel need training, education, exposure to the industry or support. Sending staff members to conferences, trade fairs, festivals, markets or other industry events like award shows not only builds morale, but it raises the profile of the production company and provides valuable information and learning to the employees.

Structure

Production companies, as we have seen, divide into definable departments. Each should be transparent to the other so that every department knows what is happening throughout the firm. An overview of some of the common and most important departments within production companies follows.

Project development is one such department. In this department, staff members identify market needs or opportunities and acquire or create materials that can be introduced to potential buyers. The hope is that an interested buyer (network, channel or distribution company) may want an exclusive right to develop the intellectual property to a stage where it can clearly be assessed as eligible for a "greenlight" into production. This is the development deal we saw in an earlier chapter.

In this respect, it should be noted that the corporations that commission or initiate the bulk of mainstream content are television, cable television and streaming channels/movie distribution companies. In each of those "buyer" companies, there are two complementary departments – original production and acquisitions of existing products. Most relevant to the development department within a production company are the buyers' original production divisions which are set up to receive, evaluate, option and develop projects that might be valuable additions to the buyers' inventory.

The development department should have the right personnel – individuals with the taste, acumen and relationships to attract the key original content executives at likely buyer organizations and match projects with the right creative, writing, animating or design talents. It must be constantly harvesting market data, rising talents and trending genres as well as receiving submissions of new projects, properly assessing them, identifying and securing those that suit potential buyers. There must be a clearly

defined line of authority for how projects are undertaken and for how projects are rejected. Is the head of the development department required to seek approval from the president before securing rights or can she operate on her own as long as she is within her proscribed budget? Are they good at selling?

Finance is another key department within the production company structure. It is responsible for setting the overall operating budget of the corporation, allocating portions of that budget to each department in consultation with the president, ensuring that the cash flow needs of the corporation are managed without interruption (with appropriate bank loans if necessary) and preparing the financial statements and reports for the corporation and its accountants or auditors.

As in other companies that undertake large individual projects, the finance department will also be integrally involved in budgeting the production costs of greenlit projects and ensuring that they are financed in an appropriate and cost-effective manner. Once in production, the finance department will be in daily contact with the internal accounting department of each production to ensure that cost reports flow regularly and that production proceeds on time and on budget.

Another major role for the finance department is monitoring the sales reports from distributors (either internal or external) of finished projects that the company has in distribution in the wider marketplace. Checking statements from distributors, challenging reports that may be inaccurate (a frequent occurrence) and collecting monies that are overdue (also a frequent occurrence) are very important duties and may make the difference between a company making a profit or a loss in a given year.

Business affairs negotiates routine documents, structures commercial arrangements and advises the senior executives on best business practices. This department will attempt to keep the expensive fees of outside counsel to a minimum. It will have to engage its law firm for larger deals such as investor or bank financings.

As the primary deal-making entity for the corporation, the business affairs executive(s) must have superior negotiating skills. Effective negotiators will have a very clear understanding of what they need to obtain and what their counterparts need to obtain. They will also need to know what they are prepared to give up or pay/concede in return and have as accurate an idea as possible of the same for the other side. Negotiations should at all times be respectful, cordial, collaborative and constructive. They should not be overly aggressive, intransigent, one-sided or imbalanced. It is very hard to make effective, productive and fruitful agreements in the content industry, but it is extremely

easy to derail them if they were not negotiated fairly in the first place or if the respective parties no longer get along.

Marketing and distribution for mature companies may generate enough cash flow to sustain annual operating costs. Much more on monetization of rights will be discussed in a later chapter. For this section, it is important to reflect on the general function and type of people in this department.

Often linked together, marketers promote the corporate image and mission in the wider marketplace as well as the projects that the company produces while the distribution staff oversee and manage the exploitation of rights to finished productions where the company has retained enough rights to monetize. In larger companies, both may be separate in-house departments. The distribution team may sometimes be an income-driving part of the company representing its own projects as well as those of other producers in the global marketplace. In smaller or newer companies, the marketing function may be outsourced and the distribution function may be assumed by the finance and business affairs departments working together.

Process

Care must be taken for the processes of the company to be regularized, efficient, result oriented and measurable. As we've seen above, it is crucial for each division to be transparent. The content industries are highly changeable and prone to gossip, information and hyperbole. Transparency is an antidote to distrust, disbelief, unhealthy rivalry and divisiveness within the company. As a corollary to transparency is the need for that company to operate from the same sets of financial numbers, reports and metrics. Decision-making must be clearly defined and not overruled or bypassed. The standard for the quality, completeness and timeliness of work, whether it is in the form of assignments due within the organization or matters to be delivered to outsiders must be clear, professional and scrupulously maintained. Exceptional efforts must be acknowledged and rewarded. Exceptions must be objectively supportable and explained.

All these principles, if followed, build the reputation of the production company and that reputation is in many respects its most valuable asset. How efficiently, professionally and openly the company's staff deals with each other and outsiders determines its status as a preferred supplier in the marketplace. This all may seem self-evident, but the proportion of companies that crumble because of the breakdown

Operating Plan

of their processes is very high. The pressures that come from rapid success or struggle can lead to the deterioration of morale, discipline and adherence to the company's processes. Once the processes dissolve, it is very hard to get the company under control again.

Information

Data gathering procedures, techniques and formats are advancing at an ever-increasing rate. More than ever before, information is available about how consumers use content. One can obtain data about the number of downloads of an episode, how many minutes were watched, when they were watched, where and how. Sophisticated sources of information will continue to be available. Artificial intelligence-driven story writing is already available to consumers and will become increasingly effective. Therefore, mining information about customers, audiences, buyers, distributors, consumer electronics manufacturers, artists, trends, social norms and historical content performance is an essential function in modern production companies. Simply "going with one's gut" about a project (although it may be just as successful) will not be sufficient to persuade a buyer's original production executive.

Modern production companies will also need data about how their own projects are performing with buyers and audiences all over the world. A show may be a breakout success in one country but not in others. The successful country would be a good place to pitch a sequel.

All sectors of the operational plan — who the company recruits and appoints, what their skill sets are, how they work together, for what purpose, based on what information, on what timeline and with what authority — need to coalesce into one concerted endeavour guided by the strategic goals of the corporation, its market advantages and the opportunities it pursues. The earlier a production company establishes a comprehensive plan, the better it executes that plan and the better able it is to adjust the plan to accommodate disruption, the more successful it will be.

The Creative Process

A distinguishing factor of a production company's reputation is its respect for and management of the creative process. This is what leads to the all-important attractiveness to both talent and buyers alike that a company needs to become a player. When a com-

pany is known to be a supportive, fulfilling and rewarding place to work, more members of the talent community will bring the company their projects and, as a result, more buyers will be impressed and motivated to do business.

There are dozens of books, articles, videos and courses on how to optimize the creative process. There is no one right or wrong way. It always depends on the mindfulness of the leaders of the creative team, their personal style and their ability to communicate. The following is a list of some basic principles that most successful creative leaders as well as team members adhere to.

1. *They are respectful to their creative staff and colleagues.* Everyone's voice is entitled to be heard in full, without interruption, ridicule or disdain. Enough time should be allotted for every conversation. Rushing through is neither satisfying nor conducive to the best result.
2. *They are sensitive to the particular personalities they work with.* Everyone has their own triggers, hot buttons, fears, insecurities and vulnerabilities. That does not make them inferior or weak. Taking care to understand, being gentle and supportive will lead to better cohesion among the team, better ideas and better work.
3. *Disagreements should be encouraged* not discouraged as long as they follow the above principles. One does not have to be right to have an opinion, but one should have a thought through reason for a point of view and be able to articulate it.
4. *Deadlines must always be met*, time for meetings kept and feedback returned when promised by both the leadership and the team members.
5. *No idea is a bad idea*, no idea is a perfect idea and no one person has all the answers. It should be clear, however, who makes the final decision and when discussion needs to be over.
6. *Credit should always be given when due* and never taken when not earned. Acknowledgements of and expressions of gratitude for work and contribution are the best way to keep creativity flowing and willingness to participate robust.
7. *Healthy competition for ideas, authority and assignments is to be supported* but ego politics, jealous rivalries and personal resentments are to be suppressed as early and often as they appear. This is harder than it seems.

These principles apply equally to working relationships inside the company itself and between the company and third parties. They apply to creative executives representing

buyers. They also must apply to members of the production crews – department heads as well as ordinary craftspeople. Crews treated respectfully and with dignity are happier, more productive and deliver more than they are paid for in production value and quality. The reverse is just as true.

Conflict Management

Any activity that comprises more than one person will inevitably involve conflict. Conflict, in and of itself, is not a bad thing. It is not necessarily something to always be avoided. Proper handling of conflict may actually lead to better results, better projects, better working relationships and more commercial success. This is nowhere truer than in production companies. Their very nature requires a balancing of business and creative values. Passion is a desirable quality in all staff members, but level headedness and sound business judgement are just as important.

Production companies should encourage openness, free exchange of information and clear and relevant communication policies. Collaboration together with accountability are to be supported and encouraged.

An easy-to-understand and simply stated description of the company's definition of success (sometimes referred to as a mission statement) helps to keep everyone aligned to the same goal.

Nevertheless, humans are human. Stubbornness, intransigence, hurt feelings and political rivalry all come into play. Sometimes communication breaks down, trust is eroded and the all-important willingness to work together deteriorates. All too often, the person with the most power or greatest leverage gets his or her way regardless of what is fair, equitable or appropriate. Countless production companies have disappeared as a result of their failure to resolve these kinds of conflicts. Partnerships break up, litigation may ensue.

It is not always possible or even advisable to try and resolve deadlocked or chronic conflicts within the production company itself. Sometimes outside help may be necessary. Professional mediators, trained in the process of resolving conflict in a collaborative way, can be a lifeline. When a production is in progress, the schedule and budget drive decisions. There is no time for the traditional justice system to resolve deadlocks, address impasses or allocate liability. Mediators, especially those familiar with the

creative process and the content industries, can help the parties achieve quick, balanced and effective resolutions to their problems. They can be brought in quickly and at the very least focus the parties on real solutions rather than acrimony.

Actual Case Study

The founding of our company was deceptively simple. We had enough resources to operate on a skeleton staff for two years. That staff consisted of one person (myself) doing the job of development officer, business affairs officer, marketing officer and CEO. By the end of year one, we had three movies greenlit for production. By the end of year three, a television series for tweens was in production that became a worldwide hit. That provided the funding we would need to carry on well into the future and the "track record" that is so valuable in opening doors.

Much of this was luck, but as my partner said at the time: "the harder I work, the luckier I get". A lot of the success though was due to prior relationships, a reputation for reliability and honesty and decades of studying the content market to develop the instinct to recognize a valuable project when it is seen and know who to present it to.

As time went on, it became clear that my partner, who happened to be my best friend as well, was more focussed on other business ventures that were growing rapidly as well. He was less involved and less equipped to contribute to the ongoing needs of our production company. We both felt very badly about the inequity. Eventually, we agreed to part ways in order to prevent the business from damaging our relationship.

What principles does this illustrate or offend? What can be learned?

Conflict Management

Questions

1. Who needs a business plan?
2. When should one make one?
3. What goes into a business plan?
4. Who is it for?

5. Can a business plan be changed?

6. What is an operational plan?

7. What is its value?

8. How does one know if the business is on track with the plan?

9. Who oversees the plan's operation?

10. How long does a business plan last?

Chapter 5
Business Development

Like sharks, content-production companies must always be in motion. If they stop, they drown. One production must be closely followed by another, then another and so on. Eventually, the reserved rights, ongoing royalties and new licences may cover corporate overhead costs or the costs may be trimmed to suit revenues. Either way, the ongoing existential challenge for production companies is to keep producing. That is no small feat.

Content production is similar in nature to most other manufacturing industries. Like shipbuilders, aeroplane manufacturers, property developers and even pharmaceutical companies, content producers engage in conceptualization, research and development, arrange financing for their projects and manufacture them using the best-available technology, processes and skilled labour. The one thing that makes content producers significantly different is that their product does not really exist. Content is not just the digital files, images, sound or celluloid that contains it. What exhibitors offer and what viewers consume is an imaginary experience that results from the human brain's strange ability to believe that static images shown at 24 frames per second are real life events. That what sounds like a real event is a real event and that imaginary characters can have feelings. Content production is the manufacturing of dreams employing the process used for constructing apartment buildings. Production companies, therefore, must create the impression that they have the magic that goes into making those dreams. The corporate image must be carefully cultivated.

Business development and projects are closely related. While project development aims to accumulate a range of marketable potential projects, business development is intended to advance the market presence of the production company itself. A successful production company must have both an impressive profile and intriguing projects. Having produced a hit or two is invaluable but far from predictable. Acquiring the adaptation rights to intellectual property that has already gained a following will also attract the right kind of attention from the marketplace. The same holds true when well-known and sought-after talent like star writers, directors or actors are engaged. Even with all these factors in hand, production companies need to continually be focussed on building, widening and maintaining their presence in the marketplace. Memories fade, styles and genres go out of favour and new competitors arrive regularly. It takes disciplined work and focussed planning to remain a company that talent wants to bring its projects to and that buyers go to for potential hits.

DOI: 10.4324/9781003379737-6

Corporate Image

If you mention Disney, millions will envision Mickey Mouse, but few will imagine the face of Walt Disney himself. All will, however, consciously or implicitly associate the name with high-quality entertainment products espousing American family values, overcoming adversity and good humour. It is hard to think of a content company that has enjoyed as long a history of success. That is in no small part due to the corporate image so carefully crafted by its founder and loyally maintained over the years. Of course, Disney is now much more than a production company, but production companies will be well served by learning from its example.

There are other examples in related fields like Apple, Microsoft and Amazon or unrelated fields like Tesla, Red Bull and Nike. These are companies that stand for something and have a definite personality and style. They have carved out their own niches in their chosen markets. Their image and branding are deliberately designed to appeal to their intended customers.

Very few content producers, other than the majors or mini-majors, sell directly to consumers, viewers or audiences. They offer their concepts, pitches, proposals, treatments and scripts to larger companies that deal with the mass market. The newcomer or independent content-production company has a dual task. It needs to adopt an image that both impresses the executives at networks, channels, streamers and movie distributors and inspires the viewers who become their ultimate audience.

The image needs to convey creativity, an appreciation of the magic of cinema, a flair for the dramatic or entertaining and at the same time reliability, stability and financial strength. It also should reflect the personality of the key members of the company, especially if they are producers or executive producers.

Logos, animated end credit stings, website graphics and design, stationery and packaging – all should follow a unified look, feel and style that supports the corporate image that the founders intend.

Networking

It can take a year from concept through pitching, development, financing and production for a program to be completed. During that year, viewers will be bombarded with an ever-increasing number of subjects vying for their attention. What may seem like

a perfect project today may be old hat by the time it comes to market (for an example, see the first case study at the end of this chapter). Wayne Gretzky, perhaps the greatest hockey player of all time once said, "A good hockey player plays where the puck is. A great hockey player plays where the puck is going to be".[1] Networking is one way to develop the instinct for predicting what the market will want. Original production executives at channels and distribution companies will tell you what kind of content they are looking for. They may share past mistakes and successes with you. They may reveal the competitive threats they are facing and the strategies they intend to follow. If they do not offer the information, it does not hurt to ask. One thing is certain – if you are not communicating with them, you will not know what they are thinking.

An indirect benefit from networking effectively is the tendency of people to spread the word about others they have been impressed with. An original production executive who comes away with a positive impression of a producer, even from a chance encounter, will be much more likely to listen to a pitch and more open to receiving it. The more industry players are familiar with the principals in a production company, its track record and its development slate, the more the stature of that company will rise in the marketplace in general. As that stature rises, so will the perception that the production company has "the magic".

Conversely, it is damaging not to network enough. Prideful network executives may be offended if they are not approached, even if it's for a quick greeting, if they have no intention of doing business or vice versa. Perceived snubs do no one any good. Moreover, a production company or its key executives who are absent from key meetings, important events or major markets may soon be considered less active, less interested, less successful and, therefore, a less desirable source of new projects. A production company should avoid being conspicuous by its absence.

The most effective mode of networking is in person over a private meal, preferably dinner. Every city has restaurants that are both places to be seen and quiet and discreet enough for conversation to be open and unguarded. Crowded bars are less ideal. Over a meal, executives can relax, let their guards down, get to know each other better and form relationships. It is the relationship building that overrides any one specific business objective. Networking meetings, different from business or pitch meetings, are for establishing a rapport, building trust and gleaning information rather than for making deals. It is excellent if deals emerge organically, but they should not be pushed too hard (for an example, see the second case study at the end of this chapter).

Business meetings, where there is a clear objective, are best held in private meeting rooms or offices, where the right number and type of participants can join in and there are few unwelcome distractions.

It has always been relatively hard to get in-person meetings with the most influential executives. In a post-Covid world it is even harder. Nevertheless, a producer's most important job is to make things happen. He must find a way to meet with all the executives that may be strategically important whether it is through charm, guile, enticement or using go-betweens. This is a role not restricted to just the senior production company executives. Business affairs, development, finance or other officers of the company may from time to time be required to network with appropriate counterparts. The more this happens, the more well known and well perceived the production company will be. It will also be better positioned to identify and take advantage of opportunities.

This type of continual social interaction often moves executives out of their comfort zones. Travel, late nights and lifestyle compromises are hard to manage. It comes with the territory, however. The content-production industries are at their core about social interaction, and social interaction on a person-to-person level is what makes projects move forward.

Trade Fairs and Conferences

Not surprisingly, given how integral social interaction is to the evolution and creation of projects in the content industries and how much money is at stake, there are more and more trade fairs, content markets, conferences, festivals and award events every year.[2]

An executive could literally attend one such event every week if she were willing to constantly be on the road, which of course is absurd. For every area of focus there are specialized trade markets or segments of markets. One can find a suitable venue to attend whether her production company focusses on animation, factual programs, drama series, reality shows, movies or variety shows. Alternatively, there are larger more established comprehensive markets like MIP, MIPCOM,[3] the Cannes Film Festival and TIFF[4] where a broad range of content genres, content creators, content distributors and exhibitors will attend.

Production companies should plan attendance to markets, trade fairs and events carefully and ensure that the venues they attend advance the companies' business

objectives. Venues should not be attended on a speculative basis – "fishing expeditions" – for ego gratification alone or as perquisites of employment. Attendance is expensive and distracting, and these should be working trips, not rewards.

Precisely because of what it costs to attend these functions in time, money and resources, they should be well planned and organized in advance. Meetings should be set up well in advance with other attendees who can advance corporate objectives, those who might need to be followed up with from previous meetings or those who have approached the production company and have a potential value. Like many, if not most other attendees at these functions, our company will have organized a prescheduled list of meetings for every half-hour of each working day that we attend. We will have also booked breakfast, lunch and dinner meetings. This schedule starts being organized for the next market as soon as one market ends. For that reason, it's crucially important to take good notes of each meeting to record what was learned, proposed or agreed and what action needs to be taken. If feasible, there should be two people from the production company in attendance so that nothing is missed, and notes and impressions can be compared.

For half-hour meetings to be effective, they need to be focussed, concise and goal oriented. Small talk and gossip should be minimized. After all, the other party you are meeting with probably has a full schedule as well. The meetings should begin and end precisely on time. One does not want to acquire the reputation of being often late, dragging out discussions or talking about nothing of value. Those are the kinds of meetings that do not get repeated next time.

There are many more important people to meet than one will have the time for at any event, so there should be a good reason for every meeting. The attendees, their notable projects and their companies should be researched beforehand. This is especially important to do when meeting with important new contacts. Time should not be wasted on exchanging track record highlights or "war stories" if there is business to be advanced.

Appropriate materials should be created and made available at markets. Whether on paper or digital, it is crucial to have something to show, share or leave with someone when a project or potential project is discussed at a meeting. Materials need not be overly detailed, but they should at the very least capture the creative essence and commercial appeal of the project and include the contact information of the production company.

Trade Fairs and Conferences

Conferences, such as the producer association conferences held in most countries or those used to exchange industry information either on their own or as trade fair side-bars, represent unique opportunities. Often attendees are seated beside strangers or at the meal table with people they have not previously met. Every chance encounter is a potential opportunity. No possible contact should go unexplored.

The other real benefit to conferences is the exposure one might get to a wide audience if one is invited to address the crowd or join a panel discussion. High visibility is important to raise or maintain the profile of the company. This should be taken very seriously, of course. The address or appearance should be well prepared, comments measured and tone and demeanour appropriate. It is risky to try and be funny, controversial or cynical.

Festivals and Award Events

Many festivals are primarily focussed on the promotion of finished content. They are set up to raise awareness of and gain media coverage of a finished production to help enhance its audience appeal and often to attract offers of distribution. The value of film festivals, particularly for theatrical or long-form movies is well established, especially if the projects are highlighted in the festival screening schedule or in competition. Press "buzz" may start and continue to build after popular screenings. That usually leads to larger box-office results.

The boost from successful screenings rarely happens in a vacuum. Press relations work must precede the screening to make sure that the right journalists attend. Press materials need to be created for them. If possible, someone representing the company should be present to take advantage of any queries, opportunities or business proposals that arise. Simply submitting a show to a festival is of limited good, even if it wins some sort of recognition. Where festivals are attended in order to attract distribution or licences for the movie or program, an executive with the authority to negotiate, the knowledge of what to ask for and the skill to make appropriate deals should be there.

Advertising, Marketing and Public Relations

There are three parts of the production company that benefit from advertising, marketing and public relations. The reality of conducting business is that, often, budgets

need to be trimmed. This applies to corporate-operating budgets as well as content-production budgets. Advertising, marketing and promotion are usually the first targets because they are least essential. That does not mean that they are not vitally important, however.

Ultimately, what every production company is striving for is the concerted attention of as many viewers as possible to the content it produces. The amounts, genres, types of sources and methods of consuming content are increasing exponentially year after year. The struggle for content creators is no longer just how to obtain the resources and skills to make high-quality commercial content. The more formidable challenge is to make the intended audience aware that any one production even exists, let alone how to view it. From that perspective, there can never be enough clever or effective marketing.

Marketing of a production should be baked into its conception and development at the earliest stages. That is not to say that the marketing needs to begin then in all cases, but the elements of an effective marketing campaign should be present and cultivated from the start. How, when, with what and at what cost to market and advertise are unique decisions that are custom tailored for each project. Typically, channels and distributors are the ones with the larger advertising budgets and devise and place the paid advertisements for shows on television, social media, digital platforms, billboards, print and the like.

All those efforts need to access material and information derived from the content itself. Images, storylines, talent biographies and interviews and electronic press kits should be created and assembled at the outset of production by the production company itself. No one knows the show better than its creators. It is foolhardy to create a marketing campaign without the right source material. Channels and distributors should not be placed in that position.

Apart from its individual productions, the production company itself needs to be promoted. Announcements of key employee hires help. Publicizing nominations and awards are good things to do. Letting the market and the audience know when and if the rights to important intellectual property like bestselling novels are obtained is good as well. It's also useful, more for industry stature than for the consumer market, to announce development deals, presales or greenlights of projects.

The third area of focus for marketing and promotion is the staff of the production company itself. Top executives should have high profiles in the industry and their achieve-

Advertising, Marketing and Public Relations

ments celebrated. Appearances at conferences, giving interviews, taking up causes in line with corporate objectives all can be publicized to enhance the company's image.

Pitching

The most important person in a pitch meeting is the "buyer" – the person being pitched to. To be effective, a producer needs to intimately understand the buyer's job. Who do they report to? How are decisions regarding new projects made in the buyer's organization? Who makes the final call? What are the buyer's priorities, targets and challenges? All these questions can and should be answered before any pitches take place.

Most end users of content – networks, channels, platforms and distributors – have two programming departments. The "original content department" is responsible for the development of new projects and the "greenlighting" of projects that have been successfully developed with their input. They develop new material to fit into the overall inventory of their organization and meet its strategic programming goals. They are as familiar as possible with the talent community – writers, showrunners, directors and actors as well as producers – and have their preferences and desires about who to work with. This is the department one pitches shows to. Once they commit support and funding to a project, they have the right to shape it to their needs by approving key creative elements such as stars, directors, writers, scripts, rough and fine cuts, music and sound mixes.

The other department is the acquisition department. It is responsible for acquiring the rights to production that have already been finished and are usually already in the marketplace on another service or medium somewhere. Their job is to screen and evaluate a production, determine whether it meets the programming priorities and licence the rights if it does. They usually meet with the sales staff of distribution companies. They do not normally take "pitches".

Meeting with the original production executive of a buyer to present an early-stage project for development or pre-licensing is what the industry refers to as pitching. Pitching has another indirect purpose as well. It familiarizes the buyer with the production company and the original production executive with the development staff of the production company. It helps to form a relationship over time even when the pitches are unsuccessful (which is most of the time) if pitching is conducted properly.

There are several elements that contribute to successful pitches. Countless books, courses and self-help manuals try and encapsulate a recipe for successful selling. Often, it comes down to good research, preparation and interpersonal chemistry. Selling skill improves over time and with practice.

First and foremost, one must have conducted the appropriate amount of research into which organization would be the best to pitch to for a given project. Ideally, this research is baked into the project itself. It should have been prepared by the production company with a specific buyer in mind. The research should identify the right person in an organization to meet with. The easiest person to get a meeting with is not necessarily the right person. A person with enough authority to make a deal is the best.

One must capture and hold the attention of the "pitchee". This is always a matter of personal style and tone. Great salespeople have a knack for disarming others and making their targets believe that they need what is being offered. Somehow conveying that a project is a probable (as opposed to possible) hit is essential. A quick, concise and engaging description of what the show is, why it is ideal for the intended organization and why the pitching production company is the company to produce it is invaluable. This takes a lot of creative focus and skill to prepare.

At the meeting itself, ask how much time is allotted. Do not overstay. Ensure that the essential elements of the pitch are covered and leave time for discussion and questions. Make sure to be attentive and aware of the body language and attitude of the listener. Have a colleague with you if you can. Is the listener leaning forward, making eye contact, smiling at the right times, frowning at the right times, fidgeting or arms crossed? Be prepared to adjust or tailor the pitch to take advantage of what seems to be getting a positive reaction and what is not.

Do not get bogged down into too much story detail. Entice and tease rather than over-explain. Intriguing, surprising and original characters are often good entry points into the storyline. It may help to invite the listener to imagine themselves in one of the characters' situations.

Be very aware of the criteria that the listener must apply to evaluate your proposal. They will need to consider not just how appealing a project may be creatively but also the cost, the practicality, the production company's track record, its connections and its ability to attract the right talent, expertise, financing and resources.

Pitching

Explain why the project fits the buyer, its current slate or its brand. Be aware that even channels as seemingly similar as HBO and Showtime each have distinct profiles to differentiate themselves in the marketplace.

In preparing pitches, make sure that there is a strong "hook". This may be a one- or two-line sales-oriented slogan phrase or sentence that gives a hint about the show and creates intrigue. The effect of the hook is intended more to entice the buyer than the audience. Most executives receiving pitches will need to re-pitch to their superiors. If the hook appeals to the audience just as well, all the better. Some titles in themselves or married with a simple image are very effective hooks. Consider the classic sitcom "Happy Days" with a picture of the cast, including Fonzy, in period costume, or "Big Bang Theory" or "Andor".

Once intrigued, the listener is ready to hear a bit more detail. Anticipate any questions and be prepared to answer them or satisfy concerns. Briefly describe the premise, theme, tone, style and characters. Reinforce why it is ideal for the buyer's target audience.

If the pitch is rejected, accept the decision without argument. It is okay to ask for a brief explanation as to why if none was given. If there is still time, ask what else the buyer might be looking for, what demographic it wants to reach and what genres (for an example, see the third case study at the end of this chapter).

If a decision is reserved for a later time to allow for more material to be submitted and/or more internal discussion, make sure that any additional material they need is instantly available. Momentum is essential. Find out what the internal evaluation process will entail, how long it might take and how, with whom and when you should follow up.

If the pitch has been very successful, know what to ask for and what kind of deal the production company would like to strike. If it is a "Development Deal" whereby the buyer will advance money towards the writing and further development of the project, have a budget readily available to send. Include all elements that might be useful to successfully develop the project to a stage where it can be greenlit or at least piloted.

Always follow up every meeting, positive or negative, with (at the very least) an email thanking the executive for their time, confirming the outcome of the meeting and any action that may follow.

Negotiation Tips

Like creative meetings and pitch sessions, negotiations need to be conducted mindfully and skilfully to be effective. Badly handled negotiations, even if they achieve the desired outcomes for one or both parties, may have the effect of ending relationships. Well-handled negotiations can lead to stronger relationships even if the outcome is very negative for one or both parties. As we have seen, relationships are generally more important to production companies than the results of any one business transaction. Common principles for negotiation are as follows:

1. *Proper research and preparation are required.* Who is one negotiating with and why with that person in particular? Obtain as complete a profile as possible. What can be found out about that person, his or her education, background, successes, failures, preferences, ambitions or fears?
2. *Meet at a neutral location if possible*, meeting rooms are better than personal offices.
3. *Know what each party needs to achieve*, wants to achieve and is likely to accept or settle for. These are all very different goals.
4. *Be respectful of time.* Begin on time, end on time. Listen carefully, do not interrupt and show neither pleasure nor disdain for comments.
5. *Humour can be a very effective tool* but only use it if it is very likely to work for rather than against the parties.
6. *Remember that the object is to achieve an agreement, not to win a battle.* Your counterpart is your colleague, not your enemy. They are there to help you achieve an appropriate result. You are there to help them achieve the same – not to vanquish them.
7. Once you have achieved a positive response or acceptance of a point you are making, move on. Do not overlabour an issue.
8. *Not every negotiation has to end with a conclusion.* If there is no consensus, it is alright to adjourn, schedule a new meeting or reconsider. Leave on cordial terms with lines of negotiation open. Once a door is closed, it is much harder to swing it open again.
9. *Take detailed and accurate notes.* Have a colleague in attendance if possible.
10. *Do not trust in the memories of either side.* If something is unclear, ask for it to be explained. Do not guess, assume or take anything for granted.

Actual Case Study 1

Britney Spears was reaching superstardom, and gossip shows, celebrity sites and fan magazines were chronicling her seemingly wild and erratic personal life. MTV was highly interested in a pilot series script about a young girl from the San Fernando Valley who becomes an overnight rock star and crumbles under the pressure. They ordered a pilot. We produced it quickly. It was sent to a focus group, and we were thrilled to hear that the results were as positive as any show MTV had commissioned. They ordered a 13-episode series. We shot the series over the course of the next year. MTV gave us the most sought-after time slot in its schedule, right after its highest rated series. Our series, "Kaya", went on the air, and we all, network executives included, expected a huge hit. To everyone's shock, the ratings were extremely poor. The best explanation we could point to was that between the time Britney was a celebrity pop idol with a sensational private life and the completion of our series, her story had become overexposed, sad and depressing. What looked like a popular obsession became something the audience would rather forget.

What principles does this illustrate? What can be learned?

Actual Case Study 2

One year while attending the NATPE television market in Las Vegas, a mutual friend invited me to dinner with the owner of a very large American home video company. He told the story of being sued by the Disney corporation for copying the cover art of their "Little Mermaid" on video releases of his own containing a low-budget Japanese version of the same story. It was his attempt to "capitalize on the parallel marketing opportunities" represented by the typically effective marketing and advertising campaigns that Disney creates for each of its annual summer film releases. He said he was ordered by the court to pay a seven-figure amount of dollars as damages. Mostly in jest, I said a similar objective could be achieved without the risk of prosecution – shooting a live-action version of Disney's upcoming public-domain movie subjects. There would be somewhat less but still significant demand for the videos but no lawsuit. His response,

knowing that the next year's Disney release was going to be "Pocahontas", was to ask if I could produce a live-action version before Disney's movie came out. I said I could. He asked what it would cost. I quoted a budget, and he agreed to finance it right there and then. I had never met him before.

What principles does this illustrate? What can be learned?

Actual Case Study 3

Caryn Mandabach, famed producer of "The Cosby Show", "Roseanne" and "3rd Rock from the Sun" recounted how, even after those enormous hit shows, she failed in a pitch to the Fox Network. She was told her pitch was not suitable because Fox was going after the demographic of men from 18 to 45 years of age. This puzzled her because 18-year-old men have distinctly different interests than 45-year-old men. On the way back to her car in the parking lot, she had an inspirational thought. What about a show centred around teenage men and their fathers set 30 years in the past? "That 70's Show" was born and became another huge hit for her.

What principles does this illustrate? What can be learned?

Questions

1. What is the difference between project development and business development?
2. Why is business development important?
3. Why does it need a plan?
4. What kinds of relationships are important to production companies?
5. Where can producers meet strategically important people to do business with?
6. What is the best way to organize trips to markets?
7. What value do festivals have, if any?
8. How does one help creative meetings to go well?
9. What makes a good pitch?
10. What is a successful negotiation?

Notes

1 *Gretzky: From the Back Yard Rink to the Stanley Cup*, Wayne Gretzky and Jim Taylor, Avon Books, 1984.

2 See Exhibit 4: List of Media Conferences.

3 International television markets held in Cannes, France, each April and October, respectively.

4 Toronto International Film Festival held each year in September in Toronto, Canada.

Chapter 6
Monetizing Rights, Managing Revenue Streams

Producers of content are driven by numerous factors. They may have a passion for storytelling. They may love the creative process and atmosphere of filmmaking. They may want to achieve celebrity status or work with celebrities. Their career may be happenstance or, perhaps, all of the above. Content production for only those reasons is not much more than a hobby unless producers earn a living or, better still, sustain a business that can continue to make project after project on an ongoing basis. In simple terms, if content production is to be a business, it needs to generate revenue. If that business is to be successful, it needs to earn more money than it spends.

The producer or production company fees and recovery of overhead allocations in productions may be one source of revenue, but they barely pay for the time, effort and risk involved in manufacturing the project. These payments occur only once – when the production is manufactured. After that, the company needs a new production, then another. The challenge and pressure of being forced to add productions just to stay in business can be very unpleasant and can lead to decisions based on financial duress rather than market strategy. Nevertheless, many companies follow that very model. This is the service production business we referred to earlier.

To avoid the trap of working solely for fees, a production company needs other sources of revenue and sources that can continue into the future with less hard work and investment. Two additional primary revenue streams producers use are distribution and ancillary revenues which have been briefly touched on in earlier chapters. They both are based on the model of retaining or owning as many rights in the production as possible.

Content Value Chain

Movies, television shows and other forms of content all have roughly the same life cycle. It begins with an idea that a certain story or subject would make a "good" show. In a business context, "good" means potentially popular and capable of generating a profit with relatively little risk. It is not enough to simply be fun to make, inexpensive or easy to produce.

DOI: 10.4324/9781003379737-7

An idea that passes the business test proceeds to be researched, designed and sketched out in writing and/or graphics. A presentation is prepared to expose the project to other organizations ("buyers") that provide content directly to viewers ("consumers"). This is the pitch.

A successful pitch is one in which a buyer expresses interest in having exclusive influence on and control over the project's further development. The buyer agrees to fund the development in exchange for that control and the option to acquire exhibition rights. This is the development deal. It is at the development deal stage where the producer first needs to be careful to avoid giving up more exploitation rights than necessary.

Development ends with the buyer either releasing its hold on the project or agreeing to fund all or part of the production. That funding will entail a negotiation over what rights the buyer acquires in exchange for the funding. This is the "presale agreement". The producer will want to give up as few rights as possible for the highest presale fee. Conversely, the buyer will want to pay as little as possible and acquire as broad and deep a bundle of rights as it can. The bargaining will revolve around exclusivity, term of licence, geographic territories, modes of delivery of content (e.g., broadcast, cable, streaming) and number of exposures of the project. The producer's profitability as a business will be enhanced by retaining rights it may exploit and the buyer's by acquiring rights to exploit.

A popular and rewarding model for financing the production of high-value commercial content is to cover the production costs while limiting the buyer's presale to only one or (if there is more than one presale buyer) very few territories. This leaves many potentially valuable countries of the world in which the producer may make additional licences of the program.

Additional licences of a program beyond the presales or production-financing arrangements are the distribution revenues. They are revenues generated from distributing rights to exhibit the finished program to numerous subsequent buyers or licencees who may operate in different countries, different media or even in the same areas but are prepared to acquire rights only for subsequent periods of time (or "time windows").

Larger, more established production companies with an inventory of rights from previous productions may have a distribution department or internal staff responsible for distribution. The advantage of that model is that all the revenues generated remain

inside the company and under its control. The disadvantage is that content distribution is a costly undertaking and requires a great deal of time, effort and expertise. It can only be economically justified when the inventory of rights is commercially valuable or numerous enough to outweigh the expense.

Smaller, newer production companies engage distributors: third-party companies who specialize primarily on negotiating and selling exhibition rights or licences on behalf of content creators. Distributors, of course, charge for their work by taking a distribution fee or commission calculated as a percentage of any monies they collect on the producers' behalf. The advantage to retaining third-party distributors is that they usually have much better market intelligence, contacts and resources and can therefore be expected to generate more revenue.

Distributors enter into agreements with exhibitors and/or content providers (networks, channels, streamers, platforms) who they charge for the right to make the content available to consumers. The distributors retain their commission and recover their expenses from the licence fees they negotiated and remit the balance to producers.

Content providers may make the programs available to consumers for free, free with advertising, on demand for a fee, on a subscription basis, on a rental basis, on a hard copy or download to own basis, by selling tickets or any combination of the above. The last step in the value chain is the actual consumption or viewing of the product by members of the audience (Figure 6.1).

Who does what?

- Concept
- Development
- Budgeting, Scheduling, Packaging, Financing
- Production

PRODUCERS & PRODUCTION COMPANIES

- Distribution
 Marketing & Promotion
- Exhibition

DISTRIBUTORS

NETWORKS, CHANNELS, PLATFORMS

- Viewing

AUDIENCE

Content Value Chain

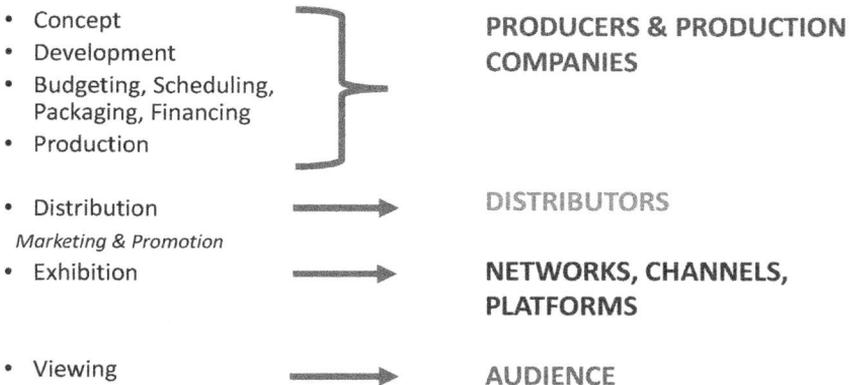

FIGURE 6.1 Value chain. Graphic by author.

Monetization

Popular content can live on in the marketplace, continuing to generate revenue from viewers for distributors and producers for many, many years. The most popular content will have value for the entire duration of its copyright protection. The best outcome for producers is to cultivate, maintain and continually refresh the commercial exploitation of projects they have produced. The money generated from continuous exploitation of content can far exceed the value of fees or overhead earned by producers through a production's budget.

Licences have fixed terms of years. They can be renewed when they expire, or new licences can be set up with fresh buyers. New media arise as fast as technology can create them. Shared or staggered windows of exclusivity for exhibitors can be worked out. Content can even have a value to exhibitors on a non-exclusive basis. For the appropriate price, usually lower, it may make sense for even competing services to both license the same show for the same territory at the same time.

There are no hard-and-fast rules of practice for any one type of arrangement in the exploitation of the rights to content. Sought-after, popular or hit shows often change the prevailing norms of deals. There are, however, common starting points for negotiations and typical forms of deals in most sectors.

Knowledgeable producers, distributors, sales representatives, agents and lawyers all become aware of the range of licence fees that networks, cable channels and streamers might pay for a given genre. They will also be very aware of what rights would be demanded in return. Obtaining the best market data and advice before deals are concluded may be costly, but failing to do so is likely to be costlier in foregone revenues or opportunities.

The adage that "content is king" is more truth than hyperbole. Demand for content has never stopped growing. The audience expands, new devices and methods of accessing content arise, new ways and places to consume content get developed and new adaptations of intellectual property rights continue to be invented to stimulate this demand.

Holding onto as many identifiable rights as possible, and especially rights to exploit content that are "hereinafter to be devised", is the way to build a revenue stream for a production company into the future and provide welcome cash flow when new production opportunities might dwindle for any reason.

Ancillary Rights

Rights to adapt, repurpose or transmute any of the intellectual property components of a production, as opposed to the right to simply display or exhibit the production itself, are commonly referred to as ancillary rights. Examples might be devising a video game based on a television series, stage plays based on movies, toys based on characters or even bed linens, backpacks or t-shirts sporting logos or characters from a series. Such rights may also include the right to release music albums with songs from a soundtrack, to publish books based on a movie or television series, and theme park attractions adapted from characters, locations and plot lines taken from animated movies.

Each of these applications have routine commercial arrangement parameters common to their particular market segment. Soundtrack album deals are much like any other album deal (especially compilation albums). Licensing TV show characters for a game is like licensing any other character for a game, and licensing logos for clothing is the same no matter what the logo. It takes specialized expertise, contacts and acumen, however, to maximize both the opportunities and value of these kinds of rights for producers. It is rare for production companies to possess the right skill sets to monetize these rights in house.

Licensing agents are often brought into the mix by production companies. Like content distributors, licensing agents identify possible commercial opportunities for a producer's intellectual property. They help develop the property to make it attractive to potential licencees by preparing style guides, prototypes and sales kits. They attend toy fairs, gaming conventions and merchandizing events in order to promote the producer's intellectual property portfolio. They negotiate the licence terms and conditions. They make sure that the intellectual property, whether in the form of copyright or trademark, is protected and its integrity as a brand preserved. They monitor sales, collect the royalties paid by licencees, take a commission and recover their expenses, just like distributors of shows might do with the underlying content.

Needless to say, retaining ancillary rights is crucial for producers and exploiting those rights at the right time, in the right way and on the right terms is an important aspect of a production company's business. Monetized properly, ancillary rights can dwarf any of the production company's other revenue streams (see case study at the end of this chapter).

Ancillary Rights

The Distribution Agreement[1]

Relationships with distributors are the most important commercial connections for producers of theatrical movies. The distributors provide the movie to theatres and often thereafter to network, cable or streaming television services. For episodic content producers, distributors provide the connections and arrange the licences to content outlets in whatever countries, media or time frames the producers have managed to retain.

Whatever the form of the content, distribution agreements are structured in very much the same way. The distribution agreement and its main deal points are vital enough to the business of producing that they deserve to be looked at in detail. In so doing, it will be assumed that a producer has not given up all exploitable rights to her project in exchange for the production financing to investors. We will assume that the producer has successfully resisted the practice of funding her production entirely by a presale to a streaming service that takes back all rights, throughout the world in all media for as much as 20 years or more. Situations where distributors provide production-financing assistance will be covered.

Parties

Every contract begins by identifying the parties to the agreement. One party will be the distribution company. It should be an operating company, not a subsidiary or intermediary company. One wants to preserve the right to hold the strongest and most asset-rich party accountable in case of any disputes, problems or defaults. The other party to the contract will be the party that holds the copyright to the production. This may be more than one company in the case of co-productions where copyright is shared.

Property

The title, format, running time, number of episodes (if applicable) and language of the production should be laid out. Any other key details, such as writer, director and stars should also be added to avoid any possible dispute as to what program is being dealt with. In the case of distribution agreements entered into before production has begun, especially if the distributor is providing financial support (such as an advance or minimum guarantee), a preapproved script(s), budget, key talent and supervising producer should also be referred to.

Grant of Rights

As we have seen earlier, special care and attention needs to be paid to ensure that the distributor is granted only the rights it actually needs commercially. The distributor will be authorized to initiate and negotiate licence agreements for the program. It will usually be allowed to conclude agreements on behalf of the producer. Alternatively, it may be required by the producer to seek approval before specific types of licences can be concluded. The distributor will be given the right to collect licence payments and royalties on behalf of the producer.

The rights granted to the distributor will almost always need to be exclusive to that distributor. No distributor will be comfortable with others approaching potential licencees with the same project. No licencee will be comfortable if more than one person represents a product. Confusion in the marketplace is sure to discourage dealmaking.

The term of the agreement will be established. It will set out when the distributor's rights begin (normally from delivery of the program is approved) and when they end. Terms are rarely as short as 5 years. They most often range from 10 to 15 years.

The geographic territories within which the distributor may operate will be detailed. A distribution agreement may cover only one territory, such as the United States, or it may cover the entire world. Each case will follow its own course but, as a rule, it is unwise to put all of one's eggs in the same basket. There is no reason to grant rights beyond planet earth, but many distributor's agreements try to permit them to operate "throughout the universe".

More complicated provisions deal with the various media the distributor will be allowed to exploit. As we have seen, new outlets, platforms, devices, formats and mechanisms keep coming up. Not every distributor is well equipped to exploit every medium. For example, for many years, only a small number of approved "aggregators"[2] were deemed acceptable by Apple to provide content to the Apple Store. Negotiations with distributors usually start with their "standard form agreement" which will assume that they are given rights in all media that "currently exist or may hereinafter be devised". Producers are expected to claw back rights that the distributor might be willing to forego. This is all based on the assumption that producers are desperate for their projects to be distributed and elated with any offer. It is a far better approach for producers to require distributors to make a good case as to how they are best suited to handle every medium they request.

The Distribution Agreement

Distribution Fees

A specific fee, commission or royalty will be charged to match each type of medium that the distributor is empowered to exploit. The fees for licences to television networks and cable channels may range from 15% to as high as 35% (depending on circumstances like whether there is an advance or guarantee involved).

Advances and Minimum Guarantees

In some cases, a producer will welcome or even need financing help from the distributor to cover production costs. It may be that all other sources of funding have been exhausted or that a particular project is attractive enough that a distributor is prepared to put up cash in order to win the rights away from a competitor.

Distributors will not commit funds to the producer without some assurance that their financial risk will be rewarded. Distributors will always insist that any money they pay to a producer can be recovered by them from revenues they generate before they pay out to the producers. The distributors are the recipients of all the licence-fee revenues they arrange and will pay themselves back any of their out-of-pocket expenditures, whether financing or sales expenses.

Financing from a distributor may take the form of actual cash payments during production or at the very end of production. These are "advances" as they are paid before there is actually a product in their hands that they can exploit.

An alternative is a "minimum guarantee". This is a binding commitment from the distributor promising that the producer will have been paid a certain amount by a certain date in the future – whether the distributor has generated the requisite amount in sales or not.

Distributors who have paid such amounts see them not as gifts but as loans. From their point of view, they are loaning money to producers against the producers' future share of revenue. Clearly, the distributor will only commit a sum that they have confidence will be more than offset by their eventual sales.

As sales revenue comes in, the distributor will apply the producers' share of that revenue to repayment of any unrepaid portion of an advance or minimum guarantee as the case may be if insufficient revenues have accumulated. Often overlooked by producers is the additional right that distributors require to charge interest on the outstanding amount of any advance or minimum guarantee, just like any other lender would. Unlike

most other lenders, however, distributors are fond of imposing extremely high interest rates, so high that they amount to a significant profit centre for the distributor. On top of that, distributors will insist on higher distribution fees to compensate them for the added risk they take in committing cash to an unfinished project.

It may be years before accrued distribution revenue is received. As a result, the accumulation of fees and compounding of interest on advances or minimum guarantees can be so high that producers never become entitled to a share of sales receipts while distributors might be repaid their outlays several times over. Needless to say, the structuring of advances and minimum guarantees, the amounts, interest rates and terms of recoupment should be negotiated with the greatest of care. Financing from distributors may be a port in a storm for some projects, but unless properly priced, they may be regretted later on.

Distribution Expenses and Caps

Distribution of content is an active rather than a passive undertaking. Producers want their distributors to work hard to find buyers wherever and whenever they can be found and to make lucrative deals. Distributors want to make lots of sales as well to earn high fees. The activity can be expensive though. Salespeople travel to markets and offices all over the world. They create sales material, print and electronic brochures, videos, trailers and swag. They rent expensive booths at trade fairs and promote projects for awards. They wine and dine key buyers and hold receptions. All of that somehow needs to be paid for at the end of the day.

Distributors require their expenses to be recovered from sales generated by the projects, sometimes with interest. It should be fair enough to agree to allow them recovery of actual, direct and appropriate expenditures that apply specifically to the producer's product. Distributors should be encouraged to spend what they think is best to generate the most advantageous sales result. Allocating a fair share of collective expenses like receptions, booths and giveaways is much trickier.

Producers want the best sales effort, but since the expenses of that effort really come out of what would otherwise be revenue paid to the producer, they do not want to give their distributor a carte blanche. Caps are negotiated to set a maximum amount of dollars that a distributor is allowed to recover from sales. This should be sufficient to allow them to conduct an effective sales campaign but conservative enough to assure that a producer is not being taken advantage of.

The Distribution Agreement

Revenue Allocation

The pool of money actually received by a distributor from sales it has generated on a project is usually called "Distributor's Gross Receipts". The agreement will set out how that money is dealt with when received, who gets what and when. First off, the distributor will be entitled to pay itself the agreed-upon distribution fee. The remainder is then applied to repay any outstanding amount of an advance or minimum guarantee, plus accrued interest. If there are funds left over, they are applied to repay the distributor its expenses plus interest.

Any revenue remaining after fees, recoupment of advances or guarantees and expenses is called "Producer's Gross Receipts". This is paid to the production company which, in turn, may have to use it to first repay equity investors.

If there is any money left over after all production costs and financing have been satisfied, it is considered "Producer's Net Profit". This is what is available to be shared with profit participants such as investors, talent or underlying rights holders.

Only a small portion of sales revenue sees its way back to producers. It can take a very long time for producers to actually see profits from any one show. Nevertheless, over time and across a number of projects, the aggregate of producers' sales revenues can be substantial.

Revenues can be enhanced by avoiding the need for distributors to supply financing. For example, one might fund a project entirely with two significant presales in complementary territories and with complementary buyers, perhaps with clever use of government subsidies, leaving the rest of the territories of the world open for exploitation. A distributor who is not risking any financing can be negotiated down to the lower end of the range of distribution fees.

Accounting and Reporting

The distribution agreement will also set out the requirements for the distributor to report on sales and expenses, preferably every three months. It should specify how soon after a report any funds due to the producer need to be paid. How advances or guarantees are recouped and accounted for will be covered. Rules for what kinds of charges may be applied, expenses claimed, taxes paid or reserves taken will be laid out in mind-numbing detail. Mechanisms for disputing statements, correcting errors

and auditing records will be described as well. These clauses can sometimes run for pages, but they are of key importance and should be negotiated by knowledgeable professionals.

Delivery

A pivotal part of any distribution agreement, as with any licence agreement, is the part dealing with delivery elements. Each organization has its own boilerplate general list of the technical elements it needs to receive to properly use the project it has acquired.

Not every list of elements applies equally to each project, of course. An experienced post-production supervisor will have anticipated many of these required elements and provided for their creation in the post-production budget she has created. Invariably, however, there will be items in dispute, required by the distributor but not necessarily available. The cost to create them after the fact may be very high. Sometimes, by the time the delivery items are reviewed by the distributor's quality control staffer, it is no longer even possible to create them. The best time to deal with delivery item issues is always as soon as a licencor or distributor is engaged. Waiting can be costly.

The impact of incomplete delivery can have very serious implications where a distribution advance is involved, especially when the advance is specified to be paid on confirmation of complete delivery. This delivery occurs once all production has been completed. At that point, interim lenders who have provided bridge financing for the project may insist on being repaid[3] (see financing chapter). A delay in receiving funds from the distributor that are expected to be used to repay interim lenders can cause unnecessary stress, cost and concern.

Library Values

Prudent negotiation of distribution agreements, careful management of distribution revenues and exploitation rights will, over time, help immeasurably to give the production and its team stability, predictable cash flow, the confidence to plan growth and the ability to increase the value of the corporation overall. The library value of a production company is an estimation of the earning potential of the rights held by the

company in the inventory of projects it has produced throughout its history. Selling those rights and monetizing that value is another of the main ways a production company can generate revenue, attract investment or provide an exit strategy for its principals.

Actual Case Study

The Maple River television series became enormously popular with 9-to-12-year-olds in Australia. The television rights continue to have value 20 years later and generate sales revenues on a continual basis, generated in part by the diligent efforts of its distributors. However, there was an unforeseen and, frankly, unplanned by-product of the series' success and popularity. A CD of songs featured in the series became the best-selling CD in Australia for a time. Merchandizers lined up to acquire licences to market items ranging from collectible horses, pyjamas, backpacks to underwear, video games and picture books. Travelling live musical horse shows based on the series were filling soccer stadiums. The interest was so high that a licensing agent was retained to manage all the different merchandizing aspects. At its height, the gross merchandizing sales based on the Maple River copyright and trademark reached nine figures in Australian dollars at the retail level. Of course, the amount actually received by the producers was much less but still well beyond expectations.

What principles does this illustrate? What can be learned?

Questions

1. Why might simply producing shows not be a good business?
2. How do producers make money from their productions?
3. What might be wrong with obtaining all of a production's financing from one buyer?
4. What is the difference between a buyer and a distributor?
5. Who is the consumer?
6. What is content distribution?
7. How do distributors make money?

8. When is obtaining production financing from a distributor not a good idea?
9. What is a common form of ancillary rights that movies exploit?
10. What is the best rights management strategy for producers?

Notes

1 See Appendix 5: Distribution Agreement Deal Memo.

2 See Glossary.

3 See Chapter 2.7, Production Financing.

Chapter 7
Ethics and Social Responsibility

We are well into the era of climate change, the erosion of democracies, cancel culture, echo chambers, ubiquitous hate speech, widespread violence and racism. With the advent and rapid evolution of artificial intelligence and natural language-processing chatbots such as ChatGPT and Google Bard, the "Attention Economy" is well under way and accelerating at frightening speed. It has never been more important to be aware and mindful of one's responsibility to preserve the health of their interactions, their communities and their environment.

Commercial grade content, content which is designed for economic gain, is both capital and labour intensive. It involves financiers who exert power over the process and creative work of many people. As societies become more diverse, both the crews that produce content and the consumers of that content include individuals from all races, cultures, religions and sexual and gender orientations. The work of content creators (the telling of stories) is especially important for its ability to influence opinions, attitudes and behaviours. That influence may be direct or indirect, intentional or unintentional, overt or covert, measured and careful or reckless and damaging.

Every item of content can be produced in a socially responsible way and has the potential to do good as well as bad. Mindfulness of the impact of content creation is more important than ever before. It may now be one of the most important social determinants of all. At the very least, content creators should recognize the power of their craft and the responsibility that comes with that power. That mindfulness is more than just a moral or ethical value. If honoured, it can lead to longer, more satisfying, more lucrative and more important careers for producers. If taken for granted, it can limit, shorten or destroy careers, lives and institutions.

Practice

Interpersonal

We have looked at the value of hiring the most talented, experienced and capable staff for a production company. Whether in the creative departments, business affairs or finance departments, the success of a production company will be directly related to

DOI: 10.4324/9781003379737-8

the abilities of its team members. Ideally, hiring of personnel should look to the widest possible range of candidates and not be restricted to any one homogeneous group. It may be comfortable and seem easier to just work with one's own social group but that is a temptation to resist. It often results in a product that has a limited audience and shorter shelf life.

Casting the net of employment as broadly as possible, blind to skin colour, gender, race or religion is likely to result in the best team. Their ability to share diverse life experiences, tastes and attitudes will more closely reflect the world's audience. The best team, managed respectfully, mindfully and positively will produce the best work. The best work will result in the best audience experience which in turn will translate into higher revenue, greater corporate goodwill and more future opportunities.

Working conditions in the content industries can be onerous. Production schedules can become gruelling. Deadlines can create high levels of stress. Financial pressures can be frightening. Creative disagreements can turn acrimonious. It is up to the leadership of a production or production company to recognize the challenges, deal with them head on and do its best to make every individual from the freshest intern to the most experienced crew member feel that their contribution is of equal value and significance. This takes sensitivity, foresight, attentive listening, good communication, honesty and courage.

It may often seem like the exigencies of a moment are more important. An unforeseen weather event, accident or equipment failure may upset all plans, wreak havoc and rattle nerves. It is only human nature to react instinctively to a crisis and place personal goals ahead of the group dynamic. Rarely will this work out in a production company or on a set. At all costs, the cohesiveness, trust and motivation of the group should be paramount.

It is not surprising that in an industry whose underpinnings are made-up stories truthfulness is a rare commodity. Producers, actors, writers, directors, agents, lawyers and almost everyone else involved in the industry are extremely careful to construct the right personal images. It seems that to be taken seriously, respected and sought after, one needs to appear cool, popular, well-connected and brilliantly talented. Often, the image is far from reality. It is human nature to want to appear as accomplished as possible but presenting images of oneself that are too far from fact can backfire. It is a fine-balancing act. Not enough self-promotion may hinder a promising career, too much may lead to unreasonable expectations.

There is already an enormous amount of effort spent on creating online images and personae, and many studies have investigated the psychological impact that online image building has on our self-esteem. It is especially impactful on young children and teenagers. Surely, responsible content creators will want to lead the way in presenting themselves accurately, truthfully, inclusively and respectfully. Hyperbole and excessive self-promotion may have some short-term benefits, but in the long term, they rarely sustain success and often lead to emotional fallout.

Business

Just as it may take a "village to raise a child", it takes a village to make a show. Even small-scale student productions where one person may perform several production roles involve at least a handful of people from ideation all the way to evaluation of the finished product. Each person working on a production is called upon to contribute talent, creative effort, labour and time. Each one expects to receive some value in return. That is a business transaction. Because the content industries rely on the passion, enthusiasm and inspiration of their workers, emotion often clouds business judgement. First-time writers may more easily bend their creative visions, and actors may be willing to go far outside their comfort zones to get the right parts. People may be willing to work for less money than they deserve or forego payment entirely.

It is up to producers to follow honourable, fair, equitable and non-exploitative business practices. Negotiations should be truthful, as transparent as possible without giving away bargaining strength and leverage should be used very judiciously and sparingly. People who feel misled, bullied or coerced rarely perform at their best.

Executives who commission content for their organizations, and or the people who lend or invest money towards content production will appreciate business dealings that are forthcoming, honest and reliable. Making representations that one has the movie rights to a given novel when negotiations for the rights have only just begun may common but it is hazardous. No one likes to find out that they have relied on deliberately inaccurate representations. What once was an open door may suddenly be hard if not impossible to open in the future.

Production credits are often given to individuals who did no producing work. Producers or distributors may underreport exploitation revenues or over report expenses to investors or lenders. Budgets may be intentionally inflated or reduced to inappropriate levels. It should go without saying that accurate and dependable financial disclosures are

crucial to the long-term success of a business but shockingly often production companies fudge the numbers under the pressure of making a project work. That may slide by once or even twice, but the production industry is very good at identifying the bad actors and weeding them out eventually. Conversely, the reliable, trustworthy and dependable producers are sought after and admired.

Messaging

Corporate

Language, speech, demeanour and conduct all reflect attitude. Every member of the corporate team is a representative of her company. Her behaviour – public as well as private – will be taken as an example of the company's personality and values. This is not to be taken lightly or overlooked. Negative behaviour creates a bad image and reduces a company's attractiveness to others. Positive behaviour elicits respect and admiration and increases the company's attractiveness. In an industry that trades on illusion, emotion and the perception of special skill, image is hugely important. A company that creates the right impression will attract better staff, creative talents (writers, directors, actors) and feel like a more suitable partner to potential buyers.

The corporate image takes sincere, dedicated and continuous work to make sure that it is what the founders intend it to be and gives the production company stature in the market that will lead to the kinds of continuing future opportunities its founders desire.

Production crews tend to emulate the ethics, working styles and value systems of their parent companies or engagers. When crews are assembled and members chosen based on the corporate values, work tends to get done better, more promptly and more pridefully.

There are many examples of productions that assemble what might look like a dream team of talent – two great actors, a terrific screenwriter, brilliant director, etc. – and the finished product is surprisingly ordinary or disappointing. There are also many examples of projects that achieve great success both critically and commercially and come from a team of unknowns. The reason is usually the presence or absence of what is often called chemistry on a set.

Chemistry is the emotional connection between the creative minds that all collaborate in the process. It is one thing to technically produce a film based on a script. It

is another to move an audience. When the key creative people are enthusiastic and feel free/empowered, the set is positive and mindful outcomes will be successful. Wastefulness, negativity, disrespect, vanity, egotism and insensitivity have the same ability to end up "on screen" or in the viewing experience. The role of leadership – the production company and its producers – is to create the optimal atmosphere on set and avoid apathy, resentment or disunity. That starts with the way the parent or engaging company and its personnel conduct themselves.

If there is one key skill that a producer must perfect it is the ability to get the best creative effort out of the people she engages or supervises. That effort comes from treating every crew member with respect, dignity, enthusiasm, clarity, support, freedom when possible and restraint when required.

Content

In the earliest days of television, westerns and police dramas were extraordinarily popular. Many were concerned that exposing children to hours of gunfights, injuries and deaths would lead to a more violent society. The fear was that children would become desensitized to violence and more likely to commit crimes or become violent themselves. Later, as cable television shows became more sexually explicit and graphically violent, fears arose that viewers' attitudes to sexuality would be tainted, and gun violence would be normalized. Now, video games and online content have taken sexual, violent and hate-filled behaviour to new extremes. Hate-filled content, untruths, conspiracy theories and propaganda seem to be the easiest way to attract large audiences.

It cannot be denied that watching a movie, an episode, even a 15-second video clip has an impact on the viewer, conscious in real time and unconscious into the future. After all, that is the entire basis for advertising – communication intended to influence behaviour.

If it is true that even the shortest video has an impact, then socially responsible individuals should recognize their duty to care in what they make public. Producers of content, who create and exhibit content as their life's work and livelihood, have an even more onerous duty to be mindful, careful and responsible with respect to their product.

It is perhaps easier to make money by producing content that is shocking, outrageous or panders to base audience tastes. Pornography, graphic violence, conspiracy theories and hate speech all attract large numbers of viewers. Those viewers usually do not

expect higher production quality, so the cost of that kind of content is cheaper. It is a business plan followed by many.

Far more difficult is the creation of content that enlightens, uplifts, reinforces socially positive values and presents balanced, fair and reliable views. Storytelling depends on good characters as well as evil ones, violence, danger and suspense. The challenge is to avoid thoughtlessness, bias, prejudice and falsehoods in the storytelling process rather than to curb free speech.

An ethical approach to content production requires the mindful balancing of creative choices. If information is presented as fact, it must be verifiable. In any audience, there are bound to be some viewers who believe what they see and hear as truth. If a social group is portrayed, it should be free of stereotypes and be represented or at least authenticated by individuals from that group. Unbridled imagination is wonderful but should stop short when it causes pain. One's right to swing his fist stops at another's nose.

It is true that graphic sex and violence do more easily attract attention — humans are hardwired that way. Are they necessary to tell the story or are they just to capture the attention? How graphic do they need to be to convey the intended meaning?

Even, or perhaps especially, in programming intended for children, there is a duty to be careful, mindful, ethical and respectful in creative choices. The younger the child, the more she may be influenced by the content she consumes. Is it inclusive and colour blind? Does it promote anger, violence, vanity, greed or callousness, even by accident? Does it contain replicable behaviour that a curious child might copy and thereby put himself in danger? Does the program promote a product, toy or event? Is it funded by commercial organizations whose main objective is to encourage the child to want to purchase a product? If so, what obligations or implications arise?

Balancing good dramatic elements against social values and still creating compelling stories is difficult. That is the magic of responsible producing. In the long run, it pays off both commercially and critically.

Environmental

The production company's head office should be a healthy, comfortable, properly equipped and environmentally conscious space. Conservation, recycling and preservation should be corporate priorities. Leadership should set the pattern and encourage

both staff and visitors to follow. The shared common effort this involves will produce a happy by-product. The team will be proud of its behaviour and feel united, and the company will have a more positive corporate image.

Productions should follow the same principles. Shooting schedules, location management, transportation, energy use and crewing should be designed with a desire to maximize healthy working conditions, minimize any negative impact on the environment and conserve resources wherever possible. Even tight budgets can be stretched to accommodate environmental mindfulness. Conversely, the fact that a budget may be healthy and have the financial room does not justify wastefulness and overuse. It would be a good idea to give an individual on either the corporate staff or in the crew the responsibility of overseeing and implementing these objectives.

Actual Case Study

We had been producing a live-action family drama series for a well-known children's and family cable channel. It had a very large viewership of both adults and children. One episode involved a gripping story where an adult was saved from drowning by a child who then performed CPR – cardiopulmonary resuscitation – a well-known safety procedure. To its credit, the cable channel delayed approving the script and therefore its production, unless and until we could verify that the CPR technique to be used by the child actor was in fact a proper procedure and that there would be a CPR expert on set to ensure it would be performed accurately. The channel was determined to try and avoid a child in the audience using CPR incorrectly and perhaps causing harm. Of course, the channel's legal department was also interested in avoiding any potential lawsuits that might be brought against it in such an event.

What principles does this illustrate? What can be learned?

Messaging

Questions

1. Does a producer need to be concerned with anything other than making a popular show?
2. What are positive social values?
3. What is mindfulness?
4. What is an ethical approach?

5. What is a representative staff?
6. What is ethnic authenticity?
7. What is balanced storytelling?
8. What is replicable behaviour?
9. Does content always influence the viewer?
10. How does advertising work?

Chapter 8
Mistakes to Avoid

Know Yourself

First and foremost, to thine own self be true. Confidence is a terrific asset in the content industries – primarily because no one really knows what will work and what wont. It can be misguided however and overconfidence is endemic in the business among creators, exhibitors and distributors alike. The opposite is just as true. Insecurity and lack of faith in one's ability can unnecessarily stall a project or even prevent it from happening altogether.

Starting out as an entertainment lawyer in Canada in the late 1970s was a challenge. There was not much of an entertainment industry in Canada in those days and not much call for entertainment lawyers. The industry was in its infancy but growing. I declared myself an expert in entertainment law right from my call to the bar and insisted on only doing that kind of work. The timing was good. As the industry grew, so did my practice. My confidence was not based on any empirical training just a belief that I could figure things out.

On the other hand, a lack of confidence also held me back. All along, my ambition was to be a producer but the longer I spent in legal practice, the less confidence I had that I could be taken seriously as a producer. As it was, I eventually resigned from the legal practice to become a producer after about ten years. Had I made the move several years earlier things might have gone even better for me than they have.

It's difficult but crucially important to gain a solid, honest and realistic insight into what one is capable of and what one is not capable of, which challenges one can rise to and which not, what one is willing to do and what not. Having a trusted support system to provide reality checks is invaluable. Life partners, mentors, colleagues, anyone who knows you well can and should be relied upon to dispel doubts or raise them when appropriate.

Clarify Motivations

Producers may be motivated by money, power, creative passion, fame, status, glamour or ideology. In and of themselves, none of those factors are either good or bad. There is nothing morally wrong about producing something just for commercial gain if it harms

DOI: 10.4324/9781003379737-9

no one in the process and the message it contains is not damaging. Creative fervour is part and parcel of good production, fame comes with success as does status. The problem lies in whether the motivation is acknowledged or not, whether they are balanced and whether the end goal is appropriate. Becoming a producer solely to be able to enjoy ordering people feels wrong but seeking power in order to provide a profound insight or moving experience may be honourable. Pretending not to be interested in glamour but pursuing it, or denouncing celebrity while cultivating attract disrespect. It is hypocrisy and duplicity that ought to be avoided. When people are clear about what they want and why relationships are stronger, work goes better and deals are easier to make. Business plans are followed more closely and objectives are more likely to be achieved.

Interviews for the hiring of a lawyer to replace me at the law firm I was leaving were fascinating. One candidate was a brilliant young man. He was charismatic, extremely knowledgeable about the film and television industries and had very high grades from a top law school. In conference with my colleague who also conducted some of the interviews, we both agreed that he appeared to have the highest qualifications. The decision was against hiring him though. Both of us realized that his real motivation was to become a producer not a top lawyer, and this would not be good for the firm. Perhaps, I myself should have been more honest about that when I joined the firm.

Understand the Market

The content market in the 1970s consisted of theatrical motion pictures, television programs, educational and industrial films and home movies. Theatrical motion pictures dominated the marketplace. Today, the theatrical market is in decline, dwarfed and even led by the digital gaming industry. Virtually everyone has a screen in their pocket or at their side to display whatever content they wish to see as well as a good amount of content they did not ask for. If that was not enough, the screen-based device in their pocket can also create and publish content that they make at any time they wish. It has never been more important nor more difficult to understand the content marketplace. And ChatGPT is only just getting started.

No amount of market research can (so far) provide a recipe for a hit but ignoring or disregarding the marketplace probably will guarantee obscurity for a show of any substantial size. Budgets for competitive content are high; they involve a lot of effort, time and resources. It would be imprudent at best to fail to do the homework necessary to

responsibly decide what to make, for whom and at what cost. Study of the marketplace is not simply a task for producers, it is a way of life. The market does not stop evolving and the study cannot stop either.

Once again, my time as a lawyer provides an example. A client approached me sometime in the early 1980s with the idea of acting for him on application to the government for a licence to found and operate a cable television channel. Cable television was just starting to take hold. The brief was straightforward but there was a wrinkle. He did not have the funding to pay for our services. Instead, he was offering shares in the new venture. The more senior lawyers did not approve. "Who would ever pay for television?" they said. That channel became Canada's most successful children's channel and its value would have been 20 times the value of our bill.

Choose Co-producers Carefully

Virtually every content production involves partners of one kind or another. At the top level, the careful choice of partners is crucial. If one is sharing creative and/or financial control of a production, one must have complete respect for, trust and faith in one's co-producer. Healthy exchanges of views on all production matters can only be beneficial to the result.

The best coproduction partners can communicate their ideas and creative thoughts clearly. They share a common vision for the project yet are open to alternative suggestions to their own. They have the same attitude to working with all others on the crew. They respect each other's values, business standards, value contributions and constraints.

The business aspects of productions are complicated enough to sort out but at least they can be quantified and standards of practice can be applied. Creative matters are much more difficult to be precise and coherent about.

"The Woman and the Alien"

At lunch on the set, one day a director described to me the premise of a screenplay he was writing. I will call it "The Woman and the Alien". It concerned an earth woman who volunteers for a university research project and to her surprise finds herself suddenly pregnant. It is revealed that the father is an alien being studied in captivity by

the university. Eventually, the woman and alien escape and struggle to avoid capture by the nefarious researchers, the government and even visitors from the alien's home planet. Their child was to become perhaps the most important life form in the universe. I thought it was an intriguing movie idea.

Soon after, at MIP, the annual spring television content market in Cannes, I described the idea to an executive at the international television distribution stand of one of the Hollywood major studios. She loved the idea and said that it was just what they were looking for as a TV series together with important clients of theirs – national broadcasters in both France and Germany. They were interested in mounting a large budget one-hour sci-fi/action television series.

I mentioned that a three-way treaty coproduction among France, Germany and Canada could be structured but that the project was not really suited for television. A baby in jeopardy week after week did not sound right. A one-off movie felt more appropriate. She insisted that we arrange pitch meetings with her clients. I hesitantly agreed and optioned the script.

At MIPCOM, the next TV market that fall the meetings took place. To my surprise, the Hollywood executive had prepared a full-scale trailer that one might see in a movie theatre using all the resources of her studio library. There were elaborate car chases, explosions, airplane hijackings, well-known Hollywood stars and the ubiquitous trailer voice doing a hard sell. I raised my concerns about the trailer misrepresenting the project but the studio exec insisted it was alright.

To be sure, both the German and French broadcasters quickly agreed to come aboard. In very little time, the four of us, Germany, France, Canada, and the US distributors, had committed amongst ourselves to share the financing of a $40,000,000 24-episode series. I had been totally seduced by the thrill of the large budget and the major partners.

We proceeded to develop the scripts for the series and begin casting for the lead parts. My instincts warned me that fielding notes from two foreign language partners who I had barely met would be hazardous. The studio exec very happily agreed to assemble and translate their notes as well as her own and give us one set of comments to follow.

All through the script development process, the Hollywood exec gave us notes and regularly told us how pleased and excited she was about the progress of the material. She visited a few times.

Towards the end of pre-production, the French and German executives were to join the studio exec on our set, walk through the departments and give final comments and approvals.

The night before their walk-through, I got a call from the Hollywood executive who was having drinks with the Europeans at their hotel bar. She insisted that I join them right away. I arrived minutes later to see nothing but frowns and scowls at their table. They had read the material on the plane trip. "Steve" she said, "we are all wondering how the scripts could have gotten things so wrong". She had clearly never shared the comments from our European partners with us faithfully, in some cases not at all. And now, she was essentially lying to my face.

It became clear that the Germans were expecting a hard sci-fi series, the French a unique romance and the studio an action series. The Canadian broadcaster I was dealing with was looking for something to replace The X Files on their network. None of the visions were reconcilable in any satisfying creative way.

The series did get completed and was broadcast with the predictably bad results. Strangely, all four of the partners did make quite a lot of money from the project. As one might expect, the production process was the unhappiest, most stressful and demoralizing of my career and of some of the senior writers as well.

Choose Business Partners Carefully

Most businesses start with enthusiasm, focus and optimism. Time has a way of eroding that spirit, however. Without disciplined planning and careful thought, small problems can become large ones, people's priorities change, market conditions dictate new approaches. I've had two relevant experiences.

In one case, I had left law to run a very busy production company that had been a client. Its founders were a very talented producer, his now ex-wife and her brother. They started the firm as young filmmakers and equal shareholders. Over the years, as the company become more and more prolific, the wife focussed more and more on her personal directing career goals and her brother detached himself from the company's work almost entirely to focus on his career as a photographer. They each expected to share equally in the company's profits, although the husband really did virtually all the heavy lifting. There were many disagreements over projects, strategy, mission, finances and benefits. Eventually, they decided to go their separate ways. There was no mechanism

for either buying out the other. The ongoing sense of unfairness evolved into acrimony. A sum the company could barely afford was applied to compensate one of the departing founders. The internal conflict proved to be toxic distraction to the company, harmed its creative reputation and discouraged potentially valuable relationships. Eventually, my contract ran out and I too left.

In the other case, I started my own production company with one of my dearest friends upon leaving. We were determined to avoid the problems we saw in other companies. Our business strategy was to stay small enough to be able to enjoy the actual process of production first hand and yet have just enough productions going to be profitable. I was the active partner; my friend was to be a financial backstop if needed. We loved seeing our company succeed and our projects do very well in the marketplace. We travelled together to most markets and many meetings outside the country. The broadcast and cable television industry which we had focussed on serving was healthy. We developed a great list of solid relationships internationally and enjoyed a great reputation as a supplier of content and potential coproduction partner. It was a great deal of fun and very rewarding.

Eventually, consolidation in the Canadian and international broadcast and cable industries reduced the number of clients for production companies. It became harder to launch projects on favourable financial terms. The company's overhead had grown quiet high with the addition of staff over the years, but one of its largest expenses was my partner. He represented a significant portion of the overhead but did not contribute (nor was he equipped or expected to) any new projects or sources of income.

Tension about the inequality of relative contributions in a shrinking market threatened our friendship. Like many similar partnerships in the production sector where there is one active and one more passive partner, we agreed that it was best for me to carry on with the company alone. As touched on above, we devised a formula designed to achieve the fairest most equitable buyout price avoiding a potentially contentious negotiation. Each of us appointed a valuator of the company and the valuators were to jointly choose a third. The three would submit to my partner and I a worst- and best-case valuation and a median case valuation of the company. I paid the median price without objection.

Anticipating changes in circumstances, market conditions, personal priorities and creative differences is vital for content companies to thrive. Mechanisms for adapting to change, exit strategies and periodic re-assessments of values, contributions and expectations will keep the company operating smoothly for longer.

The Tortoise and the Hare

It is exhilarating to consummate a deal that can lead to great things. Scooping up the television or film rights to a hit novel is exciting. Landing a deal to develop material with a major broadcaster is thrilling. Getting the green light to commence production is miraculous. These emotions are what make the frequent rejections, hard work, uncertainty and stress that are inherent in the content production sector worthwhile. Producers keep coming back to the well despite the challenges and frustrations in order to get that adrenalin kick again. It can be intoxicating.

That feeling contributes to the positive momentum that is needed to motivate everyone involved. It can also cause problems. Being overeager to close deals can produce poor bargains. Important details can be overlooked. Too much can be paid or given up.

When I left New York City with three different chapter books in hand after the first "sales trip" for our new company, I soon realized that a great opportunity was looming. The books were perfectly geared to what was then a key part of the television viewership – ten- to twelve-year-olds. That audience was the bedrock of children's television. Avid viewers, readers and fad followers.

I knew it was important to move fast to have any chance at acquiring the television rights. As soon as it was determined that the rights were available, I quickly negotiated a payment structure for the author and the publishing company. There were several competing offers so it felt imperative to have something signed quickly to avoid being out bid.

A short deal memo got drafted, I made sure that the TV rights were included and the price was accurate and we all signed. The series that we produced was to become for a time the most watched children's show on TV. It was licensed by broadcasters and cable channels all over the world. It is still getting relicensed.

Some years later, when streaming services became a force, we were approached to license the series to one of the most prestigious streamers. The price was very good. We agreed. To our embarrassment, the publishing company through whom we acquired the underlying rights stepped in. Our contract, although it did grant us the rights to produce and exploit the series in all forms of television, was missing one crucial clause. In my haste to sign the deal, I had neglected to add the standard boiler plate found in most option and literary purchase agreement. Our deal memo did not include in the rights to exploit the show by "… all means of consuming episodic productions based

on the material in … any other medium currently in existence or hereinafter to be devised". Streaming rights had not existed at the time we made the deal. The internet itself had just been invented. In my eagerness to close the rights deal, I overlooked a very important detail. It's usually wiser to be slower and more thorough than quicker and more careless.

Newton's First Law

To change the direction of an object, a force must be exerted on it. Momentum is the special sauce of content production. Rarely appreciated is the fact that the enthusiasm generated upon getting a green light for a project propels the creative force and super motivates all the personnel that one relies upon to do their best work. The longer the pause between the green light and the actual start of work the weaker the magic. In mainstream Hollywood, productions can commence very quickly after they are ordered. There are usually no extraordinary impediments. In Canada, as in many other countries, one green light is not enough. Usually, an additional green light in another country is required for the appropriate amount of financing to be secured. That takes time. Usually, by the time a second presale is arranged and the relevant government or quasi-governmental funding agencies have committed funds, so much time has gone by that even the originators of the project lose some of their spark. That momentum dampening gap in time is one of the reasons the business plan for our company was to pre-license our productions in the American marketplace. Our development strategy was directed towards that market. Even in that market, there can be slow or no movement for dangerously long periods of time. Sometimes, it may be necessary to take a risk to apply some force to shake loose decisions.

One of our first productions was a made-for-video feature film intended to capitalize on the advance marketing of an upcoming major feature film release from Disney. Our live action production (and Disney's animated version of the same story) involved a seventeenth-century British sailing ship. We had developed a script that was ready to shoot. We had principal cast standing by and ready to be signed up. We had all the financing committed but the majority was to come from a New York-based home video company. Weather was going to be an issue. We needed to be shooting in summer. A formal request was made to the New Yorkers to commence funding. They did not refuse, but the funding was not released. March went by, then April. We told our American partners that it was crucial to hire our crew a commence pre-production by May to take advantage of the optimal weather window. Still no funding.

As luck would have it, we discovered that a small fleet of authentic period British sailing ships were travelling through the Great Lakes and would stop for several days at a port a short drive from our city. It was too hard to pass up the opportunity to hire a boat that was perfect for our movie. It would contribute huge production value at a very low cost. Again, we urged our American partners to pay attention, with no avail. We had a tough decision to make. Spend the money, book the ship and get a few days of critically important footage or let the chance pass, avoid the risk and suffer the lack of creative value. We bit the bullet and did the shoot at our own expense, knowing full well that if the funding from America disappeared, we might lose the money. We placed the magic of momentum over the financial risk. Our partners in New York were shocked that we went ahead alone. They were embarrassed at having stalled. From then on, we had no cash flow delays at all.

Appreciate What You've Got When You've Got It

The most valuable commodity in the content industries is talent. Stars attract audiences, successful writers and showrunners lead to greenlights, directors, editors, directors of photography all have enormous value. All too often the whirlwind of activity on a production makes it hard to spend the time and energy cultivating lasting relationships with the people whose creative input makes the whole endeavour special. Their desire to work with a producer again is directly related to how much appreciation, support and respect they feel from the "boss".

Future productions may entirely depend on whether the right team can be assembled. Careers can be made or broken by the strength or weakness of relationships with talent.

One of our early series was an anthology. Each episode involved a new cast, mainly young teenagers. Over the four years of production, we must have employed hundreds of young actors and auditioned hundreds more. Those that were hired showed up for their work and we would be cordial but not overly friendly. There was a lot happening at the same time. At least, six of those actors have gone on to "A List" level careers in Hollywood, won awards and become celebrities. How valuable would it have been to stay in touch?

More than a few directors came and went in the same way without proper attention from us. They as well have built hugely successful careers in Hollywood.

Value the work of each person in the crew. One never knows where the next star will come from.

If You Can't Lead at least Get Out of the Way

As a content producer, perhaps the most important part of your job is to supervise, direct, shape and guide the creative work of your key people. At various stages, you will be called upon to reflect on, evaluate and give feedback regarding creative work — in other words to "give notes". Giving notes is a delicate task.

Too harsh and creators get demoralized. Too flattering and the notes may be distrusted or the effort may sag. The best note givers begin with the positive comments and then ease into the negative.

Whether it is piece of musical score, a costume design, a rough cut or a special effect, the work being submitted has importance beyond its use in a particular scene. It is the vehicle by which the creators learn their task. The notes are meant to improve the quality and sharpen future efforts. Notes are not a platform to show how smart a producer is, or how insightful. Their purpose is to lead to a better product and better work and motivation from the particular creative person.

It is not sufficient to just say something does not work. There should always be an underpinning reason or explanation. It is often useful to have a suggestion or example to elucidate on. It is always vital to acknowledge the effort. What may seem obvious, easy or simple to one person may be a great challenge to another.

It is rarely helpful to treat a note-giving session as a negotiation but sometimes it cannot be avoided.

There was one broadcast executive at a Canadian network who would often preface their comments by saying "I'm not a prude but …". One can guess where that conversation might lead.

Another executive would make comments like "Delete scene 27". How is that enough information to proceed on? Scenes are usually there for a specific purpose. What is meant to replace it?

To give helpful and constructive notes, one must understand the nature of the craft being commented on. How the creator goes about her work, what thought, planning and skill goes into the work, what is practical to achieve and what is not. If a producer does not have the appropriate knowledge to give proper and useful notes, she should find someone else more qualified to do it.

Hide and Seek

Because relationships are the standard currency of the content production industries and image perception is so influential, it is important for producers to be visible. That is not to say that they should be seeking the limelight all the time or overusing social media. The reason that there are so many industry events throughout the year all over the world is that workers in the content industries feed off the energy of meeting each other in person. It is an opportunity to gain valuable information about who is doing what, with whom, how and why. The organized events present opportunities to solidify relationships with colleagues one admires or enjoys working with. They allow one to meet people otherwise unavailable or impractical to meet.

One of the rules of being a successful producer is that to be successful one must look successful. That means the right clothing, the right accessories, dining at the right restaurants with the right people. This may seem shallow and perhaps even ingenuine but our industry is about the "show" after all.

After a few dozen years of regularly attending both MIP and MIPCOM, I decided to skip one of them. It was a much-appreciated break for me. I did make a point of going to the next one without fail. When I did go the next time, I was drastically taken aback.

From the moment that I entered the airport to take the plane oversees, I would see industry colleagues as I usually would. Often, they would have ignored me or said polite hellos. The friendlier ones would strike up a conversation. This time it was different.

One after another people I barely recognized would come up and say something to the effect of "Are you going to the market? We didn't know you were still in the business". I felt like I had to rebuild my profile in the industry after having missed just one event, only six months earlier.

It's an industry where it is very possible indeed for significant persons or companies to just disappear from the scene almost overnight. Out of sight out of mind.

All Your Eggs in One Basket

We have investigated the value of building a revenue stream from the intellectual property rights one can retain in a library of production. The value of licences usually

decreases over time but it rarely reduces to zero. Any kind of income is welcome. Lean years can be bolstered and corporate valuations supported by an inventory of shows that keep getting licensed in the marketplace. It would be a mistake to think that a healthy revenue stream of content licences is enough to protect the future and sustain a standard of living. Technological advancements will not stop. The attention economy has only grown over the last century and dramatically grown over the last decade. There is every indication that it will continue to grow as artificial intelligence, quantum computing and deep learning replace traditional work modalities.

To compensate, one must diversify the revenue streams that flow from every project. Adapting or licensing games, toys and live events are common examples.

Production-related activities can also create good revenue streams. Renting proprietary production equipment or studio spaces to third parties can come in handy.

Many production companies set up distribution divisions to monetize the rights of other perhaps smaller producers as well as their own.

During the darkest moments of the "Maple Valley" dispute with our US funding broadcaster, cash flow was a concern that created a great amount of stress. We were heavily into production and spending almost $100,000 per day when a major part of our financing appeared to fall through. None of the options in that kind of situation are pleasant.

Shutting down production might have resulted in writing off all the expenditures to date – millions of dollars. Using our own funds to replace the US presale would be costly. Commencing litigation was, of course, necessary but would be slow and painful and not helpful until very long after production was due to be completed. Delaying would not be feasible for many other reasons.

The lifeline that kept things afloat was the ancillary revenue that our "Maple Valley" series was able to generate – primarily from the Australian market. We would have been hard pressed indeed had we not had millions of dollars of revenue from the licensing of music from the show which became a top ten selling CD, backpacks, plush animals, collectible toys, school supplies, bedding, t-shirts and the like, all bearing our brand.

It is an old saw in the business world – diversify, diversify, diversify.

Teamwork

At the corporate level, a big challenge is to find and retain the best staff. The best development executives or business affairs officers may eventually want to go out on their own and become producers themselves. They might get enticed to join your competitors. Acknowledging and rewarding their work is vital. Failure to do so will damage the chemistry and positive working attitude that is so integral to the quality of work that the company needs to do. The corporate culture of a production company is also very perceptible by outsiders. Content production companies by their nature are very outward looking. Observers will quickly formulate opinions on what appears to be a solid team or a shaky one.

The chemistry among corporate staff is just as important as the chemistry among production teams. Like a major league sports manager or coach, the producer or production company CEO must have a good eye for who works best with whom, what leads to better effort and what inspires innovation.

Aspirations, ambitions and goals that employees might have might not always be readily discernable. A good producer will make them feel safe to share their dreams and creative or business urges. Failing to uncover hidden talents or ambitions may result in the loss of key staff. Indulging such aspirations for the wrong employees can be costly.

I had hired a business affairs executive at a production company I was running. She was quiet but a very clever and capable lawyer. She did a great job for the company. After about a year, she abruptly left to join a competing production house. Very soon, she was promoted to executive producer at that company. Eventually, a personal project of hers would become one of Canada's best produced and most successful prime time dramas appearing on a major US network. Because I was not enquiring about her future goals, I failed to recognize the talent. It was our loss and probably her gain.

Years later, in my own production company, the Vice President of Finance who had done a great job in his finance role for years expressed the desire to try his hand at producing a low-budget feature film. Fearful of making the same mistake twice I encouraged him to pursue it and supported the effort. The movie did get made and was mildly entertaining but by no means a creative nor financial success. In fact, it was probably a costly distraction.

Team building is always hard and it's a rare talent. Assigning roles and knowing when to loosen the reins can be extremely rewarding but may also backfire.

Teamwork

Attitude

The last type of mistake that is often on display in the industry is the haughty attitude. Snobbism about one's projects or relationships, arrogance about one's abilities, egotism, braggadocio – we've all seen it. Anyone who is impressed by that kind of demeanour soon comes to regret it. It usually covers for some deeper insecurity or tries to conceal a weakness or problem. The people one would most want to impress are those that respect and value actual accomplishments rather than showiness.

One of the most well-known and well-connected professionals in the Canadian content industry has a compulsion to drop names. It is next to impossible to have a conversation with that person without being subjected to a seemingly never-ending list of the important people or projects they have a peripheral involvement with. They have had great achievements but one wonders how much more successful they might have been without that peccadillo.

Another very successful player in the Canadian industry rose from the ranks of accountant to major producer. In similar fashion, he inevitably will steer conversation to his latest coup, financial success or high-level meeting. Rather than enticing people to work with him, it turns most collaborators off. Valuable creative and business relationships are based on a sense of equal importance among the parties rather than a self-aggrandizing attitude.

Chapter 9
Conclusion

The motivation of most content producers is to build long-lasting careers as creators of entertaining, impactful, and memorable stories on screen. They want their careers to be emotionally satisfying and financially rewarding. They want to develop and maintain close relationships with the creative people that they work with. Perhaps most importantly, they will balance the heady experiences of content production with a stable, healthy, loving and mutually supportive family life. Achieving all those goals in the content creation business is hard as indeed it is in any line of work. But the travel, long hours, industry parties and festivals, perceived glamour and creative rush that face content producers may make that goal harder to achieve. As the saying goes "because being a producer beats working for a living you have to work that much harder". It is possible though.

Content production is like the workings of a clock. There are many moving parts. They need to work in concert. A producer can be seen as the clock smith, making sure the pieces are well oiled, ticking away and the time is kept.

Having a thorough knowledge of the industry and its economic foundations is key.

Understanding the practices involved in identifying, developing and selling concepts for shows is crucial. Being able to place concepts with the right content providers who will reach the right audiences is key. Following the trends of viewing habits, consumer preferences and industry hits as well as failures needs to be a constant priority. Keeping current with technological advances in content delivery, viewing and discovery is indispensable. Being able to pivot when something new demands a change and doing so at the right time – neither too early nor too late – is a great asset.

Knowing the business and legal basics is indispensable. Virtually every step of the process involves some kind of agreement. It needs to be clear, fit for purpose, binding and enforceable.

A producer must appreciate the value of intellectual property – the rights she acquires from others as well as the rights in her productions that she may sell or license away.

A successful producer will have a solid team of reliable advisors such as lawyers, accountants, and bankers and know when to involve them and when not to.

DOI: 10.4324/9781003379737-10

A production company needs the right mix of people. Because its business is essentially creating something of value from nothing, each member of the staff needs to appreciate the creative process. Development executives will be relied on to attract talent, especially writers. Finance executives will be called upon to manage not only the company's ongoing fiscal needs but also to properly manage the financing of each production as well as it monitoring the proceeds of its exploitation. A business affairs executive will supervise all important negotiations and make sure that they are well documented and concluded when they need to be. Marketing executives will promote the company and each project. Information technology experts will handle the computing and data needs.

All those personnel represent a large payroll on top of the ongoing costs of operating a business. The company will need an adequate amount of financing in the form of equity, debt and revenue from project exploitation in the right balance. The financing may come in stages, ideally more in the early years less later when there is a sufficiently lucrative revenue stream from library assets.

The company's main sources of revenue will be fees from each production and proceeds from the licensing and exploitation of the productions once they are in the marketplace. The production fees may be sufficient to cover corporate overheads and even some annual profit. The big win however and what will establish a higher valuation of the company itself will be the distribution revenues that the productions generate, year after year.

Clearly, a successful production company will want to preserve as much of the intellectual property rights in its productions as possible. It will need to be meticulous and disciplined at the financing stage of each production to resist the temptation of giving away too much ownership. Often financial pressures force producers to give away too much because of the sheer need to be in production. Sometimes, one's emotional investment in a project leads to being too generous with financiers. In any case, holding on to as much of the value in what one creates will lead to money coming in the door at some point in time. Giving away too much will often result in cash flow crunches at the corporate level and that pressure can lead to bad business moves like committing to the wrong productions just to pay current expenses.

Too often, producers rush into business or start a company just because there is an immediate production opportunity. Those companies are hard to sustain because they count on luck more than on strategy. It is far wiser to construct a proper business plan

first. One based on a good analysis of the marketplace, its immediate past, its present and its likely future. A plan should build on the founders' strengths acknowledge and support their weaknesses and find a competitive advantage in the marketplace. Far too many producers are chasing far too few outlets for their product, let alone sources of production financing.

Much of the success that producers enjoy comes from the earliest stages of identifying what projects to pursue. They assess what is feasible, what might engage, what relationships they have or could make to further the project and what resources are available or could be supplied. They have a vision of what the project will be and who will watch it. When those elements are properly aligned, the projects may seem easy. When they are not it may take years and huge effort for a project to go forward, if it does at all. Alternatively, the projects may go forward when they shouldn't and do not succeed in the marketplace.

Producers have ambition to be storytellers that outweighs the obstacles/challenges that might stand in their way whether financial, technical, competitive, or cultural. They understand on a granular level how many different talents and skills go into creating a first-class quality production, how those talents are applied and how they must combine. They can create robust creative and positive working environments. They are good salespeople, communicators and negotiators. They lead, inspire and attract people to work with them rather than coercing, forcing or bullying them.

Successful producers command respect for their taste, knowledge of their industry and the craft of content production, the available talent and market opportunities. They do not promise what they cannot deliver and they deliver what they promise. They are socially, environmentally and ethically conscious and conscientious. They are guided by the profit motive but not dominated by greed. They desire their co-workers, partners, colleagues, buyers and licencees to enjoy success as well and be proud of the productions they share.

Producers value relationships above all.

If students, aspiring producers, new producers or even experienced producers use this book as a tool for clarifying issues in the industry, explaining concepts or simply to refresh their memory, then it has fulfilled its purpose. Hopefully, it will be a useful guide to readers and help them achieve all the unique personal gratification and commercial success that the content industries can provide.

Glossary

Above the Line Personnel: key personnel responsible for creative decisions such as executive producer, producer, writer, director and stars

Acceptance: act or behaviour that signifies formal assent to an offer and creation of a binding contract

Acquisitions: agreements whereby a content provider obtains licenses to make completed productions available to its customers

Actual Breach: act or omission that constitutes a contravention or failure to abide by agreed to terms of a contract

Ad Idem: "of the same mind", in total agreement

Advance: a payment tendered before due such as payment in respect to distribution royalties before finished content is being marketed

Aggregators: an organization the accumulates content from multiple sources and packages it for specific purposes

Ancillary Revenues: proceeds from the commercial exploitation of property derived from uses other than the primarily intended uses

Angel Investor: untraditional and welcome source of financing for a project, usually in exchange for an ownership interest

Anticipatory Breach: legal concept whereby a party makes it clear either by words, action or inaction that it will not fulfil its contractual obligations

Arbiter: third-party decision maker

Arbitration: process whereby parties to a dispute agree to a process for resolving their conflict short of court proceedings

Articles of Incorporation: documents containing the by-laws and organizational structure of a company, required to be filed in order to obtain official status as a corporation

Assignment (of a Copyright): the document by which property rights are transferred

Assistant Director: one or more crew members organizing and managing production details for a director

Attention Economy: the range of economic activities based on treating human attention as a valuable commodity

Bankable: in respect of contracts containing promises to pay, capable of satisfying a bank that a lending risk is acceptable. In respect of talent, confidence that an individual's work will be commercially successful enough to justify investment in a production

Below the Line Crew: all members of a content production crew other than the key decision makers

Beneficiaries: people who stand to gain from a contract, trust or will document

Binding Agreement: a contract that is legally enforceable

Board of Directors: individuals appointed by shareholders of a corporation to represent the shareholders' interests, supervise the key officers and oversee most important affairs of the corporation

Bond: a sum of money or binding commitment to pay dedicated to someone to fulfil an obligation

Breach of Contract: failure to perform as agreed

Breakeven: point in time when receipts equal costs

Budget: financial summary, prepared by knowledgeable professionals estimating and setting out all anticipated costs

Business Affairs Executive: employee of a company responsible for negotiating and completing most commercial arrangements and working with outside legal counsel when necessary

Business Plan: well-thought-through, researched and articulated strategy for the successful operation of a business over an ensuing period of years

Buyer: loosely used term referring to an organization or the individual in an organization such as a network or channel, in the business of acquiring licenses from

producers or distributors to use content for the purpose of making it available to its client consumers

Capacity: status of being deemed legally responsible

Cash Flow Schedule: a spreadsheet reflecting all anticipated expenditures and all anticipated infusions of cash or financing and the resulting surpluses or deficits over periods of time in the future

Certified/Certification: in respect of content the status given by an official government body designating a production to have national status and eligibility for subsidies

ChatGPT: a generative artificial intelligence natural language processing tool that allows conversations and can produce text as well as image content on request

Chief Executive Officer: the corporate official, often also the president, responsible for and having authority over all day-to-day activities of the corporation and fulfilling the mandate set by the board of directors

Collateral: in respect of loans, an item of value pledged as security for a loan and subject to being seized if a loan or obligation is not met

Collective Agreement: terms assented to between two organizations such as a trade union and a contractors' association, representing and binding their respective members with respect to terms of engagement and trade practices

Commercial Grade Content: audio-visual productions in any medium of a quality suitable for exploitation in the mainstream consumer content industries such as movies, television, cable and/or streaming productions

Common Share: share of ownership of a corporation having the same basic rights and privileges of any other owner the same class of shares

Completion Guarantee: an agreement, like an insurance policy, whereby a company agrees under proscribed terms and conditions to protect the interests of financiers of a production and in the event of a major disruption or failure by the producing company, to either reimburse the financiers for their loss or take over and complete the production or both

Consent: actual and unambiguous assent by either word or action, to a term or condition

Consideration: in respect to contract law anything of value sufficient to induce a party to enter into a binding agreement

Consumer: individual using a product for there own enjoyment, in respect to content the actual viewer

Content Value Chain: all the steps and activities involved from the very inception of a production to its actual enjoyment by an intended audience

Co-production: with respect to content, the joining of one or more entities with the common purpose of manufacturing an audio-visual production, either by ordinary practice or pursuant to the terms of an official co-production treaty

Co-production Agreement: contract setting out the respective terms, obligations and privileges of the parties to a co-production

Co-production Treaty: binding agreement between two nations governing the terms by which their citizens might work together to manufacture a production to qualify for state benefits in each country

Copyright: legal status afforded by statute conferring property rights and protections to qualifying intellectual property

Corporate Law: the body of statutes, regulations and rulings governing the way companies are created and operated

Corporation (or Company): an entity having the same rights and capabilities as a person, formed under and governed by the relevant statutes in its home jurisdiction

Cost Reports: financial statements of expenditures in a period of production activity comparing actual activity to budgeted forecasts so that producers and financiers might monitor progress

Creative Proposal/Bible: term of art designating the material(s) created by a producer, writer or production company summarizing key creative and commercial attributes of a potential production and intended to elicit the interest and participation of a buyer

Crowd Sourcing: practice of inviting the public to contribute funding for a given process or product by way of website contributions sometimes in exchange for ownership shares, sometimes for notional benefits or no benefits at all

Damages: in respect to legal conflicts, the loss suffered by one party as a result of another party failing to act in respect of or acting in contravention of a duty and capable of being assessed in monetary terms

Deal Memo: a written instrument outlining the basic terms of agreement between or among parties intended to be binding but not as comprehensive as a full-scale contract

Debt Financing: borrowing money to pay for the cost of an intended project or acquisition, the pricing, timing and manner of repayment of which is specified and the repayment of which may or may not be secured by collateral

Deferral: in respect of content production the postponing of a payment otherwise due by contract until a later date or until sufficient proceeds of exploitation are received, if any

Delivery Elements: in respect of content production the technical elements that are required to be delivered to a licensee or distributor of a production to enable them to properly exploit the production

Demo: an audio-visual representation of an intended production intended to elicit financing or pre-licensing

Denouement: the satisfactory resolution of a conflict or challenge at the end of a dramatic work

Development Deal/Development Financing: an agreement, usually between a creator or production company and a potential licensee of a production whereby the potential licensee obtains the exclusive right to fund further creative activity to advance the project to a point where it can be evaluated for production financing

Development Hell: a process of conducting development of a production with a potential end user that takes far too long and/or is creatively frustrating

Director: in corporation, an individual appointed by the shareholder(s) to represent their interests in the governance of the corporation's activities, in an audio-visual

production the person whose creative skill and judgement is engaged to plan, organize and craft the actual shooting, editing and completion of a production

Directors' Resolution: legal document evidencing the decision of the director(s) of a company pursuant to a given proposed action

Distribution: in relation to content, the bringing to market, on behalf of owners of a finished production, of the rights to exhibit the production in territories, media and/or time periods that have not been already licensed

Distribution Advance: a payment by the distributor of a production to its owner of a specific sum of money before the production is exploitable, recoupable by the distributor from revenues as they arise

Distribution Agreement: the contract whereby an owner of a production authorizes another, on specific terms and conditions and for set commission fees, to negotiate and conclude licenses of the finished production to end users

Distribution Fee: amount of money, usually a defined percentage of revenues collected that a distributor is entitled to retain from collections as compensation for its services

Distribution Guarantee: a binding promise from a distributor to the owner of a production to pay or to have paid to the owner, by a certain date in the future, a specified amount of the owner's share of the proceeds of exploitation of a production

Distribution Revenues: all proceeds of exhibition licenses entered into in respect of a production

Distribution Rights: specific territories, media and time windows in which a finished production may be licensed

Distributor's Gross Receipts: all license payments received by a distributor

Draw Down: in respect to production financing the receipt of a payment from a lender or end user

End User: an organization such as a network, channel, streaming platform or theatre that, for commercial purposes, acquires a license to exhibit, publish or provide access to a production to individual viewers

Episodic: a form of storytelling with common characters and settings in which the plot resolves in each segment but characters and settings may be present in succeeding segments

Equity Financing: funds provided for the manufacturing of a production in exchange for an ownership interest in the finished product

Exclusivity: the sole right to use and prevent others from using a property

Exercise (an Option): to perform the specific act required to crystallize a contractual right such as an option

Exploitation (of a Production): the right to sell, license or otherwise benefit monetarily by authorizing others to use a property

Express Acceptance: unequivocal assent to a term or offer either in writing or by clear action

Fair Use: permitted use of a copyrighted work without permission for specific purposes in the public interest such as criticism, satire or educational purposes

Financing Plan: a detailed outline, often in the form of a spreadsheet, describing the intended sources of funding to cover the costs of completing a project and nature, timing and rights of the respective sources

Fundamental Breach: a failure or refusal to perform a condition of a contract that it so important that the contract is rendered null and void

Going Public: the process, proscribed by securities laws, by which a corporation may offer its shares to the general public

Grants and Subsidies: financial incentives offered by government bodies or instigated by government bodies to stimulate economic or cultural initiatives where market forces may be inadequate or prohibitive

Guild: an organized body representing and negotiating with engagers on behalf of a specific labour force such as writers, actors or directors

Holding Fees: a sum of money paid to an individual or a facility to ensure availability for use for a specific time

Hook: in respect to content development the key element of a project that is of highest attraction to a potential audience

Ideation: the process of thinking up a potential project

Implied offer, acceptance: an offer or acceptance that any reasonable person would understand to be necessary but is not expressly articulated

Intangible Rights: rights created by law to do or prevent something from being done as opposed to physical rights such as possession and trespass

Intellectual Property: property such as a novel, movie or symphony whose intrinsic value is non-physical although it may be embodied or communicated by physical means

Interim Financing/Interim Loan: a loan intended to supply funding for a project during its manufacture or construction before the ultimate financing of the project is payable

Joint Venture: undertaking between or among two or more parties who join together for a common project, less permanent or formal than a legal partnership

Library Value: the estimated commercial worth of the available exploitation rights to projects owned by a production company

Licensees: entities who have acquired the right to use or commercially exploit property or property rights owned or controlled by another

Life Story Rights: the authorization to adapt, portray, publicize and/or exploit the personal history of an individual

Line of Credit: an open loan facility whereby a borrower may draw amounts from time to time without separate loan authorizations as long as the overall borrowing complies with general terms set by the lender

Line Producer: an individual engaged to oversee the actual production process of a project on behalf of a production company but who has no ownership and usually no final decision-making authority

Monetization: exploiting property or property rights such as copyright or trademarks for money

NFT: non-fungible token, a certificate of ownership of a digital file stored in blockchain that may be bought or sold

Non-Recourse Loan: a loan that is expected to be repaid only in the event that a certain event occurs but not if the event never occurs

Officer: with respect to corporations an employee with official status and authority such as a president, vice president, secretary or treasurer

One-Off: an isolated project not part of a concerted and continuing endeavour

On Spec: assuming the risk and embarking on a project without any assurance of financial reward

Operating Plan: a strategy and blueprint for actually executing a task

Option Agreement: a contract whereby a party is given the exclusive control of property or a right for a specified period of time during which it may or may not decide to acquire more extensive rights

Option Extension: an additional period of time granted to a party whose initial option period has expired

Option Fee: the amount paid to the owner of property or property rights by the party acquiring an option

Option Period or Term: the length of time that the option is alive and capable of being acted upon

Original Content: a program or show that has begun as a pitch to a program supplier or service, is developed and eventually commissioned into production by them and according to their approval

Order: with respect to content, the official commitment from an end user to license a production

Output Deal: an agreement between a producer and distributor or between a distributor and end user by which a group of projects, some not yet created, are all licensed on pre-negotiated terms

Overhead: all the costs associated with carrying on business

Overruns: production expenditures that exceed the budgeted costs of a project and therefore, usually, the financing that has been arranged

Packaging: with respect to content production the assembly of several key elements such as stars, writer and director all connected to a project to make it more attractive to buyers and/or the audience

Parent Company: an ongoing company that owns all the intellectual property and is entitled to the financial benefit from a production. It incorporates new subsidiaries, wholly owned by it who undertake the actual manufacturing of each production but do not own any of the rights

Pitch/Pitching: the material and process of describing a potential project in a sales context to elicit development interest or production financing

Pitchee: the person, executive or organization to whom the pitch is presented

Post-production Crew: the production personnel responsible for the work done on a production after video and sound are recorded such as picture and sound editing, colour correction, visual and/or sound effects

Preferred Share: a share of ownership of a corporation that has special or additional attributes of ownership or control vis-à-vis the common shareholders

Presale/Pre-License: an agreement by which a network, channel or streamer acquires an exclusive license to exhibit a production before it is produced, usually for a very high license fee

Production Company: a corporation that physically manufactures the project

Production Development: the process of expanding a project's plot, character, setting, style and tone elements from concept through to the point where it is substantial enough to warrant pre-licensing, usually involving script writing, budgeting and often key casting

Production Fees: budgeted payments to the producers and production company who were instrumental in the project being initiated

Production Financing: the money arranged to pay for the budgeted costs of manufacturing a production

Production Manager: individual responsible for coordinating all departments of the production crew

Producer's Gross Receipts: the portion of distribution revenue payable to the producer after the distributor has retained its fee, recovered its allowable expenses and recouped any advance or guarantee payment

Producer's Net Profit: the portion of distribution revenue remaining with the producer after it has repaid any production financing

Profit Participation: the right to a share of the portion of distribution revenue that fits the definition of profit

Purchase Agreement: in respect to content industries, the contract by which one acquires the right to adapt someone else's intellectual property into a new form of exploitation such as the right to adapt a novel into a mini-series or a comic book into a video game

Recoupment: in terms of production financing the right to recover investment or expenditures from the revenue stream, such as an equity investor having the right to recoup its investment or a distributor the right to recoup its allowable expenses

Revenue Stream: the flow of money that results from the exploitation of rights. An individual project may have numerous distinct revenue streams from different territories, media or adaptations

Sale: often a misnomer since transfer of ownership is rarely involved, the term used to describe a pitch or development process that successfully results in a license of a project by an end user

Sales Reports: financial statements issued by distributors detailing licenses they have concluded, collections received, expenses incurred or paid, advances or guarantees recouped (or outstanding) and the amounts owing to a producer

Security: collateral for a loan in the form of property or intellectual property pledged to a lender until repayment

Serialization: a form of episodic or segmented storytelling containing continuing plots and/or characters that carry on from the end of one episode or segment to others

Service Production: a production undertaken by a company hired by another to simply manufacture the product without any rights of ownership

Single Purpose Company: a company that is formed by and wholly owned by a parent company just for the purpose of manufacturing a production. All financing for the production is supplied for the parent company which will be the owner of all rights in the ultimate product. The single purpose company is normally wound up and ceases to exist when it is no longer needed

Shareholders: the entities, persons or other companies who own a portion of the ownership of a corporation

Shareholders' Resolution: a written record of a decision taken by a vote of the shareholders of a company

Shortfall: an amount of production costs not covered by the financing arranged

Star System: generally speaking, the system that evolved in Hollywood whereby celebrity actors are cultivated and groomed as tools to market productions

Startup Capital: the funding, resources and human effort applied at the very inception of a company, intended to last until the company becomes self-sufficient financially or able to raise outside financing

Statute: a law passed by a government legislative body

Strategic Plan: a long-term blueprint for the market position of a company, its value proposition to customers, its ability to compete and ultimately its financial success

Subsidy: financial or other assistance provided by a government to a company or sector of the economy to assist it to compete against disproportionate market conditions, usually with specific rules governing eligibility and access

Territory: literally a geographic area of the world in which a licensee of rights to a production may pursue commercial activity on an exclusive basis

Three Act Structure: a basic form for storytelling in three stages commonly known as Setup/Exposition, Confrontation and Resolution

Time Windows: consecutive or alternating periods of time in which one is given exclusive rights to market content to consumers, as in a "first window" in theatres,

"second window" on a streaming service, "third window" on cable or network television

Trade Fairs: organized conventions where companies operating in various sectors of an industry gather to offer their products or services to each other and form relationships

Trademark Protection: similar to copyright law, a law governing the use of branding and product identification intended to prevent the market from confusing one's product with that of another

Treaty: a binding agreement between two (or more) sovereign states that may supersede any laws within a state or any private commercial freedoms

Turnaround: the commercial arrangement whereby a company that may have taken exclusive control over a property during its development or production releases the rights back to the original production company or owner, sometimes reserving a right to match any new offer

Union: a legally recognized labour organization that represents workers' rights and negotiates collective agreements with engagers or associations that represent engagers

Exhibit Examples of Exploitation Rights to Audio-Visual Content

(a non-exhaustive list)

Ancillary Rights

Rights to exhibit or adapt content on platforms other than the originally intended platform. May include military bases, airplanes, hotels, cruise ships. May include adaptations such as merchandising or stage productions.

AVOD

Advertising-Supported Video On Demand — content provided to viewers free of charge but which contains advertisements.

Basic Cable

The exhibition of a production on a channel that is subscribed to as part of a bundle of channels included in a cable television service package. May or may not contain advertising.

DVD

Digital Video Discs. Sometimes known as Home Video Rights, the right to sell or rent physical copies of the production capable of being played back by consumers on electronic devices.

EST

Electronic Sell Through. The right to sell electronic or digital copies to consumers.

FAST

Free advertising-supported streamed television content. Similar to AVOD but usually in the form of linear channels that are streamed as one continuous programmed block rather than individual programs or episodes consumed one at a time.

Format Rights

The right to copy or follow a detailed formula for production of a program, usually for adaptation in different languages or countries and most often with respect to reality or game show series.

Free Television

Transmission of programmed channels by broadcast, cable or satellite on a free or unpaid basis to consumers but containing advertising before, during or after each program.

FVOD

Free video on demand is the right to provide programs to consumers at no cost. Usually used for promotional purposes as in the first episode of a series or a trial period for a paid channel.

Merchandising Rights

The right to adapt, trademark and sell elements of a program in the form of consumer products such as toys, dolls, clothing and games.

Pay Per View

The right to provide a program, usually a movie, on demand for a set fee. Similar to VOD.

Pay TV

Television content or channels available only to consumers who pay, usually as part of a cable television package which may or may not include premium subscriber services such as HBO or Showtime.

Satellite TV

Any form of transmitting television signals via satellite.

SVOD

Subscription Video on Demand. The right to provide programs to subscribers of a service at any time of their choosing.

Terrestrial TV

Any form of transmitting television programs, free or paid over the air via broadcast signal.

Theatrical Exhibition

The screening of content for ticket buying consumers at pre-set times in theatres. "Non-Theatrical" rights refers to public television and private exhibitions.

TVOD

Transactional video on demand permits a program to be obtained directly from a provider's platform for limited viewing privileges and for a one-time payment, usually at lower cost than the price for downloading a personal copy.

Exhibit Key Creative Point System for Canadian Content Status

(excerpted from: https://crtc.gc.ca/canrec/eng/guide1.htm)

Point System – Definitions

Domestic productions, as well as international co-ventures, are awarded points when Canadians occupy certain key creative functions involved in making the production.

Canadian (Individual)

A Canadian citizen as defined in the *Citizenship Act* or a permanent resident as defined in the *Immigration and Refugee Protection Act* who has received a Permanent Residence Certificate.

An individual must have citizenship or permanent residency before the start of principal photography and must retain it until the end of post-production in order for us to award points to people in key creative positions.

Canadian (Production Company)

Either a licensee of the CRTC or a Canadian company carrying on business in Canada, with a Canadian business address, owned and controlled by Canadians.

Point System – Criteria

We award points for live action productions, continuous action animated productions and animation productions based on key creative functions being performed by Canadians.

Productions must generally earn at least six points out of a possible ten to be eligible for certification.

Of the minimum six points:

> The director or screenwriter position (for live action or continuous action animated productions) or the scriptwriter or storyboard supervisor position (for animated productions) must be filled by a Canadian.
>
> First or second lead performer position must be filled by a Canadian.
>
> These mandatory points must be achieved for one-off productions and for each episode in a series.

Where multiple people share duties for a particular position, or multiple people share screen credits for a single position, the production only earns the point if all of the people are Canadian.

Example: For a production with two picture editors, one of whom is Canadian and the other non-Canadian, the position is considered non-Canadian and does not earn a point. Similarly, if there are ten writers and one of those ten writers is non-Canadian, the position is considered non-Canadian and doesn't earn a point.

Point System – Points Awarded Per Key Creative Position

The points awarded for key creative positions filled by Canadians required to certify a Canadian production:

Live Action and Continuous Action Animated Productions

> Director (2 points)
>
> Screenwriter (2 points)
>
> First and Second Lead Performers (performer or voice) (1 point each)
>
> Production Designer or Art Director (1 point)
>
> Director of Photography or Chief Camera Operator (1 point)
>
> Music Composer (1 point)
>
> Picture Editor (1 point)

Animated Productions (Other Than Continuous Action Animation)

Scriptwriter and Storyboard Supervisor (1 point)

Director (1 point)

Picture Editor (1 point)

First or Second Voice (or first or second lead performer) (1 point)

Design Supervisor (1 point)

Camera Operator and Operation (1 point)

Music Composer (1 point)

In addition, animated productions are also awarded points when key creative functions are performed in Canada:

Key animation (1 point)

Layout artist and background (1 point)

Assistant animation/in-betweening (1 point)

For animation productions (excluding continuous action animated productions), it is mandatory that the following persons or locations are Canadian. Where the point is assigned to a location, it will be awarded only if that function is performed entirely in Canada.

The people occupying the role of the director, or the combination of scriptwriter/ storyboard supervisor, must be Canadian.

The location of the key animation, excluding pixilation, must be in Canada.

The people occupying the role of the first or second lead performers or voices must be Canadian.

The people occupying the role of the camera operator must be Canadian, and the location of the camera operation, for pixilation only, must be done in Canada.

Animated Productions (Other Than Continuous Action Animation)

Exhibit Treaty Coproduction Agreements – Basic Terms

Parties

– Ensure the owners of the appropriate rights are parties

Intention

– Confirm purpose of coproduction

Copyright and Co-ownership

– Recite which party owns which rights to underlying property
– Specify what the respective shares of ownership of the finished production shall be

Production Accounting

– Specify what kinds of financial records to be kept and in what locations

Bank Accounts

– Specify which bank accounts, in which currencies the respective parties will maintain and where

Production Details and Parameters

– Describe production in detail: underlying material, scripts, budget, stars, director(s), producers, locations, etc.
– Specify the respective components of the production are the primary responsibility of the respective parties: who is responsible for writing, principal photography, post-production, etc.
– Specify respective obligations and proportions of cost expenditures
– Identify what percentage of costs are spent in which country

Budget and Financing

- Specify the amounts of financing each party is responsible for to cover all budgeted costs
- Detail all costs to be contained in budget, including financing costs

Insurance

- Confirm the types of insurance to be obtained

Completion Guarantee

- Detail the entities to be named as beneficiaries of a completion guarantee (if one is to be required)

Production Elements and Access

- Describe the key production elements to be created
- Who is responsible for each
- Where will they be located
- Ensure each party has appropriate access

Territories and Revenues

- Confirm that each party owns all rights and revenues in its home territory
- Describe how remaining territories are to be managed, who controls distribution and how revenues are to be divided
- Revenue sharing proportions should roughly follow respective financing obligation proportions

Revenue Accounting

- Specify what financial reports are required for distribution revenues
- How often delivered: quarterly, half-yearly, yearly?

Publicity

- What controls, approvals and materials apply to advertising and publicity

Transfer of Interest

- What may a party do or not do with its ownership interest
- What rules may apply

Default Provisions

- What would constitute a default of a party's obligations
- What opportunities to remedy?
- What rights or consequences apply for failure to remedy a default

Arbitration

- Agree on the mechanism to engage an arbitrator in the event of an unresolved dispute
- Decision binding or not?

Divorce Provisions

- How do parties separate their co-ownership or coproduction relationship
- When, how and on what terms

Acknowledgement of Treaty

- Confirm the application of the treaty between the countries of the two parties and that the treaty supercedes the agreement

Exhibit List of Media conferences, Festivals and Trade Shows

(Dates and locations may change from year to year)

Animation | Gaming | Virtual and Augmented Reality

The Animation Community Festivals Listings

Annecy International Animation Film Festival & Market (MIFA)

Consumer Electronics Show (CES)

CTN Animation Expo

Game Developers Conference – GDC

The International Conference and Expo on Computer Graphics & Animation

LA Games Conference

MAGfest – Music & Gaming Festival

MIA Animation Conference & Festival

Ottawa International Animation Film Festival

SiegeCon Game Developer's Conference

SXSW Interactive

VidCon

FILM

American Film Institute Festival (AFI Fest)

American Film Market (AFM) & Conference

A Day in the Life of a First AC

A Day in the Life of a Video Game Performance Director

A Day in the Life of an Intimacy Coordinator

African Film Festival NY

Ann Arbor Film Festival

Ashland Independent Film Festival

Aspen Film

Atlanta Film Festival

The Berlin International Film Festival (Berlinale)/European Film Market

Cannes International Film Festival (Festival de Cannes)

Chicago International Film Festival

Chicago International Music & Movie Festival (CIMM Fest)

Chicago Underground Film Festival

Clermont-Ferrand International Short Film Fest

Comic Con

Edinburgh International Film Festival

Frameline Film Festival

Hamptons International Film Festival

Hawaii International Film Festival

Heartland Film Festival

Hot Docs Canadian International Documentary Festival

Hot Springs Documentary Film Festival

How to Research Film Festivals

International Film Festival Rotterdam (IFFR)

Karlovy Vary International Film Festival (KVIFF)

Locarno International Film Festival (Festival del Film Locarno)

Los Angeles Film Festival

Miami International Film Festival

Mill Valley Film Festival

Nashville International Film Festival

New Orleans Film Festival

The New York Film Festival

Outfest Los Angeles

Palm Springs International Film Festival

Pan African Film Festival

Produced By Conference

Raindance Film Festival

San Diego Latino Film Festival

Sarajevo Film Festival

Seattle International Film Festival

Sheffield International Documentary Film Festival (Sheffield Doc Fest)

SlamDance

South Asian International Film Festival (Third i Film Fest)

Staff Me Up

SxSW Festival & Conference

Sydney Film Festival

FILM

Telluride Film Festival

Toronto International Film Festival

Tribeca International Film Festival

The Venice International Film Festival (La Biennale di Venezia)

WonderCon (ComicCon LA)

WorldFest: Houston International Film Festival

Digital Media | Online Video | Content Streaming

Electronic Entertainment Expo (E3)

The Future of Television Conference

NAB SHOW

SxSW Interactive

Vidcon

Television | Broadcasting | Digital Media

Banff Media Festival

Broadcast Education Association (BEA) Convention

Digital Entertainment World

Digital Hollywood

Electronic Entertainment Expo (E3)

NAB SHOW

NATPE

Next TV Summit & Expo

Produced By Conference

Society of Professional Journalists (SPJ) Conferences

SxSW Interactive

TV of Tomorrow Show

Vidcon

Television | Broadcasting | Digital Media

Distribution Agreement Deal Memo

1. Parties

- Ensure that the owner of the rights being granted is a party

2. Production

- Describe and identify the production in sufficient detail to ensure no confusion

3. Rights Granted

- Exclusivity
- Theatrical
- Video, Digital Electronic

 Rental

 Sell Through

 Subscription

 SVOD

 AVOD

 FAST, etc.
- Television
 - broadcast, cable, streaming
- Cinematic
- Interactive
- Merchandising

4. Term/Delivery Date

- How long does relationship endure
- When does it start
- When does it end
- What happens after expiry with licenses that may continue

5. Territories

- What geographic territories may distributor exploit
- Limited to earth?
- How to deal with porous borders

6. Advance/Minimum Guarantee

- Amount
- Payment terms and conditions
- How is it recouped

7. Revenue Participation

- Distributor's Gross Receipts definition
- Adjusted Gross Receipts definition
- Distribution Fee and expenses
- Recoupment of advance or guarantee
- Producer's Gross Receipts definition

8. Accounting/Reporting

- How frequently reports must be sent
- What information must reports contain
- Dispute mechanism
- When and how producer's receipts are paid

9. Delivery Items

- Detailed list and description of physical elements that are required to be provided to distributor
- Acceptance of delivery as key to payment of advance or guarantee

10. Remedies

- What constitutes default
- What mechanism to resolve
- What are consequences of failure to remedy

Option to Purchase Rights Deal Memo

1. Parties

- Confirm that rightful owner of rights is a party
- Make sure that the right entity is acquiring rights

2. Representations and Warranties

- Recite chain of title
- Confirm that seller has clear and unencumbered title
- Confirm no impediment to granting rights

3. Option Period Term

- one year?
- extensions?
- specify start and end dates

4. Option Fee and Purchase Price

- What is paid for first term
- Applied against purchase price?
- What is paid for subsequent terms
- Applied against purchase price

5. Rights to Be Acquired

- Specify all anticipated rights to be acquired
- Allow development activities
- Exclusivity

6. Exercise of Option

- By formal writing?
- By payment?

7. Credit

— What credit if any is to be given to seller

8. Ancillary Rights

— stage, novelization, merchandising, games, theme park attractions, etc.

9. Miscellaneous

— attach full purchase agreement to be automatically activated once option exercised

Exhibit Broadcast Commitment Deal Memo

1. Parties

- Ensure owner of rights is party to contract

2. Representations, Warranties

- Confirm that seller has clear and unencumbered title
- Confirm no impediment to granting rights

3. Project Description

- Genre
- Format
- Key Creative Personnel
- Budget

4. Order

- Running time, number of Episodes if series
- License Fee
- Equity?
- Term
- Number of plays or exhibits
- Payment Schedule

5. Rights

- Media
- Territories
- Uses
- Languages
- Ancillary

6. Conditions Precedent

- Content status for Quota and/or Funding Eligibility
- Financing Plan Approval
- Proof of Financing
- Series Elements Approvals
- Casting Approval
- Delivery Schedule

7. Delivery Items

- Detailed list and description of physical elements to be delivered to buyer

Acknowledgements

Many thanks to Charles Falzon, Dean of The Creative School at Toronto Metropolitan University, who first asked me to speak to a class many years ago. Thanks as well to Jean Desormeaux, Professor and Program Coordinator of the Creative Industries Management Graduate Program, Pilon School of Business at Sheridan College, for his support, comments and advice. I am grateful to Dr. Kathleen Pirrie Adams, Chair, RTA School of Media at the Creative School of Toronto Metropolitan University.

Very special thank you to Matthew Emmons for his invaluable editing input and assistance in the assembling of materials for this book.

Most of all, my deep gratitude to Barbara Cole for being at my side, behind me or ahead of me for over 45 years and to my daughters Charley and Michael Jane for being my inspirations.

About the Author

With a special concentration on Entertainment and Media Law, Steve Levitan has practised in virtually all the major sectors of the creative and cultural industries. He has advised, represented and negotiated for clients such as musicians, artists, dancers, writers, directors, designers, producers, distributors, theatres and broadcasters – both at the very beginning and at the pinnacle of their careers. He has acted in matters involving contract, copyright, licensing, distribution, exhibition, commercial as well as government financings and marketing. Steve has advised and provided key input on cultural policy at all levels of government. He has been CEO of one of Canada's leading film and television companies before founding his own production company in 1993. He still serves as President and CEO of that company which has an extensive library of television series and feature film productions produced or executive produced by Mr. Levitan. Among those productions are the "Goosebumps" and "Saddle Club" television series which have enjoyed exceptional success internationally.

Since 2012, Steve has been a frequent guest lecturer and instructor of various courses related to media production and exploitation. He teaches at Toronto Metropolitan University's RTA School of Media and its Creative Industries School, both in The Creative School faculty and Sheridan College's Pilon School of Business.

Steve was a founding chairman of the board of the Desrosiers Dance Theatre. In 2011 Steve was appointed by Toronto City Council as Chairman of Board of the St. Lawrence

Centre for the Arts. Toronto City Council also appointed him to be a member of the board of directors of TO Live which supervises and operates the major theatres owned by the city of Toronto, including Meridian Hall, the Meridian Center for the Arts as well as the St. Lawrence Centre for the Arts.

Steve is accredited by both the Alternative Dispute Resolution Institute of Canada and the Alternative Dispute Resolution Institute of Ontario. He is a member in good standing of both institutes specializing in mediation and resolution of disputes in the cultural industries.

He is proudly married for over forty-three years and has two brilliant daughters and, at last count, three wonderful granddaughters.

Index

Note: **Bold** page numbers refer to tables and *italic* page numbers refer to figures.

Index